Mothers Without Their Children

Edited by Charlotte Beyer
and Andrea Lea Robertson

DEMETER

Mothers Without Their Children
Charlotte Beyer and Andrea Lea Robertson

Demeter Press
140 Holland Street West
P. O. Box 13022
Bradford, ON L3Z 2Y5
Tel: (905) 775-9089
Email: info@demeterpress.org
Website: www.demeterpress.org

Demeter Press logo based on the sculpture "Demeter" by Maria-Luise Bodirsky www.keramik-atelier.bodirsky.de

Printed and Bound in Canada

Front cover artwork Michelle Pirovich
Typesetting Michelle Pirovich

Library and Archives Canada Cataloguing in Publication
Title: Mothers without their children / edited by Charlotte Beyer and Andrea Lea Robertson.
Names: Beyer, Charlotte, 1965- editor. | Robertson, Andrea, 1972- editor.
Description: Includes bibliographical references.
Identifiers: Canadiana 2019004389X | ISBN 9781772581737 (softcover)
Subjects: LCSH: Absentee mothers. | LCSH: Motherhood.
Classification: LCC HQ759.3 .M68 2019 | DDC 306.874/3—dc23

MIX
Paper from
responsible sources
FSC
www.fsc.org
FSC® C004071

Acknowledgments

This book has emerged from our shared interest in experiences, histories, and representations of mothers without their children.

We wish to warmly thank all our contributors for entrusting us with their work and for sharing their scholarship and creativity. We applaud and commend the work they have produced and are grateful for the privilege of being able to publish it in this volume.

Enormous thanks go to Demeter Press, Editor-in-chief Andrea O'Reilly, and all her staff for the support and assistance they have offered to us throughout this process. Their helpful advice, professionalism, and practical guidance have been crucial to the completion and publication of this book.

Finally, we want to acknowledge the love and support we have received from our families. This work would have been much harder without their unstinting encouragement.

We dedicate this book to all mothers
who are without their children.

Contents

Introduction: Researching and Reimagining Mothers without Their Children

Charlotte Beyer

Conceiving Motherhood

Is a mother a mother without her child or children? Is she tragic, diminished, and robbed of her purpose and identity? Or is she liberated, free to redefine herself, inviting alternative reimaginings? How do our society and culture conceive of mothers who are without their children, without the very relationship appearing to unequivocally define them as mothers? The figure of the mother without her child profoundly challenges our understanding of motherhood and its representation. Toni Morrison's 1987 novel *Beloved* depicts the all-encompassing abjection felt by the main character Sethe, a black slave mother, after her shocking murder of her cherished baby daughter, Beloved. Grieving her lost child, Sethe is overjoyed when Beloved returns to her in the form of a ghost; she sees her return as an opportunity to make amends to Beloved and provide her with fuller, richer mothering. Yet as Morrison's novel shows, the issue of maternal love and loss, and the figure of the mother without her child, are complex, contradictory, and not easily resolved (see also Talbot 89-90).

This book explores representations and realities of mothers without their children; it examines a variety of different historical, cultural, discursive, and artistic contexts, and the absences and losses examined in this volume are physical, symbolic, literary or real life, historical, permanent, or temporary depending on context. These investigations are informed by questions such as the following: How do changing

definitions of sexuality and gender affect conceptions of maternity and the mother-child relationship? How do issues such as employment, education, class, race/ethnicity, sexuality, and religion influence the treatment of mothers in past and present societies? If the mother without child is one of the most complex and problematic images of motherhood imaginable, how have artists and authors represented this figure? How do death and bereavement impact mothers? These and other considerations will be explored in *Mothers Without Their Children* through a variety of creative and scholarly means.

Recuperating and Reimagining Motherhood and Loss

The subject of mothers without their children addresses a central yet problematic aspect of maternal identity, which is underresearched and has rarely been examined in its complexity. Relatively few scholars have produced in-depth book length studies of mothers without their children as well as their past and present depiction. Elaine Tuttle Hansen is a notable exception in this field, and her work on literary representations remains central to the development of this book. Rosie Jackson has also investigated this topic, focusing on mothers leaving and living without their children. Our book extends these debates and develops their investigations further through its interdisciplinary scholarly focus and multidimensional creative content. Arguably, the most divisive and ambivalent, even judgmental, language has frequently been reserved for the figure of the mother without her children. Her existence deeply challenges our assumptions about the emotional and physical realities of motherhood. *Mothers without Their Children* interrogates definitions and understandings of motherhood through the scrutiny of a variety of cultural, social, historical, and literary texts and practices from diverse contexts across the globe. The analytical, scholarly, creative, and poetic texts in this book encourage and enable readers to not only understand but also reconsider the notion of the mother without her child. In this book, we have deliberately chosen to interweave scholarly pieces with creative works in order to illustrate how creative writing itself can be used as a research tool. Alongside more conventional scholarly discussions, the use of autoethnography and/or life writing in some of this book's pieces underlines the important function of personal experience in maternal

studies. The willingness to test the boundaries of disciplines and methodologies to investigate hitherto overlooked aspects of maternal experience connects the pieces in this book, be they academic or creative.

Historically, enforced separation of mothers from their children has happened under the harshest and most dehumanising of circumstances. Slavery in America provides ample evidence of the use of mother-child separation as a means of control and reinforcement of enslavement and the suppression of women. Toni Morrison has commented in an interview on the deprivations of black slave motherhood:

> One of the monstrous things that slavery in this country caused was the breakup of families. Physical labor, horrible; beatings, horrible; lynching death, all of that, horrible. But the living life of a parent who has no control over what happens to your children, none. They don't belong to you. You may not even nurse them. They may be shipped off somewhere, as in "Beloved" the mother was, to be nursed by somebody who was not able to work in the fields and was a wet nurse. (qtd. in Martin)

Several of the essays and creative contributions in this book explore the significance of nursing or breastfeeding to maternal identity, including the heartbreak of neonatal death. This book investigates what Hansen describes as "the most inadequately explored aspect of mother as concept and identity: its relational features" (5), which questions a fundamental aspect of conventional understanding of motherhood—that is, the mother is defined through her relationship with her child.

The figure of the mother without her child is frequently conceived of as bereft, incomplete, abject, and tragic. Such ideas are reflected in informal discussions in online parent forums and discussion boards, such as Mumsnet, where a 2016 thread that garnered many responses was titled "A Mother without Her Child." The thread opened with the following words: "I don't know if this belongs in here but I need to start somewhere ... Please forgive the self pity but I am in a great deal of pain." The mother in question admits to feeling unable to financially or emotionally support her child, and has chosen to leave the child with the father. The appearance of this thread on the forum clearly challenged both its premise and content. The linking of motherhood

with taboo is closely associated with the idea of the childless mother. One such taboo is the emotional rejection of motherhood, or a mother's impermissible wish to not be a mother. A recent article by Stephanie Marsh in the British newspaper *The Guardian* investigates the story of a mother who admitted on social media to regretting having her children, and she lists the extreme responses she received. She states that, "Society presumes that women, especially, feel elated about becoming parents. Social media has magnified this: taut, post-baby bodies on Instagram; mother-and-child selfies used as profile pictures on Facebook; motherhood has become an alternative identity rather than a rite of passage" (Marsh). Similarly, in 2016, the *New York Times* featured an article that also focused on the notion of maternal ambivalence and regret, daring to imagine the possibility of a mother not loving her children as much as her husband or regretting having them (Baer). Such descriptions of maternal ambivalence are indicative of the contradictory ways in which motherhood is conceived of in our culture. Hansen states that "What is said by and about mothers—full-time mothers, surrogate mothers, teenage mothers, adoptive mothers, mothers who live in poverty, mothers with briefcases—is increasingly complicated and divisive" (1). The notion of maternal regret or resentment is often seen in a negative light as an indication of selfishness. To speak of this hushed-up subject is one way to begin a conversation about the mother without her child.

The separation of the mother from her child is perceived to negatively affect the mother's identity and authority in the world. A 2015 letter to Virginia Ironside's Reader Dilemma column in the newspaper *The Independent* features the story of a mother to adult children; it details her devastation and loss of purpose following her children leaving home and establishing their own adult lives. She describes how "Since my children left home, I have become unaccountably anxious and depressed. When they were at university, we used to see them in the holidays ... now they have moved out, my life seems completely empty." While Ironside's reply does not provide any quick-fix solutions for the mother in question, the advice she gives does highlight the nurturing capacity of mothering: "Nurturing isn't just a one-way business, as you know. The nurturer can get a lot out of caring for others, as some of their kindness and compassion that's spread around, lands, like heat, on themselves as well." This comment reflects

the pertinent recognition that caring and nurturing are part of a range of activities and commitments that endow mothers with a sense of authority, agency, and power, but it also admits that this sense of self-worth is invested in others.

Maternal accomplishment is traditionally judged to be the successful psychological separation of the child from its mother through the individuation process. In other words, this model of subjectivity and individuation implicitly endorses and is premised on mother-child separation. It has as its implicit basis—the hidden image inside its triumphant narrative of selfhood—the image of the mother without her child. A quotation by the author Barbara Kingsolver demonstrates this belief in the importance of mother-child separation: "Kids don't stay with you if you do it right. It's the one job where, the better you are, the more surely you won't be needed in the long run" (24). This contradiction haunts our conceptions of maternal identity and contributes to rendering the image of mothers without their children fraught. It is paradoxical that our culture considers the mother without her child to be a tragic and bereft figure, yet our vision of the individuation process depends on that same separation and bereavement. As Wendy Hollway points out, "the mothering identity is perhaps the most relational of all identities, with intersubjective effects that ripple out into all other relationships and identities" (138). Insisting on the centrality of relationships and continuity, these revisionary critical assessments question the conventional approved narrative of subject formation. But what are consequences of this for thinking about the mother without her child? Following Hansen's argument, the idea or image of mother without child fundamentally challenges and unsettles conventional definitions and understandings of motherhood. This is because motherhood is defined in relational terms, she argues (4); however, with that relationship severed or removed, the term "mother" becomes problematic and open to interrogation. Hansen states the following: "Once upon a time, maternity seemed to be a biological fact fixed both literally and symbolically within the private, affective sphere. Now we debate the meaning and practice of motherhood and mothering in many public spaces" (1). This book takes its place as a part of these important public debates around motherhood and its meanings, as advocated by Hansen and others.

The Contents of *Mothers without Their Children*

Our primary ambition for *Mothers without Their Children* was for the book to be inclusive and interdisciplinary, creative as well as academic and practical, as well as to present a multifaceted and complex picture of motherhood and absence. We also wanted the book to contain theorized material which would suggest to readers how they might further investigate and research any of the areas, ideas, authors, or critics examined in the individual chapters in the book. With that objective in mind, we decided to structure the book is a series of thematic sections. For ease of orientation, these five sections have been titled according to the important notes of the diverse material they contain, and are intended as signposts for the readers.

The opening Part I is entitled "Textualities and Ambiguous Mothering Status" and denotes the specific literary and discursive focus of the essays contained therein. This section of the book contains contributions addressing different textualities and means of imagining and representing the mother without her child. The essays foreground the textual politics of representing an ambiguous mothering status as well as the challenges to storytelling and genre posed by telling these different and often previously unheard stories. As we shall see, the multifaceted and often contradictory facets of the mother without her child are explored in powerful ways through the textual strategies and experimentations utilized.

Emma Dalton's chapter, "The Birth Mother without Child in Joanna Murray-Smith's *Pennsylvania Avenue*," explores the uses of the motif of the mother without her child in Australian playwright Joanna Murray-Smith's jukebox musical *Pennsylvania Avenue* from 2014. Dalton highlights the importance of the genre and form in portraying the figure of the birth mother and her personal history. She evidences the persistent link between mother and child in jukebox musical, a relationship that prevails, irrespective of the duration of separation. The birth mother's life is shown to contain profound experiences of loss and mourning; however, the reader also gets a sense of her positive life and the power and significance of female friendship. Lizbett Benge's powerful creative piece, "For the Love Of: A Motherline of State Violence and Affective Residues," portrays a daughter and mother bound by love and separated by institutionalization. Using an experimental and dramatic textual form to integrate theory and lived realities,

Benge's piece explains how the mother suffers from schizophrenia and the daughter has had to go into foster care as a result. Now, in adulthood, the daughter is separated from her own daughter, whose father contends she is not capable of mothering due to her own childhood history. Benge, thus, offers a compelling affective exploration of mental health, parenting, and the difficulty of maintaining mother-child relationships.

Part II, "Institutional Frontiers and Othered Mothers," focuses on social and institutional aspects of maternal loss of children in present-day and historical societies. The essays in this part explore various dimensions of institutionalised motherhood and the impact of different forms of state intervention on both mothering and women's experience, particularly regarding the removal of children or maternal separation. Experiences of being "othered," marginalized, or made to be invisible are foregrounded in these poignant essays that explore and expose the parameters of institutionalized and state-sanctioned maternity and experiences of maternal child loss. Spanning over differing countries and cultural contexts—including Ireland, where much political debate has recently taken place around women's rights and motherhood—these chapters offer particular insight into state-sanctioned practices serving to separate mothers from children and into the wider implications of these practices. Brittnie Aiello's chapter, "'It Was Like My Soul Was Back': Pregnancy, Childbirth, and Motherhood during Incarceration," offers four ethnographic interviews with mothers who gave birth while incarcerated. In these interviews, the mothers describe how they coped with the experience of being separated from children by anticipating resumed parenting after incarceration. These interviews are incredibly informative, both about the experience of incarceration and of mothering when apart from one's child. In their essay, "Mothering Interrupted: Mother-Child Separation via Incarceration in England and Ireland," Sinead O'Malley and Lucy Baldwin examine the problematic accommodation of motherhood in the Irish and English prison systems. Further developing their investigation into mothering under enforced incarceration, O'Malley and Baldwin present a careful and detailed analysis; they show that, often, attempts are made to preserve mother-child relationships under these constrained circumstances; however, significant gaps in the system are also identified as are the traumas these gaps may lead to.

My own chapter, "'No Girl Could Keep Her Baby': Depictions of Irish Mother and Baby Homes in June Goulding's Memoir *The Light in the Window*," further examines the representation of the lived experiences of mothers without their children in twentieth-century Ireland. Through the exploration of Goulding's autobiography about working as a midwife in an Irish mother and baby home in the 1950s, the essay investigates the institutional practices that separated unmarried mothers from their babies and the inhumane treatment given to mothers at the home as part of religious and cultural discrimination against unmarried mothers, which resulted from a culture of shame. Finally, examining an earlier historical period than the other chapters in this section, Laura M. Mair's essay, titled "Protests and Plans: The Mothers of Compton Place Ragged School, 1850–1867," examines historical mother-child separations in the context of class. Exploring the context, role, and function of ragged schools, the critic Mark K. Smith states that "The ragged schools movement grew out of recognition that charity, denominational and Sunday schools were not providing for significant numbers of children in inner-city areas." Based on research carried out studying archival material of maternal testimonies, Mair's chapter discusses the mothers' diverse use of services; she shows that these mothers were not simply downtrodden and in need of intervention, but actively and emotionally engaged.

The intersecting categories of oppression and their impact on mothers without their children are addressed in the essays in Part III: "Having to Live and Mother through It: Economic, Geographic, Political, and Racialized Inequities." These essays seek to convey the diversity of maternal experience and the ways in which mothering is impacted upon by intersecting categories of inequality and difference. The phrase "Having to live and mother through it" in regards to these essays means coming to terms with and/or overcoming multiple difficulties and hardships, including the loss of one's child. The mothers examined in the chapters in this section are explicitly shown to be struggling against intersecting categories of oppression, which are then brought to bear on their mothering. These discussions, thus, endeavour to depict the complexity of maternal representation and abjection as well as the many complicated factors shaping its social and cultural context. Kristin Lucas's essay, "Grieving Absent Children in 'Three Seasons,'" presents an analysis of the Indigenous author Linda

Legarde Grover's story. Her examination of Grover's work focuses on the depiction of mother-child separation by the residential school system for Indigenous people, demonstrating that this systematic removal of generations of Indigenous children from their families and communities caused multigenerational trauma and that Grover's writing shows love and grief to be both deeply personal but also political. Her discussion calls attention to the trauma that the residential school system caused to countless mothers and their children. In her chapter "Mothers' Voices from the Margins: Representation of Motherhood in Two of Mahasweta Devi's Short Stories," Indrani Karmakar investigates motherhood and the mother-child relationship from a postcolonial feminist perspective and through a textual analysis of mothers separated from children in the writings of Mahasweta Devi. Her analysis pinpoints representations of intersecting categories of oppression and exploitation as well as the disruption or severing of the mother-child relationship these issues cause; she also examines such themes as absence and agency in a specifically postcolonial context. Shihoko Nakagawa's essay, "Toward Reproductive Justice: Single Mothers' Activism against the U.S. Child Welfare System," investigates the pathologizing of single mothers, and especially single Black women's bodies within the American welfare system. Her chapter explores the role and function of women's' activism and their view of welfare policies. Through her examination of the intersections of racism, classism, and sexism with material conditions, Nakagawa's chapter provides an incisive analysis of American single motherhood and the problems of the American welfare system. In her chapter "Towards Solidarity in Mothering at the Borderlands: Suggestions for Better Legal and Social Treatment of Mothers Migrating across Borders without Children to Work," Rebecca Jaremko Bromwich examines the complex issues involved in negotiating professional and maternal identities, especially in relation to employing live-in caregivers. Bromwich argues that her "multiple roles as lawyer, employer, and mother working away from her children have afforded [her] a variety of lenses through which to assess circumstances of mothers migrating across borders without their children for the purposes of paid work." In her chapter, she explores how this multiplicity of perspectives allows her insight into the ethical issues surrounding the employment of live-in caregivers—mothers separated from their children—and her own position as a mother.

Death is the ultimate and definitive trauma causing a mother to be separated from her child. This dimension is explored in Part IV: "Motherhood Reconfigured by Death." As editors and mothers, we felt it was important that this book explores this emotive subject in an authentic manner—through the powerful voices of grief, loss, and restoration as presented here. This section's courageous and affective work is centred on the figure of the mother without her child and on exploring the theme of death. The focus on the ways in which motherhood is reconfigured by death and the complications of representing this trauma provides the opportunity to examine in detail the experience of neonatal death and bereavement. Furthermore, the texts in this section serve to question conventional definitions of "the mother" as defined by the presence of her child. Sheri McClure's chapter, "Grieving in Silence: Repercussions of the Family Ideal on Women with Pregnancy Loss," uses an autoethnographic approach to explore experiences of pregnancy, stillbirth, loss, and grief. These experiences are, she argues, still surrounded by a profound sense of silence. To address this reluctance to articulate maternal loss, McClure calls for "healthy stories of grief and recovery." Maya Bhave's poem "The Immigrant" draws on themes of marginalization, emotional, and physical exile to convey the sense of alienation caused by a stillbirth at forty weeks. The physical and psychological trauma caused by this unimaginably traumatic event is reinforced by the knowledge that the poem's speaker is an Ethiopian immigrant, who feels that she has no purchase in the country in which her stillborn baby is buried.

In her poem "Figure Drawing," Rachel O'Donnell evokes the experience of the stillbirth of her first baby followed by the subsequent live birth of her son. By dividing the poem into three sections, O'Donnell traces the process of loss, guilt, and bereavement, as well as the physical and psychological effects of being a mother with empty arms. The subsequent birth of her son as well the experiences of motherhood she experiences go some way towards healing the loss, but they cannot erase the memory of the absent baby. In their chapter, "Suppress and Express: Breastmilk Donation after Neonatal Death," Katherine Carroll and Brydan Lenne present a compelling qualitative exploration of a theme that O'Donnell also treats in her poem— namely, a mother's lactation following the death of her baby. Based on research carried out in Australia and America, the chapter examines

the issue of milk-donation opportunities for mothers who have experienced a neonatal death. The authors conclude that whereas lactation and donation is positive for some and provides a sense of relief, others prefer to suppress lactation.

Maternal separation from children caused by geographical, emotional, and psychological factors is a subject that reverberates through many of the essays included in this book. The final section—Part V: "Navigating and Resisting Exile"—explores the different manifestations of maternal exile. Exile here refers to a variety of different physical, geographical, and psychological states in which mothers are separated from their children, including geographical and emotional forms of separation. The chapters in this section examine not only differing manifestations of exile but also different coping mechanisms. Short-term as well as long-term implications for mother-child relationships of maternal exile are also investigated as are the use of personal responses in research through autoethnography. These essays communicate a sense of hope, but they also reveal the complicated emotional states associated with exile and the maternal loss of a child. Marilyn Preston's powerful essay, "'You're Not Really There': Mothering on the Border of Identity," employs a compelling autoethnographic mode of exploration of "not being physically there" for her children. Preston's chapter explains that she lives away from her children except for eight weeks a year when they stay with her and her wife. These experiences provide the basis for her discussion of mothering discourses and mothering identities, and the ways in which these relate, or not, to her own mothering practices. Preston's essay highlights the contradictions, pains, and pleasures of motherhood, both with and without her children present. Finally, Andrea Lea Robertson's chapter, titled "Newborn Custodial Loss from the Perspective of a Midwife," concludes this book. Employing an autoethnographic perspective, Robertson explores the ethical considerations for care providers when newborn custodial loss occurs at birth. Writing from a midwife's perspective, Robertson advocates raising awareness of this emotive and complex issue; she investigates notions of "good enough mothering" and maternal love alongside the stigma and isolation that may accompany newborn custodial loss. Her essay concludes that listening to and honouring first-person accounts of newborn custodial loss is crucial but so is considering whether there

are changes to care that could be implemented and what contributions feminist ethics and care theory may contribute to approaches to newborn custodial loss.

Conclusion: Reassessing Mothers without Their Children

The critic Heidi Slettedahl has argued that "mothers are expected to be present in some form for their children" and that "feminism itself has not been able to combat prejudice against mothers who leave" (11). Central to this book is our recognition of the importance of maternal perspectives and experiences, which particularly applies to those maternal perspectives and experiences that have been previously marginalised or silenced, such as mothers without their children and mothers who leave. *Mothers without Their Children* offers the opportunity to look at maternal experience and mothering in different historical and cultural contexts, thereby opening up to reassessment and revision the ways in which we imagine and represent mothers without their children. Examining mothers without their children along with their stories, choices, regrets, and pleasures, as well as the values, hopes, and fears they articulate, the chapters in this book range across continents, cultures, and historical periods. Hansen urges critical and feminist engagement with what she describes as "the borders of motherhood and the women who really live there, neither fully inside nor fully outside some recognizable 'family unit', and often exiles from their children" (10). These maternal figures inhabiting "the borders of motherhood" appear again and again throughout the essays and creative pieces in this book. Our book extends and expands Hansen's important enquiry by affording a variety of perspectives on the histories, experiences, representations, creative manifestations, and embodiments of mothers without their children. What they all share is a determination to reveal the spoken as well as unspoken aspects of the experiences of mothers without their children.

Works Cited

Baer, Drake. "Maternal Regret Is a Taboo We Need to Examine." *The Cut*, 30 Sept. 2016, https://www.thecut.com/2016/09/maternal-regret-is-a-taboo-we-need-to-examine.html. Accessed 1 July 2017.

"A Mother without Her Child." *Mumsnet*, 1 Jan. 2016. https://www.mumsnet.com/Talk/lone_parents/2539232-a-mother-without-her-child. Accessed 1 July 2017.

Hollway, Wendy. "The Importance of Relational Thinking in the Practice of Psycho-Social Research: Ontology, Epistemology, Methodology, and Ethics." *Object Relations and Social Relations: The Implications of the Relational Turn in Psychoanalysis*, edited by Simon Clarke et al. Karnac Books, 2008, pp. 138-162.

Ironside, Virginia. "Reader Dilemma: 'Ever since My Children Left Home, My Life Seems Completely Empty." *The Independent*, 6 July 2015, https://www.independent.co.uk/life-style/health-and-families/features/reader-dilemma-ever-since-my-children-left-home-my-life-seems-completely-empty-10370000.html. Accessed 1 July 2017.

Jackson, Rosie. *Mothers Who Leave: Behind the Myth of Women Without Their Children*. Pandora, 1994.

Kingsolver, Barbara. *Pigs in Heaven*. Harper Perennial, 1994.

Marsh, Stephanie. "'It's the Breaking of a Taboo': The Parents Who Regret Having Children." *The Guardian*, 11 Feb. 2017, https://www.theguardian.com/lifeandstyle/2017/feb/11/breaking-taboo-parents-who-regret-having-children. Accessed 1 July 2017.

Martin, Michele. "Toni Morrison On Human Bondage and A Post-Racial Age." *NPR*, 26 Dec. 2008, https://www.npr.org/templates/story/story.php?storyId=98679703?storyId=98679703. Accessed 1 July 2017.

Morrison, Toni. *Beloved*. Alfred Knopf, 1987.

Slettedahl, Heidi. *Women's Movement: Escape as Transgression in North American Feminist Fiction*. Rodopi, 2000.

Smith, Mark K. "Ragged Schools and the Development of Youth Work and Informal Education." *The Encyclopaedia of Informal Education*, 2001, www.infed.org/youthwork/ragged_schools.htm. Accessed 1 July 2017.

Talbot, Kay. *What Forever Means After the Death of a Child: Transcending the Trauma, Living with the Loss*. Routledge, 2013.

Tuttle Hansen, Elaine. *Mother without Child: Contemporary Fiction and the Crisis of Motherhood*. University of California Press, 1997.

Part I

Textualities and Ambiguous Mothering Status

Chapter 1

The Birth Mother without Child in Joanna Murray-Smith's *Pennsylvania Avenue*

Emma Dalton

T his essay offers an analysis of the representation of the "mother without child" (Hansen 10) in Joanna Murray-Smith's jukebox musical *Pennsylvania Avenue*. Murray-Smith has received acclaim from large audiences, both in Australia and overseas. A number of her plays present mother characters that might be considered to fit Hansen's "fictional picture of not conventionally good enough mothers" (10). Furthermore, Harper, the protagonist in *Pennsylvania Avenue*, is not Murray-Smith's first "mother without child" (Hansen 10) character. Peta Tait's analysis of maternal emotions in *Love Child*, another play by Murray-Smith that features a mother without her child, suggests that the expectations surrounding the reunion of birth mothers with their relinquished children can be particularly fraught and emotionally complex. This essay argues that the character of Harper in Murray-Smith's *Pennsylvania Avenue* represents a mother without her child who lives a life which contains a mix of sorrow and joy. Furthermore, it shows that Harper lives a life of affect after relinquishing her son.

Pennsylvania Avenue premiered at the Melbourne Theatre Company's Sumner Theatre on 13 November 2014. It is a musical about a woman who leaves her hometown of Thunderbolt for a job at The White House.

Pennsylvania Avenue could be said to be a jukebox musical, as it consists of well-known songs and a plot. The play, like Enright's original version of *The Boy from Oz*, simultaneously resides within the genre of the jukebox musical and surpasses it (Fitzpatrick 44). Peter Fitzpatrick explains that Enright sought to make Peter Allen (the central character in *The Boy from Oz* who is based upon a real person) a complex character rather than merely to exploit the familiarity of the popular songs woven together in another form (27). This choice was not typically associated with the commercial priorities of the jukebox musical. It appears Fitzpatrick perceives a hierarchy of genres, as he identifies the different versions of *The Boy from Oz*—"arena show" is the lowest form, the "jukebox musical" perhaps a little higher, and the form that Enright's version of *The Boy from Oz* attains, higher still (Fitzpatrick 44). Fitzpatrick does not offer a new name for the structural, narrative, psychological, and emotional space that Enright's version of *The Boy from Oz* occupies. He simply states that it surpasses the "jukebox musical" (Fitzpatrick 44). However, this "surpassing" did not equate with it receiving an international audience, nor did it equate with it receiving a positive response from its producers. Perhaps, the complexity that Fitzpatrick identifies as being present within Enright's version of *The Boy from Oz* (and absent from Sherman's) is a large part of what the producers resisted when taking the show overseas. In relation to *The Boy from Oz*, the commercial priority of the producers seemed to be directed towards an international imperative—to get the show to Broadway. Murray-Smith's play *Pennsylvania Avenue* can be located in the genre of the jukebox musical. However, this essay suggests that like Enright's original version of *The Boy from Oz*, *Pennsylvania Avenue* surpasses the genre of the jukebox musical to present a character that is complex rather than simply a vehicle for the songs. The jukebox musical, as it operates within *Pennsylvania Avenue*, functions to permit Harper to move between the past and present. She remembers the son that she relinquished at birth, and she enjoys her life apart from him to the best of her ability.

The theme of loss is significant within *Pennsylvania Avenue*. The central character mourns the loss of the son that she relinquished at birth, and she mourns for the life that she might have lived if things had been different. Although loss may be a theme frequently explored within theatre (and particularly within Murray-Smith's plays), within

the context of *Pennsylvania Avenue*, loss is not presented as an exclusively negative experience. Even though Harper experiences grief in relation to her loss, she is also represented as understanding that many of the positive experiences she has had in her life would not have happened if she had chosen to keep her son. She acknowledges both the negative and positive aspects of her loss. The positive potential of loss is explored within *Pennsylvania Avenue*, as after relinquishing her child, Harper has positive experiences, career success, and meaningful relationships. This essay argues that Murray-Smith's play *Pennsylvania Avenue* presents a mother without her child who thinks about the child that she relinquished frequently, yet still lives a rich and fulfilling life.

This essay suggests the genre of the jukebox musical, as it is manifested in *Pennsylvania Avenue*, operates to emphasize a persisting link between mother and child, irrespective of the duration of the separation. Murray-Smith's play depicts a mother without her child whose story includes elements of both pathos and joy, and this essay suggests that *Pennsylvania Avenue* might offer an "alternative [story]" (Hansen 238) of potential and possibility for the mother without her child. Harper, Murray-Smith's central character in *Pennsylvania Avenue*, mourns for the child that she gave up at birth; however, although she experiences her separation from her child as an experience of loss and unrealized potential, her life apart from her child is not all loss.

Harper's Story

Harper Clements is from a small town in Georgia (USA); she is the central character in *Pennsylvania Avenue* and is also the narrator. She guides the audience through the narrative, singing songs indicating the time she is referring to, and gradually revealing her very sad history. She was brought up in a church-going family. She left her home town of Thunderbolt at the age of eighteen to take a job her aunt Abigail helped her to get—a job at The White House. Her story is not exactly a rags-to-riches tale because although Harper brushes shoulders with the rich and famous, she becomes neither herself. Harper commences her employment at The White House as "The assistant to the assistant to the assistant" (Murray-Smith 9), and she is later promoted to a job in The White House's entertainment division due to a chance hallway meeting with President John F. Kennedy. The choice to set *Pennsylvania*

Avenue in America rather than Australia may be an attempt at distancing the spectator, indicative of the Brechtian technique the *Verfremdungs-effekt*. Elin Diamond refers to this as "the technique of defamiliarizing a word, an idea, a gesture so as to enable the spectator to hear it afresh" (45). Murray-Smith, therefore, may be presenting an American character to an Australian audience to permit them to view her as different from them—to simultaneously relate to her and distance themselves from her.

Pennsylvania Avenue does not present events in chronological order. It starts with Harper's dismissal from her position at The White House. The stage directions state that the year is 2001, and Harper tells the audience that she has been employed at The White House for forty years. Harper's reminiscences transport both her and her audience members back in time to experience the encounters she has experienced over the decades which she has spent working at The White House. As Harper reminisces, she speaks the words that she has spoken and the words that individuals have spoken to her. Harper has encounters with American presidents, American singers, and other celebrities during her employment at The White House. As she encounters famous singers, she sings the songs they are remembered for. Murray-Smith's choice to begin and end *Pennsylvania Avenue* in 2001 and to move from 1961 to 2001 over the course of the play permits the audience to meet the historical figures Harper met and to observe the important political and historic events Harper observed. Furthermore, by permitting the audience to see Harper remember her time at The White House through song and to witness her engage with those memories emotionally, it allows the audience to get to know Harper as character and to sympathize with her when they learn of her sad history.

There is a secret within *Pennsylvania Avenue*, and that secret is the driving force of the play. At the climax of the play, it is revealed that Harper was raped by Curtis Fender when she was seventeen years old and that she gave birth to a child as a result of that rape. Furthermore, the play reveals that Harper gave the child away because of the advice of others. The pressure that was experienced by young unwed mothers to relinquish their children has been documented (Fessler). It is not until the end of the play, and the end of Harper's employment at The White House, that Harper chooses to try to contact the child she gave away. The child she gave away in 1961 would be forty years old at this

point. However, in the letter that she writes to him in the final scene she writes to him as if he were still a child: "My darling boy..." (Murray-Smith 43). It is important for the audience to see Harper both as she is in the opening and closing scenes (which are suggested to represent the present day) and in the scenes that span her years of employment at The White House. By having Harper remember and act out the experiences and encounters that she has had since being employed at The White House, Murray-Smith permits the audience to see that Harper has lived a life that has been simultaneously fulfilling and troubled. Furthermore, by depicting Harper as choosing to contact the son she relinquished only after her employment has come to an end (forty years after relinquishing him), Murray-Smith points to the complexity and gravity of this choice.

Harper has an impact upon significant political events and important political choices. She is depicted as influencing President Ronald Regan to tell Soviet Union Leader Mikhail Gorbachev to tear down the Berlin Wall; and influencing President Gerald R. Ford to grant President Richard Nixon a full pardon. The life she lives after leaving Thunderbolt is a life of affect. However, although it is evident that Harper has positive experiences at The White House, she mourns for the child that she left in Thunderbolt and the life that she might have had. Harper still cares for the child that she relinquished at birth, regardless of the circumstances of his conception. However, though she may question her choice to relinquish that child, and though she experiences sadness at not having raised him, she never states that if she could go back in time she would do things differently. She questions her choice but never states that she would or could have made a different one.

Rehearsal

When I was undertaking research for my doctoral thesis, I was invited to attend a rehearsal of Murray-Smith's *Pennsylvania Avenue*, and the company run. In addition, I was permitted to observe opening night seated beside Melbourne Theatre Company staff and playwright Murray-Smith. These factors provided me with a rare opportunity to view the performance from several perspectives. Furthermore, I was permitted to observe interactions between playwright Murray-Smith

and director Simon Phillips. These interactions have informed the analysis. I believe that Melbourne Theatre Company Literary Director Dr. Christopher Mead invited me to attend rehearsals as a result of our discussions about my research. I think he realized that the play would be relevant to my work. Gay McAuley describes rehearsal studies as an "emerging field" (7). From her own experience observing the rehearsal process McAuley states, "As I observed more and more rehearsal processes, it became evident that rehearsal was a site of extraordinary creativity and interpersonal relations that needed to be studied on its own terms and not simply as a means to deeper appreciation of the end product" (8). My observation of a single rehearsal of *Pennsylvania Avenue*, and the interactions between playwright Murray-Smith and director Phillips during that rehearsal, are offered here as a small contribution to "the [still emergent] field of rehearsal studies" (McAuley 7).

My observation of playwright Joanna Murray-Smith and director Simon Phillips in the Rehearsal Room at Melbourne Theatre Company Headquarters (Wednesday 29 October 2014) communicated one message to me most pointedly: Murray-Smith and Phillips negotiate with one another in the rehearsal room. In fact, Murray-Smith appeared ready and willing to make alterations to her script for Phillips upon request. She asked, in my presence, if Phillips wanted her to edit or change lines of dialogue. Phillips appeared to consider the maintenance of 'the secret' to be of the utmost importance. I understood this from the fact that when I was brought into the rehearsal room at Melbourne Theatre Company Headquarters by Literary Director Christopher Mead, Phillips requested that I be removed and brought back later. They were going to rehearse the final scene, and he did not want me to see the play out of order. He wanted to ask me a question: "When does the secret [Harper's backstory] begin to be revealed?" He said that I would be a "guinea pig." Hence, if I saw the end before I saw the rest of the play, the secret would be spilled and my capacity not to know Harper's backstory would be gone. One cannot unknow such a story once it is known. Harper's backstory is powerful because of the trauma she experienced and because of the positive life she lived after experiencing that trauma.

First Preview

On 8 November 2014 at 8:00 p.m., I sat down to watch the first preview of *Pennsylvania Avenue* at the Sumner Theatre in the Southbank Theatre of the Melbourne Theatre Company. This was to be *Pennsylvania Avenue's* first viewing by the general public. Both the theatre makers and audience members sat expectantly. The audience were eager to see what new offering playwright Joanna Murray-Smith, director Simon Phillips, actress and singer Bernadette Robinson, and the Melbourne Theatre Company had for them. This writer's viewing experience was influenced by a happy coincidence. I had seat N1. I believe I overheard two women say that they had seats N2 and N3. However, they did not sit in those seats. Instead the two women sat in seats N4 and N5, leaving seats N2 and N3 for two middle-aged American men. I was about to view a play that interacted with American history and politics in a comic and occasionally light way sitting beside two Americans. The synchronicity was perfect. What made it even more so was that these two men were politically interested. They sat beside me speaking about the current political climate in America. In fact, at one point, the man beside me apologized (or rather offered an explanation) for their animation. He said something along the lines of "we're talking about American politics." I viewed *Pennsylvania Avenue* for the third time sitting beside two politically engaged and historically informed American audience members, and this viewing made me ask some very specific questions. For this, I have the two American men who sat beside me to thank. The presence of those men caused me to think about the play in a specifically American context. My thoughts turned primarily to what was being said on stage about American politicians and historical events. However, I also started to think about what the experience might have been like for an unwed pregnant woman in the state of Georgia in 1961.

It appeared that their overall perspective of the play was positive. However, their laughter at particular moments, and their absence of laughter at others, illuminated a number of important issues for me. It suggested to me that when a nation is presented to another nation with the markers of stereotype as a means of communicating the presence of that nation or that nation's people, the individuals represented by those stereotypical markers may not laugh. I do not laugh when individuals whom I believe can be associated with aspects of my own

identity are reduced to stereotypical signs, and the Americans did not laugh when Harper used stereotypically American phrases. I heard many audience members laugh as Harper said, "you bet your sweet bippy." However, the Americans who sat beside me did not laugh. The other was laughed at, but the others who sat beside me did not laugh. The audience laughed at and with Harper for much of the performance. Yet when the secret of the play was revealed, when the audience learned that Harper was a mother without her child, and that her child had been conceived as a consequence of rape, the laughter ceased.

Maternal Identity

Hansen describes "nontraditional, nonbiological, [and] nongendered mothers" as "metaphorical" (9) mothers. Harper might be understood to exist within this category. Although Harper is a biological and gendered mother, she is also a nontraditional mother in that she does not undertake the work of mothering; she does not mother the child that she gave birth to. For Sara Ruddick, a mother is an individual who engages in the work or practice of mothering for a child. Hence, Harper would not be considered to be a mother within Ruddick's understanding of the term. However, Hansen's understanding of mother is more expansive: it permits that an individual may be a mother without having custody of her child.

Patrice DiQuinzio states that "Further analysis of mothering would benefit from a focus on non-traditional instances of mothering—for example, lesbian mothering or the mothering of women without custody of children" (qtd. in Hansen 10). Harper gives her child to others to care for. However, it is not clear whether or not Harper relinquishes legal rights to her child. It is forty years before she decides to seek him out. Though it is clear that Harper does not engage in maternal work for the child that she gives birth to, arguably she does mother the celebrities whom she works with in her capacity as an employee of The White House's entertainment division. Harper's willingness to provide emotional support for the celebrities that she engages with at The White House is evident when she comforts Sarah Vaughan as she cries. In this instance, Harper learns that Vaughan is not crying because she is upset, but because she, an African American singer, is performing at The White House.

Hansen writes of the old stories that she analyzes: "In the old stories, a mother is known to the law only by her willingness to sacrifice everything, even her relation to the child; in them the mother without child can only be either a criminal who breaks the law or a victim of evil circumstances or evil forces" (27). Harper is, perhaps, both a victim of evil forces and circumstances, as well as Curtis Fender. Harper does not break the law, but her child is conceived as a result of law breaking; Curtis Fender's rape of Harper is the act of law breaking. Although Murray-Smith's choice to represent Harper as a "victim of evil circumstances or evil forces" (27) could echo "the old stories" (22) referred to by Hansen, Harper walks away from her place of victimhood. Of the new stories she discusses, Hansen writes, "In the new stories, as we shall see, [the mother without child] can subvert these categories of criminal or victim, bad or good mother, by not fitting comfortably into either or by occupying both at the same time" (27). Harper occupies the spaces of both the old and new stories Hansen refers to. The character of Nora in Ibsen's *A Doll's House* leaves her husband and children to live a new sort of life, and with her choice not to mother, Harper chooses to live a life apart from the male child she conceived as a result of rape. Some scholars talk about the mother's position in relation to the male child as one of potential servanthood (Arcana qtd. in O'Reilly 4). In choosing not to undertake motherwork for the male child, within this discourse, it might be suggested that Harper walks away from a place of potential subservience. It is evident that Harper's choice not to mother her child haunts her. She does not know if she made the right choice for him or for herself. However, by choosing a life apart from her son, Harper walks away from the demands associated with motherwork. Furthermore, Hansen writes of the new stories, "these fictional women who are mothers (actual or, in some cases, potential) and their conventional maternal capacities, including their relational, nurturant, and protective abilities, are not utterly devalued or destroyed by the loss of a child, although they may be more or less damaged and are always changed in some way" (26). Harper exists as a woman and a mother apart from her child. Although she experiences her separation from her child as an experience of loss and unrealized potential, her life apart from her child is not all loss. She experiences love and lust, and she has positive interactions with the people she meets at her place of work. She is also illustrated as

having a friendly relationship with her neighbour, such that she can walk into his apartment unannounced and help herself to an egg when she runs out. Although Harper does not mother the child she gave birth to, she is depicted as a caring individual. The life Harper might have had is referred to occasionally—for example, she talks about picturing herself sitting with her husband at a breakfast table and hearing a child laugh. In the scenario she imagines, she sees herself and her husband, but the child in her imagination is only a disembodied voice. The motherwork that Harper walks away from is not referred to specifically; the tasks that she may have performed are neither depicted nor named. Rather, she thinks simply of being with her child.

Preservative Love and Maternal Emotions

Ruddick describes preservative love as being a maternal practice—an action of motherwork performed in response to a demand made by a child, the demand for preservation. Harper does not see her son. However, I would suggest that she could still be interpreted as engaging in the practice of preservative love in relation to him. To explain her conception of preservative love, Ruddick describes a story told by the mother of a child who slept poorly due to croup and bronchitis, caused by allergies. The story tells of the mother's suffering; she spends days and nights alone with a crying baby. In this story, the mother's partner is mostly absent; he financially supports the mother and child, but he is not at home much. Ruddick describes a night when the mother's partner could not be home. She describes how the child "[wailed] as usual" (66).

Furthermore, she describes the mother experiencing a shortness of breath and imagining an image that frightens her. Ruddick reveals that the mother imagined harming the baby. However, the mother changed the baby and gave the baby warm milk before "[shutting] the door to the baby's room [and] barricading it against herself with a large armchair" (67). Ruddick begins her chapter on the nature of preservative love by offering a story of a mother that imagines harming her screaming baby, but does not. In the introduction to Ruddick's chapter on preservative love, she offers the story of a mother shutting a door between herself and her child and then barricading that door as an example of the maternal practice of preservative love. In Harper's situation it might be suggested that preservative love is demonstrated

through her choice to distance herself from her child. If Ruddick considers the actions of the mother in her story to be indicative of preservative love, it is plausible that some birthmothers who relinquish custody of their children may be consciously choosing to engage in a similar act—distancing themselves for the preservation of and/or benefit of their child. Harper says that she relinquishes her son because she is told that it is for the best. Arguably, Harper relinquishes her son so that he can be raised by a more conventional and, hence, acceptable American family. Harper passes her son into the arms of another for his preservation and for his benefit. Furthermore, Harper's choice provides evidence of her responding to the demand for "social acceptability" (Ruddick 17). Ruddick proposes that maternal practices and the work of training are performed in response to the demand for social acceptability. Harper's passing her child into the arms of another could not be suggested to be training the child. However, in a sense, through Harper's choice to give her child to another—presumably nuclear—family, she does submit to social acceptability.

According to Ruddick, the demand for preservation is the first demand made by a child, and the maternal practice of preservative love is the work required to meet that demand. Although "feeding, holding, and nursing" (Ruddick 81) may be the most immediate requirements of a new born baby, Ruddick acknowledges that mothers may envisage their protective work to "[require] a commitment to world protection nearly as demanding" (81). The work a birthmother undertakes towards protecting her community and her world can constitute indirect acts of preservative love for her chid. Furthermore, Harper's commitment to contributing positively to her country and the world through her work at The White House can be seen as an enactment of preservative love for her child. Although this is not explicitly indicated by the text, the fact that her son appears never far from her thoughts shows that the actions she engages in for the benefit of the community and the world could be understood to be, in part, for his benefit as well.

The Redemptive Capacity of Female Friendship

After Harper confesses her (self-perceived) 'sins' to Aretha Franklin, Franklin says something of great weight to Harper: "Baby, it was not your fault" (Murray-Smith 40). She does not say what she means by "it." However, whatever "it" may mean, this brief statement acts as a sort of absolution for Harper. Franklin tells her that she is forgiven, or rather, that there was nothing to forgive in the first place. Franklin spends just a few moments with Harper; however, in those few moments, Franklin offers Harper friendship and kindness.

With this exchange, Murray-Smith represents female friendship as having potentially life-changing power. Harper's encounter with Franklin seems to instil her with the strength to articulate her thoughts and her grief to Franklin and the audience. Harper raises the issues of guilt and judgement when she states, "It wasn't God's judgement I needed to assuage—it was my own" (Murray-Smith 42). Harper admits to having judged herself. However, with Franklin's declaration that "it was not your fault" (Murray-Smith 40), Harper seems to put down the great weight of guilt and regret that she has been carrying, and she begins to look towards the future. With this future in mind, Harper begins to sing "Amazing Grace." It appears clear that Harper blamed herself because she behaved outside of the dictates of her upbringing. However, Franklin's words of acceptance and kindness help Harper realize she was not responsible for Curtis Fender's choices, or the trauma she experienced.

Harper's singing of "Amazing Grace" suggests that there has been a divine intervention, that something has saved her, and that she is, or was, a wretch. Harper's identification of herself as a wretch is incompatible with Franklin's declaration that "it was not your fault" (Murray-Smith 40). The lyrics state that Harper has gone from a state of being lost and blind, to a state of being found, seeing and understanding. It might be suggested that Harper's journey from blindness to sight may not be described as a journey of salvation, but rather, an instant of self-awareness. Over the course of the play she undergoes an emotional transformation, which ends in her being able to begin to forgive herself. Through Harper's interaction with Franklin, she discovers what has been causing her sorrow and grief. She has unresolved feelings regarding what happened in Thunderbolt. Harper appears to feel a powerful bond to her son. This impression is created

progressively throughout the play. It is created through Harper's repeated jumps in time from what appears to be the present to her memories of the past. Harper's memories are laden with emotions and with guilt. It becomes clear that Harper gave birth to a child when her fiancé tells her about a woman and a little boy with strawberry blonde hair who came to the door when she was out. This moment provides an answer to the many of the play's hints. Harper had a son. When Harper finally tells Aretha Franklin about why she left Thunderbolt, and when she reflects upon her feelings of guilt and decides she needs to forgive herself, she makes it clear that the child she relinquished never left her thoughts. Furthermore, she seems to resent that she was not permitted to make an informed and independent choice regarding whether to mother him herself or to give him to others to care for. However, that the character of Harper was directed to relinquish her son appears to be reflective of what would have been the most likely scenario for young unwed mothers in America in the early 1960s (Fessler).

Re-establishing Contact

It might be expected that if Harper were to choose to make contact with her adult son, she would do so following her conversation with Franklin. However, this does not appear to be the case. The script states that Harper speaks with Franklin in 1993, yet the play appears to begin and end in 2001. Although Harper's interaction with Franklin causes her to "[think] about the child, passed into another's arms" (Murray-Smith 42), it does not appear to inspire her to write to him. What occurs between 1993 and 2001 is not narrated. What prevents Harper from acting upon the emotions which Franklin inspired in her in 1993 is not revealed. It seems simply that whilst Harper experienced a revelatory moment in 1993, this moment did not prompt action until her dismissal from The White House in 2001. When Harper's paid employment ceases, her thoughts appear to return to maternal practice. The letter she writes to her forty-year-old son might be suggested to represent an attempt to engage in the maternal work of "nurturance" (Ruddick 17). Although Harper chooses to live a life apart from her child, he remains in her thoughts. The life that she lives as a birthmother without her child is a life full of positive interactions and significant contributions.

According to Fitzpatrick the "standard territory of the jukebox musical" (44) was surpassed by Enright's version of *The Boy from Oz*. Fitzpatrick states that it was "the way in which the pieces were arranged to deepen Allen's story emotionally, and to find psychological patterns in it" (44) which achieved this. *Pennsylvania Avenue* has an emotive narrative, yet the genre of the jukebox musical provides a structure for Harper's sad story. It is the genre of the jukebox musical that permits audiences to walk with her on her journey from the beginning of her employment at The White House to the end. The songs mark time and significant events. Furthermore, they permit Harper, Murray-Smith's birth mother without child (Hansen), to communicate her emotions to her audience, even before her secret is revealed.

Works Cited

Diamond, Elin. *Unmaking Mimesis: Essays on Feminism and Theater.* Routledge, 1997.

Fessler, Ann. *The Girls Who Went Away: The Hidden History of Women Who Surrendered Children for Adoption in the Decades before Roe v. Wade.* Penguin Press, 2006.

Fitzpatrick, Peter. "Life or a Cabaret?: Nick Enright and *The Boy from Oz*." *Nick Enright: An Actor's Playwright*, edited by Anne Pender and Susan Lever, Rodopi, 2008, pp. 27-46.

Hansen, Elaine Tuttle. *Mother without Child: Contemporary Fiction and the Crisis of Motherhood.* University of California Press, 1997.

Hughes, Emma. "Maternal Practice and Maternal Presence in Jane Harrison's *Stolen*." *Outskirts Online Journal*, vol. 33, Nov. 2015, https://www.questia.com/read/1P3-3897445841/maternal-practice-and-maternal-presence-in-jane-harrison-s. Accessed 1 Dec. 2018.

McAuley, Gay. "The Emerging Field of Rehearsal Studies." *About Performance*, no. 6, 2006, pp. 7-13.

Murray-Smith, Joanna. *Love Child.* Currency Press, 1993.

Murray-Smith, Joanna. *Pennsylvania Avenue.* Unpublished, 2014.

O'Reilly, Andrea, editor. *Mothers and Sons: Feminism, Masculinity, and the Struggle to Raise Our Sons.* Routledge, 2001.

Ruddick, Sara. *Maternal Thinking: Toward a Politics of Peace*. Ballantine Books, 1990.

Tait, Peta. "Embodying Love: Mother Meets Daughter in Theatre for Cultural Exchange." *Australasian Drama Studies*, no. 49, 2006, https://www.questia.com/library/journal/1P3-1183367281/ embodying-love-mother-meets-daughter-in-theatre-for. Accessed 1 Dec. 2018.

For the Love Of: A Motherline of State Violence and Affective Residues

Lizbett Benge

This piece is a melding of creative and critical interludes patterned after the structures of the human body and juridical processes. Within this piece, I attempt to relate my personal experience of being born to an abusive mother, growing up in foster care, having a child, going through both civil and criminal courts, and then losing custody of my daughter to larger structural issues of classism, ableism, heterosexism, and racism.

The parameters of the piece follow my own nonlinear timeline of trauma. The pieces in italics are meant to be shared, to be performed, and to be embodied and felt. The reflections elucidate the ties between personal experience, searching for community, and recognizing how nonsingular this experience is and can be. Ultimately, this work is guided by a desire for community, healing, discovery, resistance, a claim to truth, and the presentation of counter-narratives.

ILL

They're going to put this on file. Now the state has documentation that I'm afraid I am going to become depressed after the baby is born. I'm afraid because I don't know how to be a mom because I never had one myself. But I

did have one. She just wasn't the one I wanted. She wasn't the one I needed. Every other mother figure in my life couldn't be to me what Yvonne could have. She was my flesh and blood and the woman who brought me into being, but she could have NEVER been what I needed her to be. Regardless of how many pills she took or drinks she had, she would never be better for it. All the mind altering in the world could never put her back right. She was humpty dumpty and her personalities had shattered into a million pieces and fragmented her and her interactions with all those around her.

The first time I understood what an abortion was I was maybe seven. My mom was pregnant with twins. She was thirty-eight, and her body couldn't withstand birthing another two beings. I wasn't in the room with her when they told her; I learned she would die if she didn't abort. My mother was no stranger to death. She was such a strong and spirited creature. Years in Western State psychiatric hospital, corrections facilities, group homes, half-way houses, and countless bodily afflictions later, she still stood. Her posture was rather terrible, her back bending like a springboard, but I imagine her like an impenetrable fortress, the Fort Knox of females. She was square, solid, intimidating, and big. My mother was huge. She was probably no more than 5'7, but she was dense, and her breasts extended far beyond her frame. Her hair was brown and coarse like a Brillo pad and created a giant fan around her face. Her eyes were hazel and almond shaped. I might almost say they were pretty. Her top lip was thin with a much defined cupid's bow that formed her upper lip into the shape of a heart. Her skin was olive, and she wore garish pink makeup to further accentuate her features.

To think... she would be lost to the world if she had birthed these twins. Maybe for her, that's what she wanted. She was so fixated on children. She wanted so many children and dearly loved each child she came into contact with. Such enthusiasm reigned over her at the prospect of being fucked. She kept no secrets. I always knew her desires. She wanted men and she wanted children. Jealousy swelled within her at the sight of others with their blooming bellies or small crying infants. I never shared her joy. Instead, I felt fearful and incompetent around babies and children. All I knew was that once they are old enough, someone comes and takes them away because you aren't good enough to have them.

A mother's love is supposed to be sacred, untouchable, and true through and through. She relinquishes full ownership of her body so that you may have lease to it. She endures as her body grows and morphs, and her needs shift to include your burgeoning being. All of this is supposed to equate to love, a bond

more powerful and profound than any other sensation.

We were close. She would have us be too close. A mother and daughter are never supposed to be that close.

I don't think I love my mother. I am not sure if I ever have. She surely made it clear that she loved me. She smothered me. She fetishized me. She made my life the focal point of her existence. Each of her conversations implicated my existence, all of her fantasies and delusions were somehow linked to her men and me. Yvonne always wanted kisses and hugs and for me to tell her I loved her. I think she knew I thought she was ill, so she pretended even more to be normal. Her normal was schizophrenic and bipolar. She had multiple personalities, and even they all made me the centre of attention. I would hear how much I meant to her, how precious my life was, but I could never feel it. Somehow her words fell flat. How in the world she ever achieved such an all-consuming yet detached relationship is beyond me.

Rai of Sunshine: The Dream

My first and only ultrasound happened at twenty weeks. I saw my baby for the first time. I remember wanting to cry because it became so real in that moment that a human lived inside me, and in twenty more weeks, it would be coming out into this world. I decided to forgo finding out the sex of the baby. Why did it matter? R. and I were going to keep with his family's tradition of naming with R's. Seeing the ultrasound of the baby compelled me to find names that described this featureless being—Rathana, Roathany, Rowena, Rina, Reth, Rhea. Weeks later, I dreamt of our encounter. Creeping out from behind the mystical, billowing clouds, a long red dragon confronted me. It was like the scene out of Disney's, The Lion King, when deceased Mufasa visits Simba, and Mufasa is a giant smoky figure whose face is then lit by what looks like the light of the sun—this dragon came to me in such a manner. It opened its mouth and instead of an outpouring of fire, my daughter came to me. She was beautiful. I could see her small body and the pronounced features of her face as she glided towards me on a ray of sunshine. Rai. This is the person inside of me: My Rai of Sunshine.

Who I am as a mother is not dictated fully by my imaginings of what motherhood is and can be. It is a virulent mix of trauma, sadness, heartbreak, accidents, and trying to be an authentic and caring person. I did not know and could not have ever fathomed the immense emotional and mental labour involved in birthing my child, raising my

child, and loving myself enough to question if I did and could ever love my child.

The Afterbirth

Nancy tugged on the three-foot cord that extended from my vagina. As I lay in the water in shock, I felt my insides shake loose. She pulled the placenta from my body, and I watched her place it into a biohazard bag. I couldn't move from the tub, but Nancy, my midwife, urged me to stand up so she could drain the bloodied, urine and feces filled water I just birthed in. Slowly, I began to rise. As soon as I stood, all of the air inside of me escaped. Immediately, I hunched over, gasping, feeling to make sure my ribs were still intact. I felt a giant cavity in my midsection. I couldn't stand, or breathe, or feel any muscles in my stomach. Paralyzed by fear, I folded over and slid down into the bathtub. Ingrid, my doula, comforted me and held my hand as she eased me back to a half-erect position. Empty. I stood emptied of what felt like all the matter inside of me. How am I ever going to be able to do this?

There are those who would scorn me for suggesting that I could not or did not love my daughter. They might also believe that because I do not have custody of her that I am not a mother. Whether through adoption, surrogacy, fostering, caretaking, stillbirth, or miscarriage, there is an affective residue of such experiences that allows us to understand something about the patriarchal institution of motherhood and our relationship to it. We carry within us the emotions and sentiments of motherwork and the oppressive internalized expectations of motherhood from mainstream society. These feelings plunge so deep into us that they seem to alter our perceptions of ourselves, haunt our cellular core, and even take us outside of our own bodies.

Motherhood is a structure, a roadblock, a charting of a course that is as expansive as it is short and determined. My course is one where the deep knowledges of state violence permeate every interaction, every thought, every happening in my motherline—the thread that connects each woman born of another (Lowinsky). How do we mother without our children in a world where their sheer existence is a reminder of the nurturance amiss? Mothering without our children is a declaration of selfhood and an act of subversion.

Visual Inventory

When the officer took me in for processing, he inspected me and looked for any unique identifiers. We went through the standard height, weight, hair colour, eye colour, date of birth, race, and sex. He then began to visually scan for any scars, piercings, and tattoos. The officer's eyes ran up and down my body; he took visual inventory of the flesh he saw before him and called out each distinguishing aspect of my being. Tattoo right arm, mermaid; tattoo right arm, Betty Boop with the name Laura; tattoo right arm, snowflake; tattoo right shoulder, script—he turned to me "what does it say?" "sin arrepentimientos"—it means without regrets. He laughed. Tattoo right shoulder/chest, a cut above the rest with jewels—"any more tattoos?" he asked. "Yes. Left breast, Lizbett." A femme presenting officer sat across the room diligently entering all of this information into the archive. My flesh was inked, written in the lines of the law, made real by its recognition.

My maternal identity is tied to vestiges of state violence, inter-generational poverty, rape and molestation, mental illness, incarceration, and failed relationships within deviant sexuality. I write to say that we are enough, capable of giving and receiving love, and that we in the context of our own lives, as mothers without children, are creating a world where we can imagine things otherwise. We create elastic conceptual bonds between motherhood, nurturance, mother-work, morality, and the cult of true womanhood. This stretching allows us to make space for deviation, love, creativity, breath, and the ability to mother in radically new and validating ways.

Agency

My birth mom's mom, which would be my grandma Laura, sent me a packet of photocopied family photos spanning throughout the years. There were a couple pictures of a baby that I recognized as myself. I have only seen a handful of photos of myself as a baby, and this one was particularly striking. It had "New Hope Adoption Agency" written on it. I had heard stories that for the first year of my life I lived with a family who wanted to adopt me, but for whatever selfish and fucked up reason, my grandma helped my mother fight the state and regain custody of me. I stayed with my mom for four years until I called the police and told them I was hungry and that she hurt me. Exercising my agency trapped me in yet another, foster care.

My agency is wrapped up in claiming membership in an institution that was not built for me. Despite not fitting the white male elite profile, educational spaces met my basic needs growing up. School provided me family, food to eat, intellectual validation, and a sense of community, and it oftentimes led me to the next roof over my head. School ultimately served as an out from an emotionally and mentally abusive relationship. Moving out of state and pursing my doctorate resulted in the relinquishing of my custodial rights. Where I thought I could be so big, I felt so small.

Being Small

I would get my ass whooped for everything, so I learned to be obedient, quiet, smart, disciplined, and how to read bodies. The changing of my mother's body alerted me to her changing personalities. My mother, Yvonne, took up an incredible amount of space. She was an excess, her selves excessive. I couldn't be like that.

As my body changed during pregnancy, I made myself throw up. I felt huge. I would not rub my belly. I could not acknowledge the person I saw in the mirror. I saw her. I saw me. I saw it. Another finger down the throat somehow puts another pound on the scale. Excess.

As women, we are often expected by society to be small. We must be thin, be soft spoken, and not draw too much attention to ourselves. We are to have no ideas of our own, and we are always an accessory, never the outfit. My mother was huge. She yelled obscenities at every passerby, spoke loudly, and vulgarly expressed her poetically disjointed thoughts. Her illness flowed through her and radiated outwards, smeared on her face and body like paint —this woman, the world would say,—was crazy.

Hands

What have these hands done? For so long, they existed unintelligibly—girls' hands, workers' hands, women's hands, producing hands, strong hands, loving hands. These hands inflicted pain, a recorded pain. Fingerprinted. Documented. Now these hands stop me from caring for the person whom I birthed, these hands stop me from caring for our sick, our elderly, our young, and those "at risk." And now these radial loops marry me to Big Brother— always watching—'til death do us part.

He brought the case against me that I was an unfit mother. The remnants of my past glaringly stuck out under section 3.1 of the parenting plan. Despite the work of counselling, community service, and a firm commitment to leaving a legacy for my daughter via my education, they still attached themselves to me like a leech. I am a criminal coming from histories of abuse and trauma—narrations of betrayal marked on my flesh—signaling to the state that I am not worthy of even trying to figure out how to mother. My hands, hands marked by penality, femininity, white identity, and impoverishment become surveilled and coerced by the state to concede their capabilities and rights to work in ways that further isolate, devalue, and strip me of my dignity.

Head

I felt myself tearing open as her head descended down the birthing canal. I held my breath and bore down as I calmly floated in the water. Burning, burning, burning, and finally...relief. Out came her head, shoulders, and the rest of her bloody body. The baby came so fast her head tore me in two. Her presence on this earth literally split me; I think of how my mother was divided, deranged, and living in thirds. How has birthing eight children further divided her personalities, her illness, and her body? Her head —the point to which they always returned and where her illness was said to originate— was what made her a target of violence. And now, my own head, my mugshot, lives in an archive joining our deviant histories.

Torn between worlds—the academy and the criminal justice system—mothering does not come easy. It is not supposed to. This Cartesian split between the mind and body, rationality and emotion, masculine and feminine, validated and subjugated, further fractures us, and for me, serves as a constant reminder that I am not supposed to be here and not supposed to be doing this. We are not supposed to do this—to admit maybe we are not good enough in the present—and not because society seeks to discipline us but because we imagine a world of otherwise where we can, like humpty-dumpty, put ourselves back together again and learn to mother without children and (re)claim such an identity.

Structures

We act as though the law is colour blind. We pretend the institution of family is sacred and persevering. We give power to the state to regulate our bodies, our beliefs, our interactions, and even our sustenance. I saw my mom go to jail. I saw her beaten by police. I saw her mistreated by physicians. I saw mental health professionals belittle and dehumanize her. I saw her be institutionalized on many occasions. I saw case workers inspect our apartment, write their reports, and ask me questions. My mother suffered from schizophrenia, bipolar disorder, and she had multiple personalities. This world is not meant for her to survive, let alone for her to have eight children.

These structures are set up as roadblocks to deter and capture anyone deviating from the norm. I thought I was crazy because when I read I would hear voices in my head. That must be what my mom hears. So I went to doctors, I went to counselling, and I went everywhere my new "families" would shuffle me. I belonged to the state now, a ward of the court. Structures: roadblocks set up to deter and capture anyone deviating from the norm. I will never be normal—always visibly marked with the pockmarks of criminality, poverty, and violence.

It is because of this he thinks I am unfit ... the continued state-sanctioned violence that contains and flattens women. The state took my mother's children, all eight of us, and continued to remind her, to remind us, that without our whiteness, we wouldn't exist as ourselves. We would be medically kidnapped, a number on a report, soldiers in an imperial army, organs for another's body, dead at the hands of the law, and seen as human detritus. It is no coincidence that an impoverished, mentally ill, single woman and felon on public assistance is not afforded access to the limited status and value motherhood might have otherwise conferred her. As her offspring, I am a part of this deviant history. Her lack of stability in my life, her abuse and neglect of her children, and the lack of a nuclear family signals that I cannot possibly know what it is to be a "good and respectable" mother. Perhaps I don't know what a good and respectable mother is. I am sure others don't. But we deserve a chance to build community to know, to find out, to probe our deepest insecurities and question the state of injustice, personal and structural, that leads to mothering without our children.

What My Mother Did

She told me she loved me. She held me close. I resisted. She forced. She said it was her men, but it was her. She did it. Nobody believed me.

She did it. She forced me in-between her legs and made me think it was an act of love. I grew to think the pursuit of sexual pleasure was a journey of love. My daughter's father grew fearful that somehow whatever love he conceived of me being capable of having for our daughter would manifest itself sexually. The threat of being like my biological mom is ever present.

Mapping the Self

How do you confront the trauma you carry with you? Do you know it's there? Does it manifest physically? Psychically? Emotively? Draw a body. Like a chalk outline. Map what you feel, what you see, and where it hurts. Map where the pain emanates, where discomfort or distress settles. Name it. Say it. Write it. Feel it. Now throw it away. Crinkle it up. Burn it. Bag it. Float it on the river. Listen.

Foster care, mental illness, violence, poverty, and the constraints of the patriarchal institution of motherhood create a climate of perceived undeservingness. I do not deserve to be a mother or to have the opportunity to work through my own pain—to link my story to a shared experience, to a consciousness, to a community, to a structure, and to a society. What women without their children deserve, society says, is their pain, is to make themselves useful to the interests of capitalism, and is to serve others who do nothing to serve them. We deserve to be validated in the contexts of our own lives and to be afforded a self-determined justice predicated on healing, community, discovery, resistance, and a claim to truth.

I invoke Wong-Wylie's (2006) theory of matroreform, which acknowledges the space of actively resisting being like one's mother and finding empowerment in doing so (142). Mothering without children means creating a legacy of transformation and politicization; it means moving private, seemingly isolated anguish to the public sphere. It is doing the work of self-reflexivity and trying to love one's self in a climate of hate. Finally, it means accepting the changing nature of who and where we are in this world and being okay with deciding for ourselves that we might not be enough ... maybe not forever, but for now.

Orgasm

I was hoping in birth I would experience the ultimate release, absolute and utter ecstasy; after all, when else was I going to have a chance to see if this was finally my trigger, my release? I felt the baby's head descend and a burning in my vagina. I pushed, bearing down for sixteen seconds, and out came the baby into the dirtied water. I didn't come. But she did.

To my daughter: I love you and will be here if and when you decide you want me. Love, Mai.

Works Cited

Lowinsky, Naomi Ruth. "Mothers of Mothers and Daughters: Reflections on the Motherline." *Mothers and Daughters: Connection, Empowerment and Transformation,* edited by Andrea O'Reilly and S. Abby, Rowman and Littlefield, 2000, pp. 227-235.

Wong-Wylie, Gina. "Images and Echoes in Matroreform: A Cultural Feminist Perspective." *Journal for the Association for Research on Mothering,* vol. 8 no. 1-2, 2006, pp. 135-146.

Part II

Institutional Frontiers and Othered Mothers

Chapter 3

"It Was Like My Soul Was Back": Pregnancy, Childbirth, and Motherhood during Incarceration

Brittnie Aiello

Introduction

This chapter focuses on the personal narratives of four women who gave birth during their incarceration in a county jail in the Northeastern United States. Their stories lay the groundwork for a critical examination of the policies, or lack thereof, that govern pregnancy and childbirth during incarceration. An estimated two thousand babies are born to incarcerated mothers each year in the U.S. (Quinn). With few exceptions, mothers who give birth during incarceration will be separated from their babies within a few days (Women's Prison Association). The majority of women incarcerated in the U.S. are mothers to minor children (Glaze and Marushack). In 2004, an estimated 4 percent of state inmates and 3 percent of federal inmates were pregnant when they became incarcerated (Maruschak). The recent and dramatic increase in women's incarceration in the U.S. has been well documented. Between 1980 and 2014, the number of incarcerated women increased from 26,378 to 215,332, a rate of increase over 700 percent (The Sentencing Project). Yet we know very little about incarcerated women's experience of pregnancy, childbirth,

and motherhood. We also know very little about how these mothers cope with the separation from their infants or how they think and feel about their motherhood. Here, I share and consider the stories told to me by four mothers[1] who gave birth to their children during a period of incarceration. Each one was transferred from jail to a local hospital to give birth, spent a few days with her infant, and each was then returned to jail alone.

The scholarship on mothers who give birth during their incarceration has largely focused on two things: the widespread use of cuffs and shackles to confine women during labour and delivery (Clarke and Simon; Ocen) and the relatively rare use of prison nurseries in the U.S., which enables mothers to care for their babies during incarceration (Carlson; Goshin and Byrne). The penal system's practice of forcing women to give birth in chains while failing to provide opportunities for mothers to bond with their babies speaks to the disregard that the criminal justice system has for incarcerated mothers and their children. This pattern of disregard is visible in the stories of the four mothers who gave birth at Northeast Jail in the mid-2000s. Their birth experiences were tempered by their own resilience and resourcefulness and by the care of individuals who worked to alleviate the pain of the forcible separation of mothers and newborns days after birth.

Drawing on participant observation in the women's unit of a county jail and in-depth interviews with four incarcerated mothers who gave birth during their imprisonment, I contend that mothers in this study demonstrated great resilience in the face of separation from their babies. All four mothers talked about a feeling of emptiness and longing upon returning to jail without their children. They sought to make sense of having a new baby without getting up at night, changing diapers, or cuddling. The experienced mothers in the group, Natalie and Delores[2], found solace in their plans to resume caring for their children when they left jail. They also felt less anxiety over the separation from their children than first-time mothers Madeline and Sue. Madeline and Sue focused on memories of the few nights they spent in the hospital and the intense connection they felt to their newborns during that time. When possible, all four mothers used visitation to help foster a bond with their infants— feeding them, unpacking and repacking their bags, and inspecting their little bodies from head to toe.

In the sections that follow, I discuss mothers' experiences of enduring pregnancy during incarceration and how they managed labour and delivery. Based on the narratives of the participants, I suggest that vague and inconsistent protocols regarding birthing mothers reveal that security concerns were largely invalid and the behaviour of correctional staff can have a significant impact on an incarcerated mother's childbirth experience. The efforts made by the mothers to stay connected with their babies speak to the importance of early mother-child bonding and the pain of mother-child separation. Despite all of these hardships, the women in this study were extremely resilient. They endured their pain while they stayed hopeful and looked towards the future. This group of mothers was committed to reuniting with their babies upon release, even though they expected challenges associated with post-incarceration life, such as finding work and housing, and rebuilding relationships. To that end, I conclude that incarcerated pregnancy and childbirth can shed light on the cruelties of mass incarceration in general. Instead of punishment, policies regarding pregnancy and childbirth must be geared towards supporting mothers, children, and their potential reunification at all costs.

Pregnancy in Jail

Pregnancy in jail is difficult. However, I found that previous experience with pregnancy, childbirth, and mothering gave some of the women in this study a foundation of knowledge that they could draw upon to comfort themselves. The social isolation was also more challenging for the first-time mothers, who yearned for close contact with their family when they faced uncertainty about pregnancy and childbirth.

Natalie and Delores, both experienced mothers, found out that they were pregnant after they had arrived at Northeast Jail. Delores, who had two daughters from a previous relationship, explained that she suspected she was pregnant, yet she was, nonetheless, shocked when her suspicions were confirmed:

I was like, "Are you sure? Are you sure?" The lady's like, "yeah." Cause I suspected it. Cause when I first came in they said that the test came out negative. So two weeks later when the midwife came to see me, I'm like "Look, my period hasn't come, I feel weird. There's something. Give me another pregnancy test." Sure enough, it was positive.

Delores said she "was in shock at first," but then she realized, "Wow, you know, it's a gift, it's a blessing. And it was."

Natalie had three daughters when she found out she was pregnant upon her incarceration at Northeast Jail. Like Delores, she came to see her unexpected pregnancy as positive, but she came to that conclusion after some soul searching. Of her decision to continue the pregnancy, she said the following:

> I knew I was going to do time, so I had to make a decision if I wanted to keep the baby or, you know, not have the baby. And I think if I was in the streets, I wouldn't have had him. But I mean, it's a good thing that he's here, because I always wanted a boy, but I didn't want no more kids. But then I was like, "I'm about to do some time, maybe this pregnancy can help me get through this. I have something to look forward to." It was a hard decision, but I decided to keep him.

Neither Natalie nor Delores planned to be pregnant or to give birth during their incarceration, but their incarceration did not detract from the significance of pregnancy and the anticipation of new life. In Natalie's case, her incarceration actually encouraged her to continue her pregnancy because it gave her hope and strength for the future.

This is not to say that Natalie and Delores found pregnancy in jail to be pleasant. The deprivations of incarceration (Sykes) were especially difficult to endure during pregnancy— namely, uncomfortable mattresses and the lack of access to desirable food. Women often spoke of the thin mattresses that made it difficult to find a comfortable position for sleeping. Natalie said that she was comfortable during her pregnancy once she became accustomed to being pregnant in jail: "At first, I was having cravings for different food. I would see a commercial for Kentucky Fried Chicken and be like wanting to cry." The jail supplemented pregnant women's meals with a cheese sandwich in the evenings, but this did little to satisfy cravings or the hunger that comes with pregnancy.

In addition to the physical discomfort of incarceration, the social and emotional deprivations were especially pronounced for new mothers Madeline and Sue. The father of Sue's child stopped communicating with her shortly before the baby was born. Of the days leading up to her son's birth, Sue said, "There were a lot of things going

on. I didn't know what to do. This is my first baby and it's hard because you're in jail and you don't know what to expect." Sue relied heavily on her jail counsellor, who encouraged her to walk around the pod[3] to encourage labour. Sue was past her due date, and everyone was eager for her baby to be born because Sue's mother had arrived from Puerto Rico for the birth.[4] The plan was for her mother to assume custody of the baby and take him home to Puerto Rico until Sue was released and could care for him.

Although Madelaine felt secure about her plans for her mother to take care of the infant until she was released, she struggled with not having the support of her family during her pregnancy: "When I first found out I was pregnant, I was like, 'yeah, my mom's going to be there with me, my sister, you know I had all my family with me.'" That changed when Madelaine was sentenced in her seventh month of pregnancy. Later on, Madelaine asked the women she was incarcerated with what labour was supposed to feel like because she was experiencing pain: "Some of them say that they don't even remember their pregnancy because they got into drugs or whatever. It's all these inmates telling me, 'You're in labour, you're in labour, don't worry about it, get over there.' I went for like five trips to outside[5] medical because of people telling me I'm in labour." It turned out that Madelaine was having Braxton Hicks contractions and that when she actually went into labour, she knew it. She said that experiencing the pain of labour and not having family with her to support her was the worst feeling she had ever had.

For both the new and experienced mothers, isolation played a significant role in their pregnancies. Being able to draw on their previous experiences of motherhood enabled Natalie and Delores to use their pregnancy as a source of strength and hope during their incarceration, but they did so by drawing from within, reflecting on their situation, and looking towards life after incarceration. In contrast, the anxiety of not knowing what to expect for Madelaine and the insecurity of her child's placement for Sue made the prospect of labour and delivery scary without the guidance of those closest to them. Without the ability to be with their families and rely on them to provide reassurance and knowledge, Madeline and Sue were lonely as they navigated pregnancy. Their stories of labour and delivery also demonstrate that experience helped assuage the mothers' fear and anxiety about giving birth within the context of incarceration.

Labour, Delivery, and the Days Following Childbirth

The policies regarding childbirth for women in the custody of Northeast Jail were both ill-defined and rigid, and they seemed to be designed and implemented to mitigate perceived security threats rather than to foster the wellbeing of mothers and babies. For instance, mothers were sometimes cuffed to the bed during delivery and always afterwards; they had to ask to be uncuffed to use the bathroom. These kinds of restrictions on movement can be very uncomfortable during the post-partum period. Furthermore, the recovery and bonding periods are interrupted when mothers have to ask permission to perform the most basic of bodily functions.

From the women's narratives, it can be seen that despite unfavourable policies and conditions, individual actors do have some power to lessen the negative effects and to support a more respectful and humane birthing experience. For example, while security personnel were present in the room at every delivery, some members were gracious enough to turn their back and allow women relative privacy during birthing. According to the mothers in this study, the behaviour of individual correctional officers and their compliance or willingness to challenge the jail authority could significantly influence of overall experience of giving birth.

The issue of cuffing and shackling mothers during childbirth has received much attention in the press as several state legislatures have made the practice illegal (Quinn). As of 2016, reports have showed that despite the changes in legislation, the practice of restraining labouring women is still alarmingly common (The Prison Birth Project and Prisoners' Legal Services of Massachusetts). Oftentimes, there is also a similar disconnect between official policies, which tend to be unclear, and the actual practices of individual correctional officers, who guard mothers during hospital stays. The Northeast Jail's failure to provide correctional officers with clear direction in this matter contributed to some of the study participants being cuffed during labour, whereas others were not.

Natalie was the first among the group of women to give birth. Her explanation of the way she was treated during childbirth is both incredibly sad and a testament to her strength: "When I actually was giving birth, when I was pushing him out, I was handcuffed to the bed. But it was—it could've been better, but I was comfortable. I was

comfortable." Natalie reported to me that she was cuffed to the bed prior to our interview. With her permission, I addressed this with the unit director, who assured me that "We don't do that here." She acknowledged that it had happened to Natalie, but somehow it was a mistake that she was cuffed to the bed. However, the issue of shackling arose again months later when Sue was in an outside hospital in labour with her son.

Sue was in labour for four days. The correctional officer on duty did not want to shackle her to the bed, but he was nervous about getting in trouble with his superiors. He said that he knew she was not going to try and escape, but "they don't think that way with policies and procedures." Sue's caseworker got on the phone to the lieutenant on duty at the jail, who was refusing to authorize the removal of cuffs for the delivery. He finally relented when Sue's caseworker said, "lieutenant, have you given birth yet?"

Without her caseworker's willingness to go up against the lieutenant, Sue would have had to deliver her son while shackled to the bed as Natalie had, even though the unit director asserted that it was not part of Northeast Jail's protocol to shackle mothers during childbirth. The lack of clarity around policies related to childbirth was indicative of how little attention was paid to the plight of mothers who gave birth while incarcerated at Northeast Jail. Consequently, it is left up to individuals to advocate on mothers' behalf, and many mothers do not have an advocate. At the same time, correctional officers may be institutionally incentivized to make excessive use of restraint. Typically, the mothers' needs and desires seem to be subordinated to security risks.

A few weeks prior to their due dates, mothers filled out paperwork to authorize family members or friends to be present for the birth. Just like at jail, visitors to the hospital had to have security clearance to be in the hospital room during and after birth. Something went wrong with Madelaine's paperwork, and when she arrived at the hospital at midnight, the correctional officers on duty told her that she did not have a visitor's form, so nobody was coming to visit her. Finally, the officers relented and let her call her mother at six-thirty in the morning:

> I think they just gave in because in order for you to dilate and stuff they want you to walk and I wouldn't do the walking.

I wasn't trying to let myself get dilated because I wanted my mom to be there. She'd seen all her other grandchildren born. So I was like, "She's not going to miss out on this one. I'm not going to be the only one she misses out on. "*Sin mija*, my baby." And I was like, "I'm not walking, I'm not doing anything." I wouldn't cooperate with them.

Doctors convinced the correctional officers to allow Madelaine to call her mother to gain her cooperation in advancing her labour. She explained that her daughter's birth was affected because of the following:

I couldn't relax, you know? I've got people telling me, "It's okay, calm down, do your breathing." But how can you be okay and be calm without your mother or somebody close to you there? I've got COs [correctional officers]. I've never seen before—these COs I've never seen before—so that, I was really uncomfortable. I was like, "Wow, I can't have a baby with all these people. I don't know them. I want my mom."

Madelaine said the two female correctional officers who brought her in were kind and supportive. They both had children and helped her with her breathing:

But before I actually delivered, it was shift change, so there was a guy CO coming in, but luckily my mom got here just in time as shift change came, because I really was very uncomfortable with him there. And he doesn't leave the room. He stays in the room the whole time. But he was a nice CO, and he stayed facing the other way. He was telling me from facing the other way, "It's okay. You can do it."

Madelaine needed the support of her mother to have a healthy birth, but she was forced to withstand hours of first-time labour without anyone close to her present. She resisted the progression of her labour, certainly a stressful and difficult thing to do, in order to force officers to relinquish and breach protocol—protocol that had failed when Madelaine's paperwork was lost. Although she felt that the officers in charge of her were kind and tried to give her privacy, having strangers in the room while she gave birth was extremely uncomfortable.

Delores had a smooth birth with her daughter. She laboured for some time at Northeast Jail, and then she decided at four in the morning that it was time to go to the hospital:

> I was already five centimetres when I went, so they rushed me upstairs and within like two hours, I got the epidural so I really didn't feel too much pain and stuff. I was sitting up; I was relaxed and stuff, and the contractions, I'd see them on the monitor but wasn't feeling them. I was in heaven. I was in heaven. And then when I knew she was coming, when I started bearing down, it was like, "Wow, you know, this is it, this is it, she's coming." That's when I got all emotional and stuff. And she came out in four pushes and when she was out it was like, "Wow, you know, there she is. I made her. This is mine. Oh my god."

The birth of her daughter was a powerful, positive moment in Delores's life, which was not dampened, at first, by the fact that she was incarcerated. Delores said the following of the officers' who guarded her in the hospital:

> The one that was there while I was giving birth was so cool. When it was time, he'd be like, "Oh, no problem, no problem. I'll just leave the room, no problem." Most of them were really, really sweet after I gave birth and stuff. But there was one, who was a real.... I guess he felt like it was his duty to protect the rest of the hospital from me, and he was a real jerk and stuff.

The officer would not allow Delores to control the electronics in her own hospital room: "He wouldn't let me turn the light off; he had to have a light on and stuff. He took over the remote." Delores's incarceration provided this officer with an opportunity to watch television while on duty. These women's birth experiences suggest that sometimes protocol functioned as a rationale for officers' behaviour, which would be unacceptable in any other context outside of incarceration.

One practice that was consistent for all four mothers was that each was cuffed to the bed following labour and delivery. Natalie was shackled to the bed during and after labour. Madelaine said the following: "I was uncuffed the whole labour while I was having contractions, the whole labour and everything, after I had her and everything. I took a shower and then after I took the shower I came out

and they cuffed me." When I visited Sue after her baby was born, she alerted the correctional officer when she had to go to the bathroom, so he could uncuff her ankle and then recuff when she got back into bed. Delores was cuffed by the wrist: "As soon as I could get up from the bed" after birth. "It dampened me big time, because I mean, the nurses would come in and the shackles would fall on the floor or whatever, and it was embarrassing."

Beyond embarrassment, the constraints that cuffs and shackles imposed on mothers as they sought to bond with their babies and practice self-care following childbirth were extensive. The restraints made it difficult to nurse and hold their babies; they restricted the mothers' movement and their attempts to find physical comfort, and forced mothers to ask for permission to go to the bathroom immediately postpartum. The utility of cuffs and shackles following childbirth was highly questionable at best. Delores said, "I mean, I didn't leave the room at all. I wasn't going to leave the room. The whole two days I was there I didn't leave the room. So I don't think it was necessary for them to go the extreme to shackle me to the bed." Furthermore, while all mothers were cuffed and shackled following delivery, Delores reported that "Some of them were really cool; they didn't shackle me," which reveals once again that individual officers had considerable power to mitigate the harsh policies the jail imposed on women.

Leaving Babies and Returning to Jail

Women who gave birth at Northeast Jail had two to three days, depending on the timing of their births, to spend with their babies following uncomplicated, vaginal childbirth. All four of the mothers knew that their time with their babies was finite, so they made the most of their hospital stay. Natalie was the only mother in the group whose caregiver was able to take the baby home before she had to return to jail. Natalie's mother took her son home: "I seen him go. I got him dressed and stuff and bundled him up." The timing of their births meant that Sue, Madeline, and Delores had to return to jail over the weekend. Both Sue and Madelaine arranged for their mothers to assume care of their infants, but before the grandmothers could take the babies home, they had to go to court on Monday to make guardianship legal before the hospital could release the babies to their care.

Delores gave birth over Labour Day weekend, so her baby stayed in the nursery for two nights after she returned to jail on Sunday: "Coming back here was probably the hardest thing I ever had to do, you know. Tore me up." She told the nurses to take good care of her baby: "I called the nursery a bunch of times....When I was there, I didn't let her even go to the nursery, but I had no choice." Knowing that she would leave her baby and return to jail, she did not spend one minute without her: "I slept with her; she was in my sight the whole two days."

The first few days of motherhood for Sue and Madeline were joyful and exciting. They relished the short amount of time they had with their babies, but meeting their children was immediately punctuated by the experience of leaving them at the hospital and returning to jail. Sue returned to jail around nine on Saturday night, but her son stayed in the hospital for two nights without her. Sue said the following: "Well having the baby was fun, because it's your kid, being there, playful. It's kinda fun, and afterwards I got two days with my son. It's kinda hard because you just don't wanna leave your baby right there and say bye because mommy has to go somewhere else, so it's hard. I'm trying to just live with it."

Madelaine gave birth on a Friday, and she left the hospital on Sunday night. Her mother could not take the baby home until she obtained custody from the court on Monday. As a result, Madelaine struggled with feelings of guilt about leaving her baby in the hospital. She said this of leaving the hospital:

> I only stayed a day and a half. Because the COs were telling me, "Oh you're fine to go." They were just trying to rush me back here. So that was hard too because then my mom wasn't there when I was leaving, and I was holding my baby and they're telling me I got to leave, and I felt like I was abandoning my baby because I had to leave and my mom's not there with her, and I had to leave the hospital, so that was really hard.

Natalie summed up what it was like to return to jail without her baby: "Coming back, I felt like I lost a part of me. That's what it really felt like. Something was missing."

While they endured the trauma of separating from their newborns, the mothers also received lots of support from hospital and jail staff and

their fellow incarcerated women. Delores said the following: "The midwives here were great. In fact, one of the midwives, when I was coming back, the day I was coming back, cried with me and she said, 'I want to be able to see you when you come out. I want to see you with your baby.' She was just totally awesome." Hospital staff comforted Madelaine when she had to leave her baby and return to jail: "They were like, 'Don't worry, the baby's in safe hands. We're the safest place for a baby to be, in the hospital.' They gave me a hug, and they were telling me, 'Everything is okay; she's in safe hands. We're going to take care of her. Everything is going to be alright.'"

Natalie said when she arrived at the jail, everyone was happy and asking her questions: "I had the pictures of the baby, so I was showing them, and they were saying he was so cute and he was so big. How did it go?" Madelaine described breaking down and collecting herself several times on her first night back from the hospital, but she was calm when she first entered the pod:

> I had the pictures. They wanted to see them. They wanted to know how my labour was, and everybody was comforting. And then when I was in my cell, it was shift change, and I was in my cell, and I had dozed off, and when I woke up, I broke down crying. And everybody knew. My roommate came in and she's like, "Oh my God, are you okay?," and she hugged me and everything. She's like "It's okay. You want to call your mom? Do you want to talk with somebody or something?" Everybody was like, "We're going to pray for you. You're going to get out of here."

Mothers received support from medical staff, jail staff, and other incarcerated women when they had to return to jail without their babies. Their births were celebrated by other women who welcomed them back; they wanted to hear the details, and they marvelled over their newborns—or at least pictures of them. The kindness of others seemed to help the women manage the pain of separation.

Motherhood without Children

Once they returned to Northeast Jail, mothers had to figure out what it meant to be mothers to infants whom they were not caring for on a regular basis. Oftentimes, this took the form of turning inwards: staying out of others' business and channelling their mental energy towards the future and reunification with their babies. Sue explained how she managed to feel like a mother when she was not with her son: "Regardless of the fact, it wasn't like I don't love my son, because I love my son with all my heart. It's just that I made a mistake before and now I'm paying for it. So I have to do what I have to do so I can go back to my son...I know that I'm not here forever, so I'm just trying to do everything to stay away from trouble and so I can get out and be with my son."

Delores also turned inwards; she reflected on her past and imagined a positive future with her baby in an effort to stay connected to her motherhood: "The only thing about jail that I can see makes it easier to be a mother is it makes you think. You can think about what you've done and what you can do to make it better.... I'm always going to be Mama."

Madelaine also tried to focus on herself and her future with her baby: "I didn't come in here to meet friends and leave with friends. I came in here by myself; actually, I came in here with my baby, but I'm planning on leaving without taking anybody with me." Still, Madelaine struggled much more than the other three mothers, as she tried to figure out what it felt like to be a mother:

> I don't know how it's supposed to feel to be a mom. But I know I don't feel like I'm a mom. I feel like I just had a baby just to give her away. But everybody's like, "Don't worry, she's with your mom." But I don't feel like I'm a mom. Everybody says that's a normal feeling. I don't think that's a normal feeling to have a baby and not feel like you're a mom. I don't think that's normal.

Madelaine only had two days of mothering to draw upon when she tried to feel like a mother. The following quote illustrates several important aspects of her new motherhood, including the intensity of it, her efforts to connect emotionally to her baby when she was separated from her, and the conditions under which she made the important memories that sustained her:

I think about how the last night before I left the hospital she slept in the bed with me because she kept crying in the little thing that they have where she sleeps. And I had her sleep in the bed with me. And I always think about that and how I couldn't sleep because I was afraid I was going to roll over on top of her or something. You know it's kind of hard to sleep with your leg shackled to a bed. Yeah. I think back to that night every night because I used to just lay there and stare at her. I just lay there and stared at her like, "Wow she's actually mine. That's my baby." It was a weird feeling. But then when I came back up here it felt like, you know, I had that feeling. but it kind of faded away, like I didn't get to spend that much time with her. I didn't get to get that bond with her. That feeling sucks.

Madelaine went on to explain that her inability to feel like a mother was connected to her inability to do the tasks of mothering: "I'm not waking up with her in the middle of the night. I'm not the one feeding her. I'm not the one bathing her. I'm not the one changing her.... It's like I said; I feel like I had a baby just to give her away."

Northeast Jail tried to assuage the distance that Madelaine described through a weekly visitation program for mothers and children. All of the mothers in this study participated in the program in some capacity. The visit was bittersweet for many, as they relished the time they had with their children but were keenly aware of the inadequacy of visiting with their children for only ninety minutes per week, and doing so within the constraining context of the jail. Delores had her first visit with her infant daughter the week before our interview. The baby had grown and changed quite a bit since Delores and I both saw her in the hospital weeks before. During the visit, Delores held her baby for the entire time except when she went through her entire diaper bag, unfolding and refolding every single item in the bag. Delores described the visit as the following:

Memorable. I could see every detail of her face, every detail, everything. I could describe everything she wore, her smell; I mean, it's like something that's imprinted in my brain. I couldn't sleep the night before. I was like having an anxiety attack, and when I saw her, it was like my soul was back. You know, I don't know if you can understand that. I felt complete. I felt whole. I didn't feel the emptiness I've been feeling.

Delores returned to her cell after the visit and slept for several hours; she was sad and tired from the experience of seeing her daughter and then saying goodbye again. She said she did not want to talk about the visit: "I just kept to myself for a little while. And then, I'm like, 'Okay, I'm sitting here feeling sorry for myself. I had a big visit. My daughter's fine, so I gotta snap out of it.'"

The mothers needed to connect, inspect, and know their babies through visitation. As with Delores, Sue undressed and dressed her son; she unpacked his bag and looked through everything her mother had packed. Sue was incredibly emotional at her first visit with her son after his birth. She started quietly crying about fifteen minutes before it was time to leave. She cried with her back to the room. Another mother who consoled her started crying too. By the time Sue handed me her baby, she was full-blown sobbing.

Natalie described the visits as such: "Good at first, nerve-racking towards the end. But you know, it's good to see them happy. To see them playing, to see how they are, and at the end of the visit to see how much they do miss me because they are sad and they don't want to leave." Natalie's first visit with her infant included her three other children. It was a lot to manage, but Natalie was skillful at distributing her attention among all her children, even though she held her son the entire time. Three weeks had passed since she had given birth, and Natalie thought he looked quite different than he did when she returned to jail. He slept most of the visit, and Natalie really wanted him to open his eyes so she could see them.

At the time of our interview, Madelaine had not yet decided whether or not she would participate in the visitation program. She was concerned about the baby's health and the cleanliness of the facility: "She hasn't gotten her shots yet, and so I don't want her up here." She also feared that visits would make her feel as though she was abandoning the baby again, as she had when she left her at the hospital. In addition, Madelaine doubted that the visit would be an adequate way to bond with her child: "What is it, an hour and a half? That's not a lot of time to spend with your baby. Your new baby. She's my new baby."

Madelaine's concerns echoed the words of many other mothers in this study: the visit was valuable, but it was not enough time to spend with their children.[6] Furthermore, as a new mother, Madelaine's separation from her child made her even more doubtful about the

potential of visitation to provide for bonding. However, Madelaine's baby did start coming to visit regularly. Although she remained circumspect about visitation, Madelaine appeared to enjoy the time she spent feeding and cuddling her daughter.

Conclusion

All the incarcerated mothers in this study endured painful correctional measures in the course of their pregnancies as well as in giving birth and returning to jail without their babies. The measures that compromised the mothers' and babies' wellbeing were inconsistent and unnecessary. The behaviour by hospital and jail staff could assuage or aggravate the difficulties, indignities, and grief associated with being incarcerated and separated from family during pregnancy and then separated from their newborns after birth.

All four mothers strove to connect with their babies despite the nearly insurmountable obstacles of physical separation and social marginalization. Their resilience and determination to mother suggested lost opportunities for mothers and their children to develop a loving bond in the early days of life. Returning to jail without their babies was incredibly painful for all of the mothers, but the experienced mothers were more able to manage their pain and identity as mothers.

Given that most women who give birth during their incarceration will be separated from their children within days, this research forces us to consider the cruelty of a legal system that disregards the importance of the early days of life in favour of incarceration and all its consequences. As the U.S. begins to wrestle with the damage caused by mass incarceration, the plight of pregnant and birthing incarcerated women, and their babies, provides us with incentive to make changes. We must make reforms that lessen our dependence on incarceration as a primary response to social problems so less women, and people in general, end up in jail or prison. When confinement is deemed necessary, alternative options and settings where mothers and babies can be together must be used to allow for mother-child bonding and for mothers to capitalize on the hope that new motherhood provides them.

Endnotes

1 These four women were participants in a larger study about the experience of incarcerated motherhood. All participants agreed to take part in the study and gave signed consent.

2 All names are pseudonyms.

3 The pod is the living space of the jail. The women's unit consisted of two pods of about seventy women each.

4 The father of Sue's baby was supposed to assume care for child, but he disappeared during her incarceration. After several unsuccessful attempts to reach him, Sue put together a last-minute plan for her mother to take the baby.

5 "Outside medical" refers to medical facilities off the jail's campus.

6 For an in-depth analysis of the visitation program, see Aiello and McCorkel (2017).

Works Cited

Aiello, Brittnie L., and Jill A. McCorkel. "'It Will Crush You Like a Bug': Maternal Incarceration, Secondary Prisonization, and Children's Visitation." *Punishment & Society*, vol. 20, no. 3, 2018. *Sage*, https://doi.org/10.1177/1462474517697295.

Carlson, Joseph R. Jr. "Prison Nurseries: A Pathway to Crime-Free Futures." *Corrections Compendium*, vol. 34, no. 1, 2009, pp. 17-22.

Clarke, Jennifer G. and Rachel E. Simon. "Shackling and Separation: Motherhood in Prison." *AMA Journal of Ethics*, vol. 15, no. 9, 2013, pp. 779-785.

Glaze, Lauren, and Laura Maruschak. *Parents in Prison and their Minor Children*. Bureau of Justice Statistics, 2008.

Goshin, Lorie Smith, and Mary Woods Byrne. "Converging Streams of Opportunity for Prison Nursery Programs in the United States." *Journal of Offender Rehabilitation*, vol. 48, no. 4, 2012, pp. 271-295.

Maruschack, Laura M. *Medical Problems of Prisoners*. Bureau of Justice Statistics, 2008.

Ocen, Priscilla A. "Race, Incarceration and the Shackling of Pregnant Prisoners." *California Law Review*, vol. 100, no. 5, 2012, pp. 1239-1311.

Quinn, Audrey. "In Labor, in Chains: The Outrageous Shackling of Pregnant Inmates." *The New York Times*, 26 July 2014, https://www.nytimes.com/2014/07/27/opinion/sunday/the-outrageous-shackling-of-pregnant-inmates.html. Accessed 3 Dec. 2018.

The Sentencing Project. Incarcerated Women Factsheet. The Sentencing Project, 2012.

Sykes, Grisham. *The Society of Captives: A Study of a Maximum Security Prison*. Princeton University Press, 2007.

The Prison Birth Project and Prisoners' Legal Services of Massachusetts. *Breaking Promises: Violations of the Massachusetts Pregnancy Standards & Anti-Shackling Law*. Prison Birth Project, 2016.

Women's Prison Association. *Mothers, Infants, and Imprisonment: A National Look at Prison Nurseries and Community-based Alternatives*. Women's Prison Association, 2009.

Chapter 4

Mothering Interrupted: Mother-Child Separation via Incarceration in England and Ireland

Sinead O'Malley and Lucy Baldwin

*I woke up in the early hours of the morning, and it was
still there [the worry about my daughter]—the first thing that
came into my head. I had pictures of my little girl in the cell.
Before I knew what I was doing, I was slitting my wrists.*
—Padel and Stevenson 100

The quote above immediately reveals the pain and trauma of a mother separated from her child by incarceration. The separation between mother and child is undeniably difficult, never more so when it is unwarranted or unexpected. Helen Codd's work in *In the Shadow of Prison* has shown that when a mother is summoned to court, it is not uncommon for her to expect to return home that day; for many, though, this is does not happen. As a mother is separated from her children, her prison sentence can, therefore, be consumed by attempting to negotiate multiple tasks: taking care of her children, her mothering role, and maintaining some level of meaningful contact with her children. For many, this is impossible, and as children learn not to rely on their mothers for immediate, practical, and emotional support, the mother-child bond can become difficult to

rebuild. Katherine Gabel and Denise Johnston's overall message in their work *Children of Incarcerated Parents* is that once children are separated from their imprisoned parent, especially when it is mother and child who are separated, those relationships are extremely arduous if not impossible to re-establish. This chapter draws together research from England and Ireland to represent the situation for mothers separated from their children due to maternal imprisonment. There are some comparative aspects between both jurisdictions on the topic of managing imprisoned mothers; indeed, many themes are found to transcend national borders. Many aspects of maternal incarceration and appropriate practitioner responses are discussed throughout. The emotional complexities and mental wellbeing of mothers separated from their children are primarily acknowledged. Thereafter, the focus is given to the nuanced differences in policy and practice. These differences—particularly those related to visitation, phone calls, and letter writing—affect the mothers' ability to maintain contact with their children while incarcerated.

Mothers in Prison: The Emotionally Complex Landscape

Approximately 700,000 women and girls are held in penitentiaries around the world (World Prison Brief). Although there has been a 20 percent increase in the world prison population since 2000, the number of incarcerated females has increased by over 50 percent in the same period; this increasing female prisoner population is, however, a global trend (World Prison Brief). In 2016, 8,447 women were sent to prison in England and Wales from a national population of 58 million, which accounted for 10 percent of overall committals (Ministry of Justice et al.). In Ireland, 2,937 women were sent to prison in the same year, accounting for a significantly larger proportion of 21 percent of all committals (IPS 31), which compares to a much smaller national population of only 4.6 million. Surprisingly, when the number of committals in each country is calculated against their national population, women in Ireland—with its significantly small female prison population compared to the UK (3.5 percent compared to 5 percent respectively)—are much more likely to receive a custodial sentence than women in England. Moreover, Ireland has one the highest prisoner turnover rates within the EU; it has an average prison

sentence of 2.8 months, whereas in England and Wales, it is 8.5 months (Council of Europe et al.).

Ireland's judicial system, which relies on the "principle of proportionality," provides that judges are the sole arbiter of sentencing, and as a result, they have huge judicial discretion in Irish courts. Such discretion has resulted in Irish judges using imprisonment as the preferred sentencing option (O'Hara and Rogan); incarceration is used twice as often as probation (Carr). In the UK, although judges also have some level of discretion, sentencing guidelines and a sentencing council do exist (which do not exist in Ireland), and judicial practices in the UK use community-based sanctions twice as often as (and in lieu of) a custodial sentence for women offenders (Carr; Ministry of Justice et al.). However, even though it is acknowledged that Irish judges do not consider probation to be a punitive sentence (O'Hara and Rogan), the overuse of probation and community sanctions, such as in the UK, has also been linked to increased legislation remit and the criminalization of people who would not have otherwise received any criminal sanction (Carr). These facts are interesting considering the relentless rise of female incarceration in both England and Ireland, which has more than doubled in recent decades.

However, Ireland and the UK are both member states of the United Nations (UN), and, therefore, they are also subject to the United Nations Bangkok Rules on Women Offenders and Prisoners[1] (United Nations), which recommends that except in the most extreme of circumstances, mothers (and primary carers) ought not to be sentenced to imprisonment. In the UK, despite such recommendations and the existence of sentencing guidelines and a sentencing council, Rona Epstein found that judges were failing to take the mothers' maternal responsibilities, or the rights of the child, into account at the point of sentence, which resulted in the separation of mothers and their children. Sinead O'Malley found that although primary caring mothers are certainly imprisoned in Ireland, their caring roles are at least considered and they are often awarded time to organize the care of their children before they start their sentence, contrary to judiciary in the UK ("Motherhood, Mothering and the Irish Prison System" also see the Irish Examiner).

Most women sent to prison are mothers. In the UK, 66 percent of women in prison are mothers of children under eighteen (Caddle and

Crisp)—a statistic that does not recognize mothers of adult children. A 2018 contemporary study involving 97% of the entire female prisoner population across Ireland, ("Motherhood, Mothering and the Irish Prison System" O'Malley) confirmed that 78 percent of women in prison in Ireland are mothers with an average of 2.4 children; of which 73 percent are children under eighteen years of age.

Many commentators, both motherhood scholars and feminist criminologists, have recognized how mothers across the globe are subjected to and prejudged by oppressive good mother ideals (O'Reilly; Carlen; Corston; Enos). As Andrea O'Reilly asserts, "mothers who, by choice or circumstance, do not fulfil the profile of the good mother ... are deemed 'bad' mothers in need societal regulation and correction" (14). In Ireland, there is an added layer of cultural and religious oppression of which imprisoned mothers do not conform. Motherhood and sexual morality is a highly charged topic in Ireland, and it is inseparable from the country's Catholic history and the Church's religious influence on state policy and legislation. As Christina Quinlan explains, sexual morality was (and still is to a lesser extent) controlled by the Irish Catholic Church; within this, motherhood is curtailed (45). Of further importance is how Irish motherhood is enshrined and awarded special recognition within the Irish Constitution (O'Malley and Devaney, "Maintaining the Mother-Child Relationship").[2] This idealism may render mother-child separation more difficult to manage. Moreover, the Irish constitution provides the basis for welfare provision, including the state's duty to care for children in cases in which their parents cannot, which links this to the needs of mothers in prison in Ireland and the care and support they and the children require. However, there is no doubt that entering prison immediately places all mothers at odds with good mother ideals and morals. As English Baroness Corston confirms, "[Mothers] still define themselves and are defined by others by their role in the family. It is an important component in our sense of self identity and self-esteem. To become a prisoner is almost by definition to become a bad mother" (20).

Sandra Enos and Helen Codd argue that maintaining a mother identity and mothering role while incarcerated is important in terms of how mothers manage their sentence and achieve positive long-term outcomes. Enos highlights related challenges in maintaining a mother identity for mothers separated from children via imprisonment; to

some extent, who people are in terms of identity is closely related to what they do (i.e., a firefighter fights fires, a baker bakes, and, similarly, a mother mothers). The mothers in Michal Shamai and Rinat Billy Kochal's study stated that once they surpassed the initial deep shame and guilt of their imprisonment, their motherhood identity, in fact, provided them with something positive to focus on—a plan for the future, a reason to get up in the morning, and "a defence against insanity" (328).

Mothering from prison is a different lived experience from mothering outside in the community, as a quote from the governor of an Irish female prison aptly describes: "A mother is serving her sentence ... in her head, outside as well as inside" (O'Malley). When a mother is sent to prison her heart and mind can become consumed by thoughts of her children. However, not all incarcerated mothers' ought to be viewed as a homogenous group. Indeed, not all mothers enter prison with existing positive relationships with their children. Certainly, socioeconomic factors—coupled with chaotic lifestyles, substance dependencies, and law breaking—mean that some mothers have already lost their children to the state care system (Enos). In "Mothers Addicted" for example, Baldwin, O'Malley and Galway discuss the specific difficulties for substance dependent mothers who attempt to manage mothering while also negotiating their motherhood through multiple criminal and social justice system agencies and institutions.

Although involuntary mother-child separation can add difficulty, Sinead O'Malley found that some mothers embraced prison as an opportunity for reflection, motivation and positive change ("A Mother Is Serving Her Sentence"). For example, prison can provide a space to think; mothers become focused on their children in ways that for many, particularly for those managing substance abuse issues in the community, were unable to prior to imprisonment (Cartwright). Baldwin's conclusion to Mothering Justice reminds us that regardless of whether a mother is the primary carer for her children or not, or if she will reunite with her children upon release or not, most mothers experience "mothering specific emotions" (264), which add further significant pain to what imprisoned women already feel (Carlen; Caddle and Crisp). Indeed, mothers in prison have described mother-child separation as "a physical, deep pain that envelops you" (Baldwin,

"Mothering from Prison" 161), particularly if it is the first time and they are separated for any significant time. Other mothers, as in Baldwin's research titled "Motherhood Disrupted" found, choose to disconnect from their emotions and their children as means of coping with the painful reality of the separation from their children.

Enos's work on mothers in prison found that mothers who cannot maintain a mothering role while in prison often feel a range of oppressive emotions, such as powerlessness, anger, frustration, worthlessness, and depression. Moreover, the emotional impact of not being able to complete mothering-associated tasks remains with the mother long after they have been released from prison. In "Motherhood Disrupted," Baldwin explores "the emotional legacy of prison" (3) and how the emotional scars of mother-child separation via imprisonment is an ongoing experience. Beth, an ex-prisoner in Baldwin's research, vividly recalls the agony of being separated from her baby and subsequently not being able to breastfeed: "I was locked in this horrible lonely, scary place with leaking breasts and no baby ... I held my pillow like it was my child and it was soaked with my milk and my tears ... I felt bereft, I have never felt grief or pain like it" (4).

Sue Kesteven's research has linked these negative experiences and the subsequent emotional states of women in prison to breaches of prison discipline, self-harm (such as that described in Padel and Stephenson's opening quote above), and even to suicide. Likewise, Linda Moore and Phil Scraton's research focuses on the general neglect of the mental health needs of female prisoners and highlights the tragic circumstances surrounding the death by suicide of Roseanne—a young lady imprisoned in Northern Ireland who ended her life only hours after learning that she may never see her daughter again. Strikingly similar in the UK is the death of Michelle Barnes in December 2015, who took her own life after learning she too was to lose her baby ("Inquest").

The stories of Roseanne, Gaby, and Michelle mentioned above all illustrate the depth of pain and frustration mothering while incarcerated can cause. The pain is perhaps all the more profound, since criminologists and sociologists have consistently acknowledged how women—and thus mothers and grandmothers—entering prison are already a vulnerable population (Corston; Moore and Scraton; Carlen). For example, Meda Chesney-Lind and Lisa Pasko found that

43 percent of female prisoners in their study were being abused directly prior to their current admission into prison, as compared to 12.2 percent of male prisoners in the same study (149). In "A Mother Is Serving Her Sentence," O'Malley describes how senior prison personnel have highlighted the frequent disclosures made by women during their sentence of past child sexual abuse and neglect, made when the women are sober, have limited access to drugs, and are reflecting on their past. One prison personnel reported that "sometimes, it's only when they are in here [that it] all that comes out" (59). Oftentimes, past traumas are the precursor for addiction issues, and being substance dependent is often the catalyst to imprisonment and children being placed in alternative care.

However, whereas women in prison must manage re-emerging repressed memories and emotions of past traumas, incarcerated mothers have the added challenge of simultaneously managing painful emotions related to their separation from their children, regardless of whether the mother-child separation occurred prior to their imprisonment or as a direct result of it. In *Motherhood, Mothering and the Irish Prison System* (O'Malley), several mothers who discussed child sexual abuse expressed concern for their own children. Mothers spoke about the "fear" and "worry" they had that their children may be abused in the community and their perceived inability to protect them while incarcerated. One mother said the following:

> I was abused when I was seven, and when she was seven that was my worry that was in my mind – I was dreaming about my daughter being abused... dreaming in here about [my daughter] out there.... he only lived up the road from her... that constant worry ... it was driving me up the wall ... I went crazy (233)

Sadly, 46 percent of women in UK prisons have previously attempted suicide (Prison Reform Trust). When compared to their male counterparts, imprisoned girls are nearly twice as likely to be separated from their own mothers and placed into foster care (Prison Reform Trust), and they are four times more likely to deliberately self-harm (Ministry of Justice 7). Many women enter prison with addictions, which are often a strategy for dealing with pain-filled and broken lives (Minson et al.). Some mothers believed traumatic childhood experiences factored in becoming addicted or their

subsequent offending. One mother said the following about how childhood trauma suffered while living in a residential care institution impacted on her behaviour in later life: "I would never have got into trouble if I hadn't been raped at nine and if I hadn't seen what I seen gone on in the home; and this place was supposed to be run by the health board – where is the justice in that?" (O'Malley 212).

Managing emotions effectively, particularly mothering emotions, is key to surviving incarceration. When such emotions are ignored, the outcomes can be devastating; many mothers leave prison only to begin the same cycle of substance abuse from which they left (Reilly; Corston).

Prison for mothers is an extremely sensitive time, and this uninvited reflective space can be quite traumatic, particularly when mothering emotions are not given the recognition and professional support they so desperately require. O'Malley has found that maternal guilt related to retrospective reflections on past performances of their perceived poor mothering difficult to cope with during imprisonment. When such detrimental and self-destructive maternal emotions are left unmanaged and unsupported, they can leave the imprisoned mothers in an extremely dangerous mental space:

> Some nights I do be terrified that I'm going to end up killing myself like. Just kind of not having my child and I look at programs on telly and I see kids with their mams and I'm saying oh ... "I would have been lovin for that to be me, me and my child." Because she never done anything on me... she didn't ask to come into the world... why I went wrong... I really, really don't know... I feel really, really, really guilty... every night I was in here crying. Every day I'm writing letters out to the baby telling her how sorry I am for everything I've done on her... but at the time I wasn't thinking you know. (*Motherhood* 232)

Internationally, the topic of mothers in prison has been extensively explored through literature and research; however, in the UK, *Mothering Justice* was the first book to present mothers (as opposed to women more broadly) as its focus. Drawing from a range of practitioners working with mothers in the criminal and social justice settings, this edited collection invites and encourages practitioners to appreciate the need for, and the value of, understanding the additional layer of motherhood to better equip practitioners to support women in their relationships

with their children, particularly those who are separated. The authors argue that the failure to recognize and engage with offending women as mothers first and foremost can result in consequences that fail not only the women but potentially also their children for years to come.

Although some prison staff in England and Ireland do receive gender-specific training (O'Malley and Devaney, "Maintaining the Mother-Child Relationship"; Baldwin , *Mothering Justice*; Crawley), the reality is that most prison staff members are from different socio-economic environments and communities than those of the majority of the female prisoner population (Roche). As Richie Roche's research found, it is only when staff become immersed in their prison work that they become aware of the complexity of the prisoner's psychosocial and historical challenges, and the distinct issues faced by prisoners, including imprisoned mothers separated from their children.

Elaine Crawley's research also highlights the importance of supportive professional relationships between prison staff and incarcerated mothers. O'Malley and Devaney make a specific case for the revival of the social work role in prisons to advocate for the mothers, their babies, and children, particularly when mothers are separated with children who are living in foster or alternative care arrangements. The authors have also focused on the practitioner perspective for mothers in prison in Ireland. Their research found that in the absence of clear policy to support mothers in prison in Ireland, the good will exercised by a variety of staff and practitioners is crucial for supporting mothers in their endeavour to maintain meaningful relationships with the children from whom they are separated ("Maintaining the Mother-Child Relationship" 29). However, Gaby, a mother of four who was serving a six-year sentence in Ireland at the time, articulates her frustration with the lack of basic and practical support:

> I've had family law court hearings [regarding maintaining contact with children], but I have had no-one to come to court to be a "voice" for me. Even though I was able to get letters to show my progress to the judge, it wasn't the same as having a social worker speaking up for me.... the judge and the HSE[3] are not going to just take my word for it, especially if I had a bad track record... just seen as a "drug user" ... The [Prison] Probation Service are "snowed under" ... they cannot support us 100 percent when it comes to our children. ("Gaby" 6)

Gaby voices the structural obstacles she and other mothers are faced with, and they have no alternative but to attempt to negotiate their way through—with limited support and already cast down as a "bad" mother—if they wish to maintain contact with the children they are separated from while they serve their custodial sentence.

Complex Mothering: To Be Visited or Not to Be Visited, That Is the Emotional Question

One might expect visits from children to be a source of only joy; the reality is, however, that prison visitation provokes complex and bittersweet emotions (Baldwin). Farrah, a mother of three children under the age of eleven, explains this complexity: "Visits or no visits, my pain, their pain, whichever you decide there's still pain. I've done two lots of time now, and I still don't know if it's best to let them come or not" (qtd. in Baldwin, "Mothering from Prison" 159). Mothers can experience a wide spectrum of emotions in just one day—from anticipation, apprehension, and excitement before a visit to sadness, anger, frustration, and grief following a visit. For some mothers, the ending of the visit simply reinforces the sense of separation and disconnection. Vicky Pryce, a well-known UK economist and ex-prisoner, describes an event in which a mother left the visiting hall and was so distressed at being further separated from her baby that she returned to her house block following the visit and attempted to take her life.

Subsequently, many women, particularly those on shorter sentences, make the decision not to allow their children to visit (Masson; Baldwin and Epstein). Diane Caddle and Debbie Crisp found that only 50 percent of the mothers in their study who had lived with their children prior to their imprisonment had actually received a visit from their children while in prison. In O'Malley's study "A Mother Is Serving Her Sentence," prison management stated that they are aware some mothers may avoid declaring the existence of their children at committal point to prevent unwelcome state and social service intervention (25) (see also Carlen; Codd). This study also found that for many incarcerated mothers, the stigma attached to their current location is too much to bear, and "being in hospital" or "being away working" become replacements for the truth that they tell their

children. Baldwin asserts that some mothers prefer to absorb the anger their children feel against them as they "choose to work away" rather than be with them, instead of revealing the harsh realities of their incarceration to them ("Motherhood Disrupted"). Mothers find themselves torn between their own mothering needs to see their children, missing their children, and a need to protect their children from the experience of visiting a prison and, indeed, seeing their mother incarcerated. For some mothers, the experience of maternal incarceration is incompatible with childhood innocence. Certainly, mothers in Baldwin's research describe not wanting their child to experience the trauma or shame of visiting a prison: they want to avoid their children considering prison-based visitation as a normal childhood experience ("Mothering from Prison"). Furthermore, as O'Malley and Devaney's research highlights, "time restrictions, hard-to-reach prison locations, restricted physical contact, visits behind glass, sniffer dogs, unfriendly staff and more generally the non-child friendly physical environment" provide for an uninviting experience for children ("Maintaining the Mother-Child Relationship" 22).

O'Malley found that in situations in which mothers are not the primary carers for their children (e.g., mother-child separation occurs prior to imprisonment and children are possibly in foster care), it may not be necessary to disclose their true location ("A Mother Is Serving Her Sentence"). Indeed, such a disclosure may not be possible, as contact in the community is either limited or non-existent. Additionally, for some children, the reality of their mother's location would cause further distress, which one social worker in this study confirmed: "The oldest child worried a lot about his mother, and it would not have been reasonable to burden him" (66). In this case, as in others, child protection and welfare social workers charged with the management of children in state foster care act as information gatekeepers for the children in the perceived best interest of the child (UNCRC).

Additionally, for imprisoned mothers who are not successful in abstaining from substance abuse and are subsequently imprisoned, being incarcerated can expose this perceived failure to their children, particularly considering that many mothers in addiction often make promises to their children related to remaining drug free. Such mothers can struggle with the exposure of their reoccurring perceived failure

through their prison (re)entry; this, coupled with overarching guilt and shame, can become overwhelming for mothers in these circumstances, who are also managing emotions related to their separation from their children. There is sense that their children—not society, family, friends, or the deciding judge—are actually their most feared judge and jury, not for the crime they are incarcerated for but for the reasons behind their separation from one another. The symbolic representation of being an incarcerated bad mother reaffirms their child's negative perceptions.

Similarities and Differences: England and Ireland Prison Visitation

Many mothers do of course choose to disclose their location and want to receive visits from their children. In fact, understandably many find it extremely difficult to finish a custodial sentence without seeing, touching, and embracing their children. One of the main overall findings in Shamai and Kochal's research was that once the mothers in their study surpassed the initial deep shame and guilt of their imprisonment, they became focused on contact and visits with their children. However, how mother-child contact and visitation are managed can depend on the category of prison and how that prison is managed. In this regard, there are some noted similarities and significant differences in relation to how the female prison estates are run across both Irish and English jurisdictions and the impact this has on mother-child visitation and contact.

In England, women can be held in open or closed conditions, or both, throughout the duration of their sentence. Mothers and babies are held in one of the seven mother and baby units (usually in the grounds of the prison but separate from the main prison). In Ireland, however, there is no female open prison, semi-closed, or high security prison for females; all categories of prisoner are housed within the same unit, mothers and babies included, and all women complete their custodial sentence within closed prison conditions.

All mothers in prison in Ireland experience similar mother-child visitation conditions than those for mothers held in closed conditions in the UK. Visits are not a private affair, as the vast majority are communally managed in a visiting hall and are not especially conducive

to children and families. They take place at fixed tables with rigid seating, and the mother is restricted in movement and is permitted only minimal physical contact, if any at all. In open conditions in the UK, mothers tend to enjoy fewer restrictions—a mother can freely hug her child for example.

Irish governors have a great deal more autonomy in how they manage their individual establishments. They, therefore, have more flexibility in how they can respond to the needs of incarcerated mothers and their children, particularly in relation to mother-child contact; this is much less the case in the UK. In relation to visitation, for example, although Irish legislation permits one thirty-minute visit per week, women are generally permitted a second in the same week with some additional flexibility around their management. A senior prison staff member explained the following: "We facilitate what we can. Particularly if someone is coming from the country; they need extra time, a morning or an afternoon or both" (O'Malley and Devaney, "Maintaining the Mother-Child Relationship" 25).

Mothers in both jurisdictions, (except for most foreign national mothers jailed in the UK), are assessed on an individual basis, have access to weekend leave, escorted visits out, childcare leave, and extended or special family visits. These provisions are vital forms of maintaining important contact between mothers in prison and their children living in the community, particularly if mothers find prison-based visitation either emotionally challenging or impossible to organize, or both. Some out visits are restricted to the family home, whereas others can include family days out. Some are merely escorted by a support worker; others are strictly supervised, and some are neither. Mothers nearing the end of the sentence can eventually apply for home leave, which permits them to go home once a month for the weekend and can increase over time. In exceptional circumstances, such as serious illness, bereavement or impossibility of visits due to disability, permission for special home visits can be granted. Such visits would be undertaken at the discretion of the Governor and made only after consideration of individual needs and are influenced by risk assessments and nature of the index offence.

Internationally, female prisons are fewer in number and, therefore, more geographically dispersed than male prisons. In Ireland, for example, the two female prisons are located at opposite ends of the

country (Dublin and Limerick). In the UK, although there are twelve female prisons across the country, this is far fewer than the number of prisons for men. Consequently, many mothers in both jurisdictions are located over 100 miles away from home. National transport systems can be expensive, untimely, and often incompatible with prison visiting times, which adds pressure to an already lengthy and emotional journey (Martyn). The distance can be prohibitively costly to drive to or access via public transport, which means many families are simply not able to maintain visits, or, at best, they visit irregularly. As well, since many women serve short sentences, many mothers choose not to put their children and family through the cost and journey associated with visiting (Baldwin and Epstein). However, this obviously results in being consistently separated from their child.

Alternative Methods of Contact: Phone Calls and Writing Letters

For mothers who do receive visits, but more so for those that do not, phone calls and letter writing remain a huge part of prison life for mothers attempting to maintain contact with their children and retain their mothering role. The Irish prison system is commendable in that all Irish prisoners can use free unlimited international postage and have a limited number of weekly free telephone calls worldwide (O'Malley and Devaney, "Supporting Incarcerated Mothers in Ireland"). This is particularly important when travel is too expensive and difficult. Free phone calls in prison is particularly noteworthy, since common international practice is for private companies to profit from prisoner phone calls and, in some cases, to actually charge prisoners (many of whom derive from the poorest communities) higher call rates than the general public (Poehlmann et al.). Although Irish legislation permits convicted prisoners one phone call per week, research has found that in reality, all female prisoners are automatically permitted one phone call per day, and those imprisoned mothers with enhanced privileges (rewarded for productive use of custodial time) get two calls per day (O'Malley and Devaney, "Maintaining the Mother-Child Relationship).

This practice in Ireland described above would be deemed a luxury in the UK, as many mothers cannot afford to phone their children

more than once a week, often less if they have multiple children in more than one location—for example, if siblings are split up into separate foster homes or have multiple carers (Baldwin and Epstein). Prison phones in both England and Ireland are located on prison landings, so prison acoustics and communal noise are issues. However, mothers imprisoned in UK can experience additional restrictions, such as incompatible phone times with their child's schedule. Rita explains her frustration:

> I once went ten days without any contact [with my children] at all because—and how stupid is this—the only time the phone on the wing was allowed to be used was between 3:00 and 4:00 p.m. ... where are children...? Coming home from school that's where! ... What made it worse was in our cells there were... actual phone sockets. Imagine how it felt locked in your cell... staring at something that with a little piece of wire would allow you to hear your children's voices?!" ('Baldwin, "Motherhood Disrupted" 6-7)

In the UK, there are some partnership charitable organisations working with prisons to support some mothers with phone credit or stamps, but there is no escaping the reality that for some mothers, these costs and restrictions are prohibitive in maintaining mother-child contact.

Additionally, there are no restrictions placed on how many letters prisoners can post free of cost in Ireland. In the UK, however, women are only funded for one letter per week. A finding of Baldwin and Epstein's recent study found mothers were forced to choose between which child to write to or which child to phone due to limited opportunities and/or funds. However, the physical writing of letters can be a general issue, as Irish prisoner Gaby explains, many mothers in prison cannot read or write. In her piece on "The Plight for Women in Prison," O'Malley highlights that "a large proportion of women in prison are from the poorest socioeconomic communities with low levels of educational attainment. Literacy levels among the prison population are generally very low" (8). Prisoners do elicit the support of other prisoners for support in writing letters for them, but, again, family privacy is sacrificed by engaging with this form of social and peer support.

Although it could be argued that in Ireland, the commitment of the Irish Prison Service to support mothers in their contact with their children is apparent, it does, however, remain true that in both jurisdictions, mothering via letters and phone calls is less than the ideal, and it serves only to highlight the physical separation of the mother and child.

Conclusion

There appears to be little doubt—certainly as evidenced in the current research of the authors of this chapter—that incarcerated mothers are additionally punished by the separation from their children (who incidentally are also punished). No matter what their past, present, or future relationships with their children may look like, mothers in prison experience pain, shame, guilt, loss, stigma, and judgement. Most mothers entering prison come from broken lives, filled with abuse, victimization, and trauma, and they are being further traumatized by a system that purports to value rehabilitation and justice at least as equally as punishment. Yet there remains a persistent failure to recognize the additional harm caused to mothers in prison—specifically, by failing to acknowledge the importance of supporting their mothering emotions and mothering role. Positive, supportive working relationships with prison staff, facilitated contact with children where appropriate, therapeutic responses to pain, and the reduction of custodial sentences for mothers would go some way towards minimizing such harm for mothers separated from children via imprisonment. Nonetheless, it is good to be cognizant of the hardship and multiple traumas many incarcerated mothers have endured in the past and are managing in the present, particularly the trauma and impact of incarceration and the disruption of mother-child bonds. These mothers and their children will face added challenges in their post-release journey as they attempt the difficult task of restoring their relationships. However, the strength of many mothers to carry on against all odds, which most mothers do, should be fully appreciated, respected, and admired.

Endnotes

1 The Bangkok Rules were adopted by the UN in December 2010. They focus on the needs of women offenders/prisoners. It supplements existing international standards that apply to all prisoners regardless of gender, and it is the first set of rules geared specifically towards women prisoners.

2 That a mother need not work for fear of neglecting her place in the home (See: Article 41.2.2)

3 At the time of the research, the HSE referred to the statutory child protection and welfare service in the Republic of Ireland. This service is now an independent agency called TUSLA, the Child and Family Agency.

Works Cited

"Gaby." "Service User Viewpoint: Why Social Workers Should Be Advocates for Women Prisoners." *Frontline: The Social Work Action Network Ireland Bulletin,* 1 Dec. 2015, p. 6.

Baldwin, Lucy. "Motherhood Disrupted: Reflections of Post-Prison Mothers." *Emotion, Space and Society,* 2017, pp. 1-8, https://wephren. tghn.org/site_media/media/articles/ESS_final_article__llorl7Z. pdf. Accessed 3 Dec. 2018.

Baldwin, Lucy. "Mothering from Prison: Understanding Mothers and Grandmothers, a Prison Perspective." *Mothering Justice: Working with Mothers in Criminal and Social Justice Settings,* edited by Lucy Baldwin, Waterside Press, 2015, pp. 139-166.

Baldwin, Lucy, editor. *Mothering Justice: Working with Mothers in Criminal and Social Justice Settings.* Waterside Press, 2015.

Baldwin, Lucy, et al. "Mothers Addicted." *Mothering Justice: Working with Mothers in Criminal and Social Justice Settings,* edited by Lucy Baldwin, Waterside Press, 2015, pp. 239-262.

Baldwin, Lucy, and Rona Epstein. *Short but Not Sweet: A Study of the Impact of Short Custodial Sentences on Mothers & Their Children.* De Montfort University, 2017.

Caddle, Diane, and Debbie Crisp. "Mothers in Prison." Great Britain, Home Office, Research and Statistics Department, 1997.

Carlen, Pat. "Mothers in Prison (Book)." *Sociology of Health & Illness*, vol. 9, no. 1, 1987, pp. 105-106.

Carmody, Patricia, and Mel Mcevoy. A Study of Irish Female Prisoners. Stationary Office, 1996.

Carr, N. "Community Sanctions and Measure." *Routledge Handbook of Irish Criminology*, edited by Deirdre Healy, et al., Routledge, 2016, pp.106-121.

Cartwright, Luke. "Respite and Repair: How Mothers of Incarcerated Long-Term Problematic Drug Users Make Prison Work for Them." *Journal of Substance Use*, vol. 21, no. 4, 2016, pp. 439-443.

Chesney-Lind, Meda, and Lisa Pasko. *The Female Offender : Girls, Women, and Crime.* Sage Publications, 2003.

Codd, Helen. *In the Shadow of Prison: Families, Imprisonment and Criminal Justice.* London: Routledge, 2013.

Corston, Baroness. *Corston Report—Review of Women with Vulnerabilities in the Criminal Justice System.* 2007.

Council of Europe et al. *SPACE 1—Prison Populations Survey 2015.* Council of Europe, 2017.

Crawley, Elaine. "Emotion and Performance; Prison Officers and the Presentations of Self in Prisons." *Punishment and Society*, 2004, vol. 6, no. 4. pp. 411-427

Donson, Fiona, and Aisling Parkes. "Changing Mindsets, Changing Lives: Increasing." *Irish Family Law*, November 2012, pp. 408-413.

Enos, Sandra. *Mothering from the Inside: Parenting in a Women's Prison.* 2001.

Epstein, Rona. "Mothers in Prison: The Sentencing of Mothers and the Rights of the Child Making This Research Possible." *Howard League What is Justice? Working Papers 3.* December 2012, 1-33.

Gabel, Katherine., and Denise Johnston. *Children of Incarcerated Parents.* Lexington Books, 1995.

IPS, Irish Prison Service. *Annual Report.* Irish Prison Service, 2016.

Irish Constitution. The Stationary Office, 1937.

Irish Examiner. "Judge Sentences Mother of One to Year in Prison over Death of Dale Creighton," Jan. 2017, https://www.irishexaminer. com/breakingnews/ireland/judge-sentences-mother-of-one

-to-year-in-prison-over-death-of-dale-creighton-773665.html. Accessed 3 Dec. 2018.

Kesteven, Sue. *Women Who Challenge: Women Offenders and Mental Health Issues.* NARCO, 2002.

Martyn, Michelle. *IPRT Briefing on Women in Prison in Ireland.* Irish Penal Reform Trust, 2017.

Masson, Isla M. "The Long-Term Impact of Short Periods of Imprisonment on Mothers." King's College London, 2014.

Ministry of Justice et al. *Offender Management Statistics Quarterly: October to December 2016—GOV.UK.* Ministry of Justice, 2017.

Ministry of Justice, National Offender Management Service (NOMS) Women and Equality Group. *A Distinct Approach: A Guide to Working with Women Offenders.* Ministry of Justice, 2012.

Minson, Shona, et al. *Sentencing of Mothers: Improving the Sentencing Process and Outcomes for Women with Dependent Children.* Prison Reform Trust, 2015.

Moore, Linda, and Phil Scraton. *The Incarceration of Women : Punishing Bodies, Breaking Spirits.* Palgrave Macmillan UK, 2014.

O'Hara, Kate, and Mary Rogan. "Examining the Use of Community Service Orders as Alternatives to Short Prison Sentences in Ireland." *Articles*, vol. 12, 2015, pp. 22-45.

O'Malley, Sinead. "'A Mother Is Serving Her Sentence ... in Her Head, Outside as Well as Inside': Motherhood and the Irish Prison System." Unpublished Masters Thesis, National University of Ireland, Galway, 2013.

O'Malley, Sinead. "Commentary: The Plight of Women in Prison." *FRONTLINE The Social Work Action Network Ireland Bulletin*, 2015, pp. 7-8.

O'Malley, Sinead. *Motherhood, Mothering and the Irish Prison System.* Dissertation. National University of Ireland, Galway, 2018.

O'Malley, Sinead, and Carmel Devaney. "Maintaining the Mother-Child Relationship within the Irish Prison System: The Practitioner Perspective." *Child Care in Practice*, 2015, vol. 22, no. 1, pp. 20-34.

O'Malley, Sinead, and Carmel Devaney. "Supporting Incarcerated Mothers in Ireland with Their Familial Relationships; a Case for the

Revival of the Social Work Role." *Probation Journal*, 2016, https://doi.org/10.1177/0264550516648393. Accessed 3 Dec. 2018.

O'Reilly, Andrea. *Matricentric Feminism : Theory, Activism, and Practice.* Demeter Press, 2016.

Padel, Una, and Prue Stevenson. *Insiders : Women's Experience of Prison.* Virago, 1988.

Poehlmann, Julie et al. "Children's Contact with Their Incarcerated Parents: Research Findings and Recommendations." *American Psychologist*, vol. 65, no. 6, 2010, pp. 575-598.

Prison Reform Trust. *Prison: The Facts.* 2013.

Quinlan, Christina. *Inside : Ireland's Women's Prisons, Past and Present.* Irish Academic Press, 2011.

Reilly, Judge Michael. *Inspector of Prisons Standards for the Inspection of Prisons in Ireland —Women Prisoners' Supplement.* 2011.

Roche, Richie. Changed by the Job—The Impact That Working in a Prison Has on Prison Officers. 2016.

Shamai, Michal, and Rinat Billy Kochal. "'Motherhood Starts in Prison': The Experience of Motherhood among Women in Prison." *Family Process*, vol. 47, no. 3, 2008, pp. 323-340.

The Guardian. "Inquest into Death of Prisoner after Giving Birth Finds 'Very Serious Matters.'" 21 Oct. 2016, https://www.theguardian.com/uk-news/2016/oct/21/inquest-into-death-of-prisoner-days-after-giving-birth-finds-very-serious-matters. Accessed 3 Dec. 2018.

UNCRC. *United Nations Convention on the Rights of the Child.* Children's Rights Alliance, 2010.

United Nations. *United Nations Rules for the Treatment of Women Prisoners and Non-Custodial Measures for Women Offenders (the Bangkok Rules).* UN, 2010.

World Prison Brief. *World Female Imprisonment List Women and Girls in Penal Institutions, Including Pre-Trial Detainees/remand Prisoners.* World Prison Brief, 2015.

Chapter 5

"No Girl Could Keep Her Baby": Depictions of Irish Mother and Baby Homes in June Goulding's Memoirs *The Light in the Window*

Charlotte Beyer

Introduction: A Midwife's Perspective

The poignant phrase "no girl could keep her baby" reflects the main theme of maternal loss and its inevitability, which June Goulding examines in her 1998 memoirs *The Light in the Window*. Goulding's autobiography explores the time she spent working at Bessboro, an Irish home for unmarried mothers, between 1951 and 1952,[1] and articulates a powerful social critique of the conditions she experienced there by paying witness to the experiences and treatment of unmarried and single mothers at the home, who were socially marginalized and stigmatized by the discourses of shame that defined Irish public life (Fisher). In recent decades, the complex subject of women's reproductive rights in Ireland has been debated in the media and by critics (Auxiliadora Pérez-Vides 77)[2]—a debate that has been further prompted by the serious questions raised in relation to the controversial practices used at mother and baby homes and Magdalen laundries. Recent novels, autobiographical writings, and films also explore the

harrowing stories of unmarried mothers and the loss of their babies and children in Magdalen laundries, mother and baby homes, and industrial schools.[3] As we shall see, Goulding's memoirs contribute in important ways to these debates around maternal rights, cultural silences, and shame. *The Light in the Window* has previously been discussed by critics as part of more general overviews of Irish maternity practices (see McLeod 119; Redmond); however, this autobiographical text should also be approached as an important piece of writing in its own right with significant gender-political ramifications. This chapter aims to redress this and argues that Goulding's book makes an important contribution to vital and ongoing debates in Ireland over motherhood and women's reproductive rights.

I specifically examine Goulding's representations of mothers without their children in *The Light in the Window,*[4] and argue that her book is centrally concerned with a specific maternity that has loss at its affective and thematic core. Through an examination of the social and cultural context of Goulding's memoirs, and an analysis of the depiction of mothers without their children through her own perspective as a midwife, this chapter demonstrates that her narrative pays particular attention to lives of childbearing women who were severely marginalized and stigmatized in Irish society at the time. Furthermore, Goulding's memoirs illustrate the critical potential of life writing: by foregrounding the experiences of marginalized mothers and insisting on the validity and significance of women's personal testimony, she exposes the repressive and oppressive social and cultural practices that have shaped and curtailed Irish unmarried motherhood. Goulding's role as midwife provides her with a unique perspective on the experience and embodiment of motherhood, which allows her not only to observe and experience those mothers and babies affected by enforced separation but also to engage with them emotionally.

1950s Ireland and Unmarried Motherhood

Goulding's book uses an autobiographical format to explore and expose the darker underside of history and culture as part of contemporary efforts to uncover and reveal long-standing injustices and inequalities in Irish society, here centrally focused around issues of motherhood and women's reproductive rights. Recent scholarship has investigated

the importance of autobiography as a significant but hitherto underresearched Irish literary tradition. Liam Harte's edited volume, *A History of Irish Autobiography* (2018), is an example of such recent critical efforts to explore and reclaim the genre. Moira J. Maguire's chapter in the volume explores the emergence in recent decades of a specific gender-political subgenre, which she calls "the Irish abuse survival memoir." Although Goulding's memoir is not a testimony of her own abuse, it importantly pays witness to the abuse of the Bessboro mothers; it documents her observations of abusive relationships and structures at the home and how she was traumatized by them. Goulding's autobiographical narrative presents a personal and subjective critical perspective of 1950s Ireland and its history and contributes to recent gender-political debates around the constructions of Irish femininity and sexuality. Critic Clara Fisher recently argued that Irish postcolonial identity was predicated upon the assertion of "superior moral virtue" for women, and this emphasis on "sexual purity" resulted in the formation of the discourses of shame, which dictated definitions of motherhood and femininity in Irish public life and lead to institutions such as Magdalen laundries and mother-and-baby homes (Fisher). As a newly trained midwife working in constrained and challenging circumstances at Bessboro, Goulding assisted the mothers confined there in giving birth and then witnessed how they were forced to give up their babies—practices that were financially supported by the church and local authorities as Maria Luddy explains ("Unmarried Mothers" 115). Mother and baby institutions were underpinned by legal and religious discourses, as James M. Smith explains in his commentary on Ireland and the social castigation of unmarried motherhood in the 1930s: "In its concrete form Ireland's architecture of containment encompassed an array of interdependent institutions: Industrial and Reformatory Schools, mother and baby homes, adoption agencies and Magdalen asylums, among others" (209). Smith elaborates on how "With little or no social welfare system to fall back on, [an unmarried mother's] choices were limited to entering the country home[5], begging on the streets, or possibly resorting to prostitution" (208). The taboo surrounding unmarried motherhood was further underlined in Ireland's 1937 Constitution, which romanticized maternal devoutness, purity, and domesticity (Luddy, "Moral Rescue ", 121). Examining the insidious ways in which

these institutions rendered unmarried mothers social outcasts, James explains how mother and baby homes helped to conceal unwanted dimensions of Irish society, such as illegitimacy and crimes, including "incest and infanticide" (209). Placing young women and their children in these homes meant that they were "invisible" to the mainstream society, which presented itself as "Catholic and morally pure" (James 233). Thus, *The Light in the Window* offers a critical reflection on mid-twentieth-century Irish social and cultural conditions, and explores the ways in which these conditions affected women generally and unmarried mothers specifically.

Luddy's research on motherhood in Ireland throws light on the practices also portrayed in Goulding's memoirs; it draws attention to hitherto silenced areas of culture and the experiences and conditions of marginalized mothers. Historical analysis provides the broader picture in which Goulding's personal memoirs necessarily focus on subjective experiences. Commenting on the various functions served by mother and baby homes, Luddy explains how: "They offered 'respectable' society the promise of freedom from contamination, not only for the inmates but also for the wider community. They also offered ... the possibility of regaining her reputation by returning to society with her 'secret' intact" ("Moral Rescue" 117). Smith emphasizes the importance of feminist historians' research into this subject and notes the contribution this work has made to uncovering maternal oppression in Ireland, such as investigating the constructions of "Catholic notions of sexual morality" and their impact on the stigmatization and "oppression" of single mothers (Smith 210). Neither mother nor child were deemed eligible for rights as citizens, and the child would continue to bear the stigma of illegitimacy (Luddy, "Moral Rescue" 123). Commenting on this social marginalization and invisibility, Linda Clarke argues that "In the eyes of the state these mothers do not exist, as they operated outside the law of the father and transgressed the sexual taboo" (3). In examining the experiences of these mothers, Goulding's book powerfully critiques Irish society's hypocritical tendency to apportion the blame for pregnancy and the responsibility for the consequences on the mother, without any consideration of the father's implication.

The stigmatized reality for unmarried mothers stands in sharp contrast to, but is not separable from, the romanticized maternal and

feminine image of Mother Ireland traditionally associated with Irish national identity (Clarke 1) (see also Beyer 2017).[6] As Goulding's memoirs show, the premise of the mother-baby home is not to celebrate the sanctity of the mother-child bond but the enforced separation of mother and child. According to Clarke, "Mothers ... evidently do not have a position in the constitution. This is borne out by the huge number of reported cases of child and identity theft at the hands of the church and state" (3). Goulding's memoirs confirm this, as they repeatedly depict the traumatic removal of babies and children from their mothers at Bessboro, a process Clarke describes as "child and identity theft" (3). In her examination of the portrayal of maternal characters in fiction, Marianne Hirsch makes a point about this kind of enforced removal which is relevant also to Goulding's memoirs, stating that "the bond between mother and child is subordinated to another order which has political primacy, but which is both emotionally and morally questionable" (37). The imagery of Mother Ireland was, thus, upheld and politically leveraged in ways that forced unmarried mothers to be incarcerated in homes and give up their babies, who were either adopted or sent to orphanages. The tension between the matter-of-fact tone of Goulding's narration and the shocking facts she recounts adds to the sense of authenticity in the narrative and demands the reader's critical and emotional engagement.

Goulding's personal narrative and first-person storytelling voice present a subjective emotional perspective on an oppressive and highly gendered social and cultural situation, and add a vital presence to those mothers who would otherwise remain vilified, invisible, and unheard. The complex realities of Irish women's experience of sexuality and motherhood starkly contrast with idealized and stereotypical constructions of maternal identity, and these dimensions are communicated through Goulding's memoirs in ways that allow the reader insight into, and empathy for, the unmarried mothers. This educational or didactic capacity is an important aspect of life writing, as Grubgeld acknowledges. She argues that "[a]utobiographical self-representations exist in a mutually influential relationship with the conversation, politics, private writings, and even architecture, material culture, and domestic practices of a society" (xi). This social and cultural dimension of life writing is also remarked upon by Grubgeld, who notes that "The autobiographers of Anglo-Ireland situate their life

stories within what most see as the story of their culture" (xi). However, the specific story of Ireland's culture that Goulding focuses on in *The Light in the Window* is the repressed narrative of maternal oppression. To counter this repression, Goulding situates her narrative in the context of her Irish culture through her careful accounts of the individual mothers' backgrounds and circumstances, which acknowledge their individual uniqueness while also engendering an understanding of the shared loss these mothers face. As Elaine Tuttle Hansen states: "The story of the mother without child frees us, experimentally and provisionally, to focus on the mother, and in doing so to see her as a multifaceted and changeful subject" (22). Goulding's autobiographical account is situated within the historical and cultural context in which she acted, and the narrative techniques she uses intentionally foregrounds those perspectives silenced within that context.

Goulding's memoirs reflect the way women have used the genre to examine previously unheard aspects of individual and collective experience, as argued by Sidonie Smith and Julia Watson who state that "Autobiography has been employed by many women writers to write themselves into history" ("Introduction" 5).[7] She uses the term "witness" to describe her autobiographical Bessboro testimony, as she observes the enforced removal of babies and children from their mothers: "I witnessed the usual ritual of Germaine walking down the long corridor and crying onto her baby's downy hair. She returned, empty-handed, to the nursery, her eyes red and swollen from crying. All the other girls feeding their babies started to cry, and some of them reached out to hug her" (84). This powerful passage describes Germaine, one of the young unmarried mothers, after having to give up her baby and how her abjection is mirrored in the tears shed by her fellow inmates, whereas Goulding is positioned as witness, reporting through affective vocabulary, such as "empty-handed." Goulding's observations in this passage are rendered all the more acute due to the repetitive nature of the traumatic separations she regularly witnesses throughout the book. Her anecdotal stories repeatedly explore the themes of loss and the trauma of mothers being forced to give up their babies—thereby examining the affective position of mothers without their children and exploring the limitations of literary language and narrative employed to convey these themes. These insights evoke Cathy Caruth's critical exploration of trauma and its representation: "We can

also read the address of the voice here, not as the story of the individual in relation to the events of his or her own past, but as a story of the way in which one's own trauma is tied up with the trauma of another" (8). *The Light in the Window* stands in challenge to the publishing trend that markets memoirs as reading material for "niche audiences" (Smith and Watson "Reading Autobiography" 127). Rather, Goulding's midwife memoirs offer a form of life writing that is specifically woman centred and promotes increased visibility to the diverse experiences of motherhood. Furthermore, recent examples of "midwife memoirs" include Jennifer Worth's *The Midwife: A Memoir of Birth, Joy, and Hard Times* (2009) which has been televised as the popular BBC series *Call the Midwife*; Patricia Harman's *The Blue Cotton Gown: A Midwife's Memoir* (2008); and Cara Muhlhahn, *Labor of Love: A Midwife's Memoir* (2010). Through Goulding's recollections of a previous historical era, readers are given insight into latter-day practices at Bessboro and the desperate position of the women and girls who were regarded as "fallen".

Goulding's social critique is articulated through the observed perspective and experience of mothers on the periphery of society, and it employs autobiographical strategies to bear witness. This connection is made specific from the moment the book opens through Goulding's dedication to "all those thousands of unmarried mothers and their babies who were incarcerated in that horrendous Home, especially those it was my privilege to nurse in 1951-2." She explains that her inspiration to write the book came via prompting by one of the young women at Bessboro who asked her to tell the outside world about their stories, since they themselves were not in a position to do so (Goulding 77). Her anecdotal narrative structure enables her to mesh her own experiences with those of other women, which creates a sense of affective continuity and solidarity among women. This solidarity extends to emotional identification, as Goulding's anecdotal style reflects the technique of giving a voice to many different women's stories, but, in the case of many of the stories, it is done without closure, which invites imaginative and emotional engagement with the material and the characters and situations depicted, prompting further critical reflection. *The Light in the Window* combines Goulding's development narrative with the unmarried mothers she encountered there. Her anecdotes are loosely tied together with her own more conventionally linear narrative, ending with her wedding to her fiancé

Pat and leaving her employment at Bessboro. Her memoir, thus, demonstrates the challenges of writing about issues of motherhood and birth with limited agency, and in a context of mothers being deprived of their children.

Goulding's memories and recollections are used to depict the plight of Irish unmarried mothers deprived of their children, thereby striving to challenge social perceptions and promote change. *The Light in the Window* highlights the importance of historical and cultural change in the way motherhood is viewed, and promotes it both through this retrospective narrative perspective and through the contrast between the main body of the memoirs and the postscript. The epilogue brings further clarification of Goulding's motivations for writing her memoirs. Here, she explains that she felt an obligation to share the stories of the mothers in the Home with the wider world as a testimony to the experiences and silenced traumas of those mothers. Commenting on the significance of her solidarity towards the Bessboro mothers, Goulding concludes "I have kept my promise" (204). This nurturing woman-centred focus of the memoir is foregrounded by the author's acknowledgement of the assistance and support from other women she received at various stages throughout the process of writing *The Light in the Window*—from an old school friend who helped to type up the manuscript, to her daughter and husband, and her editor at Poolbeg Press. Using autobiography to counter the discourses of shame, Goulding's sense of solidarity with the unwed mothers carries no judgment or sense of privilege; instead, she intentionally uses her autobiography to speak out on their behalf. Her autobiographical voice and her role as midwife, thus, place her in a unique narrating position, which is crucial to the effect of her memoirs.

Affective Writing and Social Critique: Mothers Without Their Children

The motif of the mother without her child is a central thematic orientation point in Goulding's *The Light in the Window*, and is employed to explore affective aspects and to expose the hypocrisy of her contemporary society. On the surface, the idea of a mother and baby at home suggests an exclusive maternal environment seemingly centred on maternity, yet it transpires that its ultimate purpose is to completely

break down and deny the mother-baby bond. The premise of Bessboro, and other Irish mother-baby homes, is to separate mothers from their babies and to make it impossible for them to ever reunite. The devastating nature of the mother-child separation is thus magnified by its finality. On arriving at the Home, Sister explains to June that the mothers "stayed in the Home after the birth and worked there until their babies were three years old. The children were then fostered and the mothers were free to go" (Goulding 16). The hypocrisy inherent in this contradiction underlines the definition of unmarried mothers as unworthy of their children. In the memoir, Goulding reflects on her ambivalence towards the inhumane and hypocritical system of which she is a part and the contradictory feelings she experiences due to her identification with the mothers and their loss. She reports that she is gladdened by the news of the adopted babies securing good homes (Goulding 148), but is sad and angry on behalf of the mothers whose invisibility and silence are cemented by this system: "the mother that bore and loved him for three long years had to let him go and then be cast out into a society that was uncaring and judgmental of her plight" (Goulding 148).

In *The Light in the Window*, the midwife's unique position enables a subjective perspective on the process of childbirth and the representation of mothers without children. This reconsideration of women's personal and collective history includes the task of exploring representations and roles of mothers and maternity. Commenting on this task, Grubgeld argues that "[w]riting the unwritten mother is a difficult accomplishment" (95). The midwife motif furthermore aligns the narrative with Irish culture and mythology. Goulding's intense focus on motherhood and birthing implicitly draws on the significance of the motif of the birthing woman in Irish mythology—the Sheela-na-gig. According to Michele Lise Tarter, the Sheela-na-gig goddess and the mythology she derives from "embodies ages of oral narratives that could never be told by women, due to patriarchy's historical erasure and/or control of the subject of childbirth in literary discourse, ultimately reflecting the social guards placed upon women's bodies, women's sexuality, women's procreative power, and women's voices" (Tarter 19). Goulding's midwife role gives her a unique perspective on the experience and embodiment of motherhood and birth, and furthermore allows her not only to observe but also to identify

emotionally and physically with those mothers whose children were taken from them. Her character is central to *The Light in the Window*'s interrogation of femininity and motherhood, mediating between the claustrophobic and oppressive isolation of the home and the wider social sphere. To the unmarried mothers, and to Goulding herself, the external world appears to offer agency and privilege for women. For Goulding, these privileges include a fiancé and the promise of marriage and social status. However, as the position of the unmarried mothers illustrates, such privileges are deceptive and precarious. Once inside Bessboro, the mothers' individual identities are erased through the discourse of sexual deviance used to justify their treatment. One girl says, "We all have different names here, but Sister says we are all the same and it was the same thing that landed us in here. We have to stay here for three years and then part with our babies" (Goulding 25). This institutional erasure of individual identity and the social denial of maternal agency and authority extend to Goulding herself who at one point bitterly exclaims: "I felt that I had wasted my time in this place. I was powerless to help anyone—powerless to change even one of the inhuman rules" (201). The book demonstrates the contrast between Goulding and her careful, conformist courtship, conventional engagement, and eventual marriage, and the tragic lives of the girls in the home. This contrast serves to highlight the arbitrariness of female respectability and the precarious nature of maternal agency and self-determination for Irish women.

The examination of images and stories of mothers without their children is at the heart of *The Light in the Window* and the book's critique of past cultural practices and their impact on mothers. Based on her observations at the home, Goulding defines the mother-baby bond as singular and exceptional in its intensity and wholeheartedness: "The only expression of love I witnessed there was between each mother and her child.... Mother and child were alone and together for at least ten days, at most three love-packed years until the final and inevitable parting forever—amputation without anaesthetic" (Goulding 42). The affective language used by Goulding underlines the pain of separation inevitably tied to maternal love at the home, and the physical and emotional abjection resulting from the enforced separation of mothers from their children. Irene, Goulding's "girl Friday" who looks after her at the home, is herself one of the unmarried mothers who stands to

lose her loved child at the end of the three-year period. Looking distressed, she explains to Goulding that her three-year-old son over in the convent will soon be leaving (Goulding 35). Observing Irene's grief at having to be imminently parted from her son, Goulding is reminded of a previous incident of maternal devastation and separation that she witnessed at the home, when a nine-month-old baby girl, Assumpta, was taken from her mother: "I could still hear her mother's screams. And now to think that Irene had to be parted from her little boy of three years—it was a double-edged tragedy" (74). Goulding knows that the mothers are given no information of where their children are going and that the children would have no way of finding their birth mothers later in life (74).

Through her empathetic accounts of maternal loss, Goulding incorporates a powerful element of social critique. This critique is carefully placed in its specific historical context, as we see in the story of baby Assumpta and in Goulding's powerful depiction of maternal loss. She describes how Assumpta's mother screamed uncontrollably as her beloved daughter was carried off, knowing that she would never see her again. Goulding drily concludes: "I had witnessed the horrific ritual that would be repeated for each and every mother in this hellhole. But this was Ireland in 1951" (Goulding 39-40). Assumpta's mother's agony and her deep distress, which later results in her refusing to eat, are mirrored in Goulding's own emotional response. However, it is the depth of the former's pain and loss that remains unspeakable. "I could not even contemplate the depth of her mother's grief" (40), Goulding confesses, acknowledging the limitations of language and the difficulty of telling the story of the mother without her child.

Goulding's narration of the mothers' stories both expresses and invites anger and social critique, as she reflects on specific aspects of the oppression and marginalization of mothers within the particular environment in which she works and within wider society. Her writing shows the intersections of class, race, and age that are rife at Bessboro. For example, the anecdote about Dympna, a woman in her forties who comes to Bessboro to have her baby, shows that it was not only young women who became pregnant and ended up in the home. Goulding reveals that she felt particularly sorry for older women who found themselves in this situation because in addition to having to relinquish their baby forever, there was little to no hope of ever having another

child within a secure relationship during their remaining reproductive years (Goulding 97). The emotional toll caused by maternal loss is evident in Goulding's later description of Dympna, whose body and appearance aged drastically following the trauma of being separated from her six-week-old baby daughter (Goulding 114). Other mothers' stories critique male-dominated patriarchal society—for example, the story of a young woman from a well-to-do background, Marie, who is raped following a party, and the parallel story of a fifteen-year-old girl from a farming family who had been sexually abused by the farm hand. Goulding's book critiques a contemporary society that turns a blind eye to rape, blames the victim for her own misfortune, and leaves her to face motherhood alone—only to be separated from her child forever. Furthermore, Goulding reflects on the stigma suffered by women who had been taken advantage of by married men who had made promises to them in order to have sex (Goulding 118) and the racist abuse suffered by those mothers who had slept with black men. All of these women are subjected to inhumane treatment and are ultimately forced to endure the loss of their babies forever.

The most disturbing and distressing parts of Goulding's book are those dealing with maternal loss and abjection. These affective episodes demand the reader's uncompromised engagement with the narrative and with the plight of the characters it presents. Goulding recalls a painful episode that illustrates the depth of the physical and emotional bond between mother and baby. Goulding is sent to Dublin with a four-month-old baby girl who was to be adopted. During the journey, Goulding discovers that she cannot bottlefeed the distressed baby because the infant was used to exclusive breastfeeding. The episode focuses on Goulding's sense of powerlessness and despair at the baby's deprivation and unmet need: "That little baby girl's cries were still being replayed in my mind, and I could not help wondering how the hungry little thing was managing" (128). Goulding's emotional response underlines the inhumanity of the system with which she was forced to cooperate, as well as her identification with both the mothers and their babies. This episode illustrates the agony of enforced separation of mother and baby, and the lack of empathy in a system that disregards the humanity of both. The mother is treated as a vessel and the baby as a commodity to be traded. This maternal perspective is partially displaced in Goulding's narration, with her mediating the

marginalized mother and her loss. Over and over in the memoir, Goulding reflects on the plight of those young mothers suffering the loss of their babies; they are "so vulnerable and alone and without hope" (156) and are left to face these traumatic experiences alone with no knowledge of what became of their children (156). Goulding's emotional identification with the mothers and their anguish is both physical and emotional: "I could not prevent myself from imagining the heartbreak of the natural mothers as their child was picked from the bunch" (65). Her depiction of this intense identification serves the purpose of humanizing the bereft mothers and creates a link of empathy between the reader and the experiences Goulding mediates.

Another emotionally wrought episode focuses on a young mother, Germaine, and her premature baby, Tony. When baby Tony was later sent out to foster care, Goulding's description of Germaine's distress on parting with her baby once again reveals the callousness of the regime at Bessboro. Germaine later gets her son back, after the temporary foster mother is found to have neglected him. However, for Goulding the question remains whether getting her son back ultimately made things worse, as she knew they would have to separate for good when he turned three (85). Sadly, Goulding's postscript reveals that the mothers who lost their babies and children this way were unlikely to ever be reunited with them. She explains that following the publication of *The Light in the Window*, she was contacted by a man who was convinced he was Tony, and whose personal history resembled his. However, the loss and heartbreak experienced are shown to be absolute, as this man remained unable to trace his birth mother despite many attempts. Goulding's sensitive portrayals of maternal bodies giving birth, lactating, and expressing a range of complex emotions, from anger and jubilation to tenderness, grief, and solidarity, add further dimension to her depiction of the mothers she encountered at Bessboro. These complex and often conflicting depictions of mothers without their children are at the heart of *The Light in the Window*. Reflecting on the significance of the motif of the mother without her child, Hansen notes that "literature of trauma and recovery, the story of the mother without child provides us with images of victims, survivors, and witnesses who model the possibility of alternative stories and call in turn for an alliance of creative, generous listeners" (239). This insight also echoes Caruth's observation about encountering

the other through trauma: "It is this plea by an other who is asking to be seen and heard, this call by which the other commands us to awaken" (9). As the midwife narrator, Goulding serves as the mediator between the mothers and the reader; she communicates their plight and engenders a sense of empathy and solidarity with the silenced. The representation of previously "unwritten" and socially marginalized mothers, as in *The Light in the Window,* is an exceptional feat. Goulding must be commended for the creative and personal risks she took in writing these women's stories, as well as her own.

Conclusion: Finding a Voice

Through a reflective journey back to her own personal past as a midwife working at the Irish mother and baby home Bessboro, Goulding depicts the trauma experienced by single and unmarried mothers and the social and religious stigma of Ireland's postcolonial "politics of shame" (Fisher). Goulding's subjective reimagining of the autobiographical form incorporates those crucial features of revision discussed by critics Smith and Watson in their examination of women's life writing. They state that "women's autobiography [can be seen] as a previously unacknowledged mode of making visible formerly invisible subjects" (Smith and Watson 5). The powerful act of a woman telling her life story—rejecting silence and acquiescence and offering a strong social and cultural critique exposing wrongs and inequalities—is the foundation of women's autobiography. The stories of the mothers and babies at Bessboro were never meant to be shared in a public domain. When "hitherto unspoken female experience" is incorporated into autobiographical writing, it forces profound changes in both "the content and purposes of autobiography" through a feminist insistence on "alternative stories" (Smith and Watson 5-6), which presents a powerful challenge to existing patriarchal and religious cultural norms. Through her use of a unique personal narrative voice based on her memories and recollections, Goulding's autobiography accomplishes a subjective and affective critique of the social and cultural problems that continue to haunt Ireland and its conception of motherhood and female sexuality, and of the religious hinterland that formed the context for the depictions of mothers without their children in her book. Her anecdotal life writing mode illustrates how autobiography can have a

powerful affective impact and can promote social critique through insisting on the significance of women's lives and generating new possibilities for marginalized women's voices and experiences to be heard. Goulding links this purpose with an endeavour to heal from the trauma she witnessed and to find her own voice—thereby enabling her to negotiate the relationship between herself, the mothers without children whom she encounters, and wider society. As Smith and Watson state: "Writing and reading autobiography have long been regarded by psychoanalytic practitioners as instruments of healing, in the ongoing search to find and recognize one's story" (40). Using autobiographical writing, Goulding's memoirs give, as Maguire argues, "a voice to a generation of women ... who were silenced by church, state and society precisely at the time when they most needed to be listened to" (359). Goulding's compelling depictions of maternal abjection and anguish form a vital part of the book's critique of Irish social and political conditions and their detrimental and deeply damaging effect on women, particularly mothers, as well as the entire social fabric. Her memoirs undercut the discourses of shame surrounding the Irish mother-and-baby homes, enabling readers to see those mothers who inhabited the homes in a different light, to understand their plight, and to reconsider those historical value systems that vilified unmarried motherhood and sanctioned the removal of children and babies from their mothers.

Endnotes

1 The title quotation is taken from Goulding's *The Light in the Window*, 37.

2 See Corless's research on the St. Mary's Mother and Baby Home in Tuan, Ireland, which revealed a mass grave of babies and children, described in Gentleman, also in Duncan.

3 See for example the film *The Magdalene Sisters* (2002) and the life writing volume, *Whispering Hope: The True Story of the Magdalene Women* (2016).

4 John McLeod also references Goulding's memoirs and its depiction of unmarried mothers in his book *Life Lines: Writing Transcultural Adoption*, 119.

5 "Country home" here is another term for mother and baby home—an institution set up for pregnant unmarried or single women. The girls and women would stay at the home during their pregnancy and birth, typically carrying out manual work. Their babies would be taken away for adoption, but many babies also died (see Hickey).

6 See also my discussion of Mother Ireland in relation to the Irish author Deirdre Madden's novel, *One by One in the Darkness*.

7 Feminist critics examining the significance of women's life writing include Brownley, Watson and Kimmich, and an Irish-specific volume by Lynch.

Works Cited

Beyer, Charlotte. "Their Mother Was Waiting For Her": Mother-Daughter Relations and Irish Identity in Deirdre Madden's One by One in the Darkness. *Mothers and Daughters*, edited by Dannabang Kuwabong et al., Demeter Press, 2017, pp. 234-250.

Brownley, Martine Watson, and Allison B. Kimmich, editors. *Women and Autobiography*. Scholarly Resources Inc., 1999.

Caruth, Cathy. *Unclaimed Experience: Trauma, Narrative and History*. John Hopkins University Press, 1996.

Clarke, Linda. "Mother Ireland ... the Myth." Paper given at Literature & Psychoanalysis in Dialogue, 9 November 2013. ICLO-NLS—Irish Circle of the Lacanian Orientation.

Costello, Nancy, et al. *Whispering Hope: The True Story of the Magdalene Women*. Orion, 2015.

Duncan, Pamela. "Mother and Baby Homes Commission to Begin Work." *Irish Times*, 19 February 2015, https://www.irishtimes.com/news/social-affairs/mother-and-baby-homes-commission-to-begin-work-1.2110150. Accessed 14 July 2016.

Fisher, Clara. "Philosophy in the Contemporary World: Women's History and the Politics of Shame in Ireland." *Blog of the APA*, 2 Aug. 2017, https://blog.apaonline.org/2017/08/02/philosophy-in-the-contemporary-world-womens-history-and-the-politics-of-shame-in-ireland/. Accessed 4 September 2017.

Gentleman, Amelia. "The Mother behind the Galway Children's Mass Grave Story: 'I Want to Know Who's Down There.'" *The Guardian.* 13 June 2014, https://www.theguardian.com/world/2014/jun/13/mother-behind-galway-childrens-mass-grave-story. Accessed 14 July 2016.

Gillies, Midge. *Literary Biography.* Cambridge University Press, 2009.

Goulding, June. *The Light in the Window.* London: Ebury Press, 2005.

Grubgeld, Elizabeth. *Anglo-Irish Autobiography: Class, Gender, and the Forms of Narrative.* Syracuse, New York: Syracuse University Press, 2004. Print.

Hansen, Elaine Tuttle. *Mother Without Child: Contemporary Fiction and the Crisis of Motherhood.* University of California Press, 1997.

Harte, Liam, editor. *A History of Irish Autobiography.* Cambridge University Press, 2018.

Hickey, Kate. "What You Should Know about Mother and Baby Homes in Ireland." *Irish Central,* 11 Mar. 2017, https://www.irishcentral.com/news/what-should-you-know-about-mother-and-baby-homes-in-ireland. Accessed 20 July 2017.

Hirsch, Marianne. *The Mother / Daughter Plot: Narrative, Psychoanalysis, Feminism.* Indiana University Press, 1989.

Luddy, Maria. "Moral Rescue and Unmarried Mothers in Ireland in the 1920s." *Women's Studies,* vol. 30, 2001, pp. 797-817.

Luddy, Maria. "Unmarried Mothers in Ireland, 1880-1973." *Women's History Review,* vol. 20, no.1, 2011, pp. 109-126.

Maguire, Moira J. "The Irish Abuse Survival Memoir." *A History of Irish Autobiography,* edited by Liam Harte, Cambridge University Press, 2018, pp. 348-362.

McLeod, John. *Life Lines: Writing Transcultural Adoption.* Bloomsbury, 2015.

Mullan, Peter. *The Magdalene Sisters.* PFP Films Limited, 2002.

O'Sullivan, Majella. "'Extraordinary' Doctor Stood Up to Clergy and Closed Home." *Irish News,* 11 June 2014, https://www.independent.ie/irish-news/news/extraordinary-doctor-stood-up-to-clergy-and-closed-home-30344924.html. Accessed 14 July 2016.

Péres-Vides, Auxiliadora. "Gender, Deviance and Institutional Violence in Ireland's Magdalene Laundries: An Analysis of Two Filmic Representations of Abuse." *Teaching against Violence: Reassessing the Toolbox: Teaching with Gender; European Women's Studies in International and Interdisciplinary Classrooms*, edited by Ines Testoni et al., Central European University Press, 2013, pp. 77-91.

Redmond, Paul Jude. *The Adoption Machine: The Dark History of Ireland's Mother & Baby Homes and the Inside Story of How "Tuam 800" Became a Global Scandal.* Marrion Press, 2018.

Smith, James, M. *Ireland's Magdalen Laundries and the Nation's Architecture of Containment.* University of Notre Dame, 2007.

Smith, James, M. "*The Magdalene Sisters: Evidence, Testimony ... Action?*" *Signs: Journal of Women in Culture and Society*, vol. 32, no. 2, 2007, pp. 431-458.

Smith, Sidonie, and Julia Watson. "Introduction: Situating Subjectivity in Women's Autobiographical Practices.". *Women, Autobiography, Theory: A Reader*, edited by Sidonie Smith and Julia Watson, University of Wisconsin Press, 1998, pp. 3-52.

Smith, Sidonie, and Julia Watson. *Reading Autobiography: A Guide for Interpreting Life Narratives.* University of Minnesota Press, 2010.

Tarter, Michele Lise. "Bringing Forth Life From Body to Text: The Reclamation of Birth in Women's Literature." *This Giving Birth: Pregnancy and Childbirth in American Women's Writing*, edited by Julie Ann Tharp and Susan MacCallum-Whitcomb, Bowling Green State University Press, 2000, pp. 19-38.

Chapter 6

Protests and Plans: The Mothers of Compton Place Ragged School, 1850-1867

Laura M. Mair

Introduction

This chapter explores the experiences and testimonies of impoverished mothers in the mid-nineteenth century, concentrating on maternal responses to intervention within homes and families as well as, more specifically, to the removal of children. These themes are investigated in the context of the British ragged school movement, which arose in response to concerns about juvenile delinquency and child poverty. Prior to the Education Acts, destitute children learned to read and write in ragged school classrooms, taught by predominantly volunteer teachers. In April 1844, the existing schools for poor children in the metropolis were united upon the formation of the London Ragged School Union (LRSU); by 1860, London alone boasted 560 schools attended by 49,290 children ("Ragged School Union"). Many ragged school scholars had the opportunity to emigrate to Australia, Canada, or New Zealand. After the government withdrew its support for the scheme in 1849, the LRSU established the emigration fund to enable the practice to continue; 600 former ragged school scholars had immigrated to Canada alone by 1857 ("Ragged School Union—City of London").

Ragged schools offer fertile ground upon which to explore the responses of mothers to the early schooling efforts. Although ragged

school literature warned that the removal of children from their parents should be avoided, it nevertheless referenced "those who *must* be removed" for their physical or moral welfare (emphasis in original, Hall 59). Using the journals of Martin Ware, a ragged school superintendent, which cover a seventeen-year period (1850 to 1867), this chapter highlights the diverse nature of the relationships mothers formed with one teacher. The entries testify to the challenges mothers could face when engaging with child savers, and they demonstrate the stress placed on maternal morality and the silencing of mothers' voices in discussions surrounding their children's welfare. At the same time, the longevity of the journals provides rare access to how relationships evolved and developed over time, showing the possible malleability of the relationships forged between mothers and teachers. Finally, in analyzing individual testimonies, it is evident that mothers not only resisted or passively accepted intervention, but also sought out and utilized the aid offered. In *Heroes of Their Own Lives*, Linda Gordon observes that the households of single mothers have historically faced great economic hardship. She asserts that poverty was highly likely in cases where a male breadwinner was absent. In the context of her research on single mothers in Boston between 1880 and 1960, Gordon argues that the absence of a father made "neglect" inevitable (83). Such mothers, Gordon writes, struggled to fulfil the contradictory roles of both raising and providing for their children, and they were consequently caught in a "double bind," unable to fulfil either expectation (89). Given that ragged school children were qualified by their destitution, it is unsurprising that a large proportion of the children filling the classrooms hailed from female-headed households.

In the research of social control theorists, child savers, like ragged school teachers, are interpreted as dominating middle-class figures, uninvited and unwelcome in the poor's homes (Mahood; Platt). In *Policing Gender, Class and Family*, Linda Mahood writes that children were "the wedge used to prise open families," which indicates that poor families were the victims of interfering child savers (2). Similarly, in their expansive work on the discourse underpinning child-migration schemes, Shurlee Swain and Margot Hillel argue that the parents of poor children were demonized to legitimize intervention (30). Furthermore, the portrayal of poor parents in promotional literature is critiqued by Mahood and Barbara Littlewood. In the context of Scottish

child-saving discourse, they state that "the brutal father and the feckless mother" were recurring figures (549). Underlying the child-saving cause— and supported by such imagery—was the notion that intervention in the homes of the extreme poor was both a moral obligation and a societal necessity. In response to narratives that cast child savers as intervening agents, Louise Jackson argues that "the emphasis on rescue and reform as social control can be misleading because it reduces the different vocabularies to one very fixed and inflexible one" (141). Gordon's research supports this statement, as she highlights the complexity of the relationships struggling mothers had with social services. In Gordon's estimation, Boston's single mothers were "not merely passive recipients of help, advice, or punishment, not merely manipulated, but also manipulators, active in attempting to get help" (83). Moreover, she asserts that even mothers deemed neglectful formed significant attachments to their offspring. On this issue, Gordon writes that "even incompetent mothers wanted to be with their children," and as a result often responded aggressively when their children were at risk of being removed (106). This chapter builds on Jackson's and Gordon's work by focusing on the relationships that Compton Place mothers formed with the man responsible for intervention within their families. As Jackson shows, interpreting such relationships as top down does not sufficiently reflect the diversity found in practice.

Child-saving literature provides ample descriptions of "feckless" mothers, yet it does not give space to their testimonies. Such depictions distract from the genuine angst mothers felt at the removal of their children. The absence of women's voices limits understanding of maternal experiences and confines the narrative to the words of the predominantly middle-class child savers. In response, this chapter shifts the focus from the child savers to the mothers they encountered. By drawing on the diverse responses of mothers in one ragged school community, the fragments of which are contained in Ware's journals, this chapter highlights the importance of mothers' testimonies as well as the value of microhistory more broadly as a means by which to access such voices. Ware's school journals present a decidedly richer picture of the character, experiences, and testimonies of poor mothers than those found in ragged school literature. His meticulous journal keeping makes it possible to trace his relationships with families over

time. The seven bound and marbled journals allow snatches of Ware's conversations with both parents and children to be grasped. As a qualified barrister, Ware composed thorough, well-researched entries that frequently convey the sense he was constructing a case either in defence or prosecution of the individuals concerned. The entries evidence Ware's own middle-class interpretation of situations while also giving access to the words of poor mothers in the community. Although he was often content to paraphrase the words of those he spoke with, particularly emotive or significant exchanges, Ware made a point of preserving the words as he recalled them, segregating them from his narrative within quotation marks. His meticulous organization—most apparent in his marginal cross-references—and tendency to assess credibility, both traits crucial to his profession, culminate in a rare account of the ragged school teacher's work and how it impacted local families and, of most relevance here, how local mothers responded to and interacted with such figures.

This chapter begins by focusing on two cases in which mothers had their children removed. In both cases, the circumstances instigating Ware's intervention are explored and the responses of the mothers, both in actions and words, are analyzed. Following this, the chapter moves to investigate the various ways mothers utilized the aid Ware could offer.

"Though He was in the Queen's Palace": Protesting Mothers

My analysis draws on the experiences of two Compton Place mothers, Mrs. Hart and Mrs. Smith, who both had children taken into the school's refuge against their will. It is important to note that few women Ware encountered were as vocal and demonstrative as the two touched on here. This chapter focuses on these women because of the richness of Ware's entries regarding them. The voices of other, perhaps more amenable, women are less prominent in Ware's journals. It could be concluded that Ware's exchanges with Mrs. Hart and Mrs. Smith affected him more. Alternatively, given Ware's legal training, it is possible he was inclined to record difficult or confrontational events in greater detail with the expectation that he may need to return to the entry in the future.

When Ware visited Mrs. Hart on 13 February 1853, he noted that the family resided in a "very untidy room" before adding that Mrs. Hart herself was "in a very stormy state of mind." It is worth referencing here Leonore Davidoff and Catherine Hall's observation that nineteenth-century middle-class domestic ideology dictated mothers "should regard good domestic management not as degrading but as a moral task" (183). Ware's description suggests that Mrs. Hart deviated from this maternal ideal. From the concise nature of this entry, it appears that the untidiness of both Mrs. Hart's residence and her mind concerned Ware. It seems to have been more than a passing visit, as Ware noted they discussed her hometown of Killarney (13 Feb. 1853). Like many residents in the Compton Place area, Mrs. Hart was an Irish migrant. Unlike a large number of the mothers Ware engaged with, however, Mrs. Hart's husband, "Old Hart," resided with her. Yet Ware's entries indicate that their marriage was less than harmonious. For instance, in July 1853, Ware recorded an exchange in which Mrs. Hart pleaded with him "not to lend her husband any more money," afterwards adding with reference to her spouse: "He has before now performed the same kind office towards her." At the time of Ware's visit in February 1853, only one of the Harts' three sons resided with them. Their two eldest boys, William and James, immigrated to Australia in 1852 with financial support from the LRSU (6 Jun. 1853). By March 1853, the Harts had not heard from their two emigrant sons since their initial letter in June 1852, which had stated that they were "well & comfortable" (26 Jun. 1852).

Just two weeks after discussing her hometown with Ware, Mrs. Hart "came to the door of the school as drunk as a sponge." When describing the scene, Ware detailed that she "clamoured against me for 'taking her boys away from her'" (Ware's emphasis). The situation was only resolved when a passing police office ordered her "to move on!" Across his journals, Ware utilized underlining as a tool to convey either emotion or emphasis, **suggested here by italics,** yet his precise reasons for underlining words are often ambiguous. In this case, it is difficult to discern whether he was indicating the force with which Mrs. Hart spoke or his own indignant response to the accusation. Later the same evening, Mrs. Hart's husband also visited the school to articulate similar concerns about their children. From Ware's entry, it appears that he was decidedly more civil than his wife had been. According to

Ware, "Old Hart came in & sat down" confiding that "he is anxious about his emigrant boys." Like his wife beforehand, Ware noted that Old Hart was drunk. He closed the entry with the exclamation: "How thankful I should be if he & his wife or either of them would take the 'pledge'!" (6 Mar. 1853). Ware's overriding concern regarding the moral failings of the Harts is manifested in his closing the entry by bemoaning their drunkenness rather than referencing the cause of their worry.

On 19 July, the Harts' fears were confirmed when Ware received a letter from their sons' employer in Australia stating that they had "run away." Twelve days later, Mrs. Hart again vocalized her grief upon the school doorstep. In Ware's emotive words, "Mrs. Hart came to the school & lamented about her boys." Just as he had earlier noted her "stormy state of mind," his use of the word "lamented" points towards Mrs. Hart's emotional anguish. In his note that Mrs. Hart "lamented about her boys," Ware recognized that her behaviour stemmed from grief. Once again, he identified drink as an influencing factor, as he closed his entry with the observation that "She was not more than *half drunk*" (Ware's emphasis, 31 Jul. 1853). Whether Ware deemed Mrs. Hart's drunkenness a cause of grief or vice versa is unclear; nevertheless, his entries indicate that as had been the case in March, Mrs. Hart's distress at her separation from her sons was most audibly communicated when she had been drinking.

Young John Hart may well have been in the building on the two occasions that his mother conveyed her anguish at the school door. Living in the midst of the drama and drink in the Hart household, Ware surveyed John's welfare during school hours. He spoke with him in August and commented on the fact that he, like his home, was "untidy." John responded by informing Ware that "he has only one shirt" (7 Aug. 1853). In January 1854, Ware wrote that he had put John forward for a prize from the LRSU because of his good attendance record. Ware's concern for the boy's wellbeing is discernible in his accompanying note that "He says he should like a pair of boots—that it is no use giving him books, for his mother sells them all for drink." Just as Mrs. Hart fell short of the maternal ideal in her housekeeping, she similarly failed to clothe her son. It is noteworthy, however, that it was Mrs. Hart's drinking rather than her husband's that was cited as young John's main concern. At the close of this entry, Ware exclaimed

"Poor boy! [W]hat is to be done with him" (15 Jan. 1854).

On 8 January, Ware recorded "I have induced Hart to leave his father & mother & go to the Shoeblack Dormitory. He has promised to go on Tuesday." He closed the entry with an explanatory comment: "I think it is impossible that he should improve while he is living with his parents." Such a brazen approach seems to have been unusual for Ware, as he recorded few cases in which he advised a child to leave their parents. Evidently, he believed the physical and moral risk John faced—from both poverty and his parents' drunkenness—necessitated his removal from the family home.

The following week John returned to the school and informed Ware that "his father will not let him go away from home." It is striking that there was no mention of Mrs. Hart's feelings on the matter. The absence of Mrs. Hart's words should be interpreted in the light of the premium placed upon the male head of the household, certainly among the middle class. As Leonore Davidoff and Catherine Hall have observed in relation to middle-class households, mothers and children were subsumed under the father's authority. Ware then visited the Harts and "urged" them to permit John to stay in the school dormitory (11 Mar. 1854). His entry detailing this visit is noticeably concise. Significantly, his account of the visit does not reference the response of either Mrs. Hart or her husband. From the immediately ensuing entries, it appears that the Harts steadfastly refused Ware's offers to accommodate their son in the dormitory, as for the remainder of the month, his references to the Harts were restricted to his own and Mrs. Hart's efforts to find John employment.

On 30 March, Ware noted his success in obtaining a position for the boy; however, he did not mention that John was being or had been relocated. Three days later, he wrote that "Mrs Hart accosted me & asked me where Johnny is—I would not tell her." He noted that Old Hart had also refused to tell her, yet "she was determined to find out." Ware then quoted Mrs. Hart, who had proclaimed her intention to "bring him home 'though he was in the Queen's Palace'" (2 Apr. 1854). This entry suggests that Ware had succeeded in obtaining Old Hart's consent to his son's removal. Mrs. Hart's memorable vow that she would find John "though he was in the Queen's Palace" powerfully encapsulates her fierce resolution to be reunited with her son. For Ware, Old Hart's authority overrode his wife's objections, while Mrs.

Hart's response illustrates her objection to the authority of either Ware or her husband. Furthermore, this exchange demonstrates her belief that poverty did not justify the removal of her child. To Mrs. Hart, the offer of luxury for her son elsewhere did not trump what she could provide as a mother. True to her word, Mrs. Hart succeeded in finding her son's workplace. Six weeks after telling Ware that she "would bring him home," Mrs. Hart visited John's workplace and "made a row" with his employer. Shortly afterwards, John left his employer (14 May 1854).

Ware made little mention of the Hart family until June 1855, over a year later, when he was preparing for John's immigration to Canada. He tellingly noted that "His father gave a written consent to his departure" (9 Jun. 1855). Again, Mrs. Hart's voice was missing from Ware's journal entry. Her consent—whether it was given or withheld—was nullified by that of her husband. In accordance with her previous response to such circumstances, Mrs. Hart made her presence known at the school door. Just as a police officer was required to order her to "'move on!'" in March 1853, assistance was again needed. Ware described how another child's father "came in rather tipsy but very friendly; and did good service afterwards by defending the door against Mrs Hart who was still tipsier and tried to effect an entrance" (19 Aug. 1855). Following this, Ware did not reference Mrs. Hart until an entry in May 1857 in which he related that "Mrs Hart says her two sons from Australia have sent her some more money & are coming home—probably now on the way" (17 May 1857).

As Ware's contact with Mrs. Hart waned, Mrs. Smith, a single mother of two children, emerged as a similarly prominent figure in his journal entries. On 30 December 1860, Ware recorded that John Smith's mother had pawned his jacket. The day before, the Morning Chronicle had reported that the weather was "very severe" and the pavements in a "slippery," "very dangerous condition," and it is, therefore, unsurprising that Ware noted the necessity of him borrowing a coat ("The Weather and the Parks"). The Smith family situation did not improve the following year, as Ware observed in May that they had "been in great trouble." Pawning clothing evidently did not enable Mrs. Smith to meet her financial demands, as her landlord took "every bit of furniture that they have" to recoup unpaid rent (5 May 1861). As a consequence, the family was forced to sleep upon the bare floor. The

following week, the already desperate situation escalated into conflict. When Mrs. Smith's daughter, Margaret, refused to pawn her dress, her mother beat her severely. According to Margaret, her mother had beaten her "so much" that she "ran away & took refuge with Mrs Dale," a neighbour (12 May 1861). Shortly afterwards, Mrs. Dale brought Margaret to stay in the school dormitory. Perhaps Ware was recalling his encounters with Mrs. Hart on the school doorstep when he wrote the following Sunday that "Mrs Smith has been drunk very often this week and has annoyed the neighbours—but has not been to the school" (19 May 1861). In noting that she had not visited the school, Ware indicated his belief that her drunken state was related to the removal of her daughter.

The testimony of the neighbours is referenced a number of times in Ware's entries regarding Mrs. Smith. It was presumably "the neighbours" who had notified Ware of Mrs. Smith's drunkenness the week after Margaret left home. As was his usual practice when he suspected mistreatment, Ware began compiling a case by seeking the testimonies of others in the community. He spoke with two of Mrs. Smith's neighbours, Mrs. Drake and Mrs. Dale, as well as her landlord, Mr. Eldridge, to ascertain what they had witnessed. He summarized their testimonies in his journal: "They all argue that Mrs S has often cruelly ill treated Margaret—& that John has sometimes joined" (19 May 1861). In crossing out "ill" and embellishing the description with "cruelly," Ware stressed the strength of the local testimonies against Mrs. Smith. Despite such unflattering and condemning references, Ware noted that he had "interceded" with Mrs. Smith's landlord on her behalf and had succeeded in persuading him to allow Mrs. Smith and her son to remain (2 Jun. 1861).

Upon visiting the household just three weeks later, Ware found that Mrs. Smith was "very angry" with the landlord, complaining that he had increased the rent. When speaking with Ware, Mrs. Smith "said she would 'lame' John if he dared to pay it any more." In noting Mrs. Smith's use of the word "lame," Ware both communicated his discomfort at the threat and preserved the exchange for future reference. Just as he had commented upon Mrs. Hart's mental state earlier, he noted of Mrs. Smith that "She talked very wildly indeed" (23 Jun. 1861). As Gordon found in relation to single mothers in Boston, Mrs. Smith was trying and failing to both raise and provide for her



children. Although Ware did not expand upon how Mrs. Smith's behaviour or words warranted the term "wildly", the entry as a whole suggests Ware believed that the household's economic situation had negatively impacted Mrs. Smith's mental wellbeing and her ability to care for her children.

The following month John, like his sister before him, fled from his mother. Upon returning home from paying the rent, John found his mother had been drinking. Incensed that he had visited the landlord without her consent, Mrs. Smith threw a kettle at her son, who "took refuge" with a neighbour, this time a Mrs. Hudson (30 Jun. 1861). Next week, Ware found John at his legal chambers in Russell Square, a location that children or parents visited when in need of immediate assistance. John told Ware that his mother had lent money, the majority of which she had spent "in drink." When he returned home that evening, he had discovered her "mad with drink." Mrs. Smith's anger had patently not subsided, as she "threatened to cut off" John's head. John again sought refuge with the neighbouring Mrs. Hudson "who hid him" (4 Jul. 1861). The next day, Ware recorded that the "same scene took place between Mrs. Smith & John. The latter took refuge again with Mrs. Hudson, who sent for a policeman." Despite Mrs. Smith making it clear that she did not wish for her son to stay in the school dormitory, Ware arranged accommodation for him (5 Jul. 1861).

In the same entry in which he related Mrs. Smith assaulting her daughter, Ware gave space to the mother's own voice. After noting that Margaret had been "carried" to the refuge, Ware wrote "Mrs Smith is frantic about it." His use of the word "frantic" to describe Mrs. Smith's response to the removal of her daughter suggests he recognized her distress at the situation. Although her relationship with Margaret was, according to Ware's journals, a tumultuous one, she nevertheless patently desired to be with her. Moreover, Mrs. Smith's paraphrased words are preserved in Ware's account that she had been "talking about going to the magistrate and reclaiming her" (12 May 1861). By threatening to go "to the magistrate," Mrs. Smith, like Mrs. Hart before her, indicated her belief that her maternal rights were being infringed.

Mrs. Smith's feelings towards the school are further illustrated in Ware's journal entry on 26 May. Before fleeing his mother, John had served a short prison sentence for questionable behaviour in the street.

According to Ware, "Mrs Smith was in great trouble and raved about her hard lot in having two of her children in prison." In parentheses, beside this, Ware noted "(meaning *Margaret!* & John)" (Ware's emphasis). In combining both an exclamation mark with underlining, Ware expresses his disbelief that Mrs. Smith had likened the school to a prison. Again, Ware's account reveals Mrs. Smith's distress at her separation from her children. Ware's use of words such as "wildly," "frantic," and "raved" in association with Mrs. Smith shows the deep impact that the removal of her children—whether actual or threatened—had upon her.

The week after Mrs. Smith "raved about her hard lot," Ware wrote that she "seems to be calming down." He observed that she was "civil & satisfied" when visiting her daughter at the school refuge (2 June 1861). It is noteworthy that Ware commented on Mrs. Smith's behaviour and mental state on a number of occasions. In previous entries, Ware described her as being "mad with drink," "very angry," "frantic," and as talking "wildly with drink." Ware was seemingly perceptive to her mood and attuned to the stress that financial woes could cause, perhaps out of concern for her children. Moreover, Ware's entries indicate that both Mrs. Smith's neighbours and her landlord had questioned her capability as a mother. Five months before Mrs. Smith beat her daughter, Ware had a conversation with Mrs. Drake, who lived in the same building as the Smith family. Mrs. Drake confided her concerns to Ware that Mrs. Smith was not "right in her head." Ware concurred with this evaluation, adding "in which I quite agree with her" (19 Jan. 1861).

Although little is recorded of Margaret, Ware made a number of later references to John, and it is clear that he continued to have a problematic relationship with his mother. In October 1861, Mrs. Smith was "locked up for 5 days" for "annoying" John while he worked as a shoeblack in the street (27 Oct. 1861). The following year, John returned to stay with his mother; however, the old problems continued. In March 1863, John told Ware that his mother had "pawned many of his things, particularly a pair of trousers which he could not well do without" (22 Mar. 1863). By June, he had moved out again following a similar incident. When John visited the school two years later, he told his teacher that he sent his mother money each week. Notably, however, he also informed Ware that he "does not let her know where

he works or the lodging where he lives" (26 Nov. 1865). As a boy, John's refuge from his mother was facilitated by both neighbours and the local ragged school. This conversation reveals that John continued limiting, though not ending entirely, his mother's presence in his life. When she died in February the following year, Margaret and John visited Ware, who observed that Margaret was "dreadfully distressed" and John was "very much agitated." John told Ware that he was especially upset because upon visiting the morgue, he had not recognized his mother and kissed the wrong corpse (18 Feb. 1866).

Ware's entries regarding Mrs. Hart and Mrs. Smith relate both his ambiguity regarding their capability as mothers as well as their reaction to such concerns. There are a number of shared themes in the two cases explored above. Both women faced financial strain and were reliant on monetary aid or practical assistance. Mrs. Hart and her husband failed, in Ware's view, to adequately clothe their son, while Mrs. Smith struggled to pay the rent. In both instances, Ware overrode the mothers' feelings and disregarded their opinions in relation to the removal of their children. Furthermore, in each case the mothers responded to the removal of their children through drunkenness and public displays of anger. These entries powerfully support Gordon's observation that "even incompetent mothers wanted to be with their children" (106). Anger and grief are common to the stories of both Mrs. Hart and Mrs. Smith. Ware's emotive entries record the lamentations and "frantic" searching of both women upon the removal of their children, demonstrating the strong reaction of these two destitute mothers to intervention within their homes. A striking similarity is evident in Mrs. Hart's vow to find her son "though he were in the Queen's palace" and Mrs. Smith's assertion that she would go "to the magistrate." In these statements, both mothers asserted their maternal rights and rejected Ware's—and, in the case of Mrs. Hart, Old Hart's—claim to authority over their children.

"Having Started Her Boys in the World": Planning Mothers

Mrs. Hart and Mrs. Smith are not representative of all of the mothers that Ware worked with. Contrary to scholarship that depicts mothers and child savers as diametrically opposed, not all women rejected

intervention within their families (Mahood; Platt). Ware's journals demonstrate that many mothers welcomed or even instigated external aid. Confrontational encounters such as those described in the previous section, though memorable, were a minority in Compton Place. Ware's journals suggest that he fostered amicable and long-lasting relationships with a number of mothers, and it is clear that the support he and the school offered was appreciated by many. For instance, in October 1857, Ware recorded that Mrs. Spundley "expressed great gratitude to me for having started her boys in the world" and said that her sons "had been doing well ever since—which I was glad to hear" (25 Oct. 1857). As in the example of Mrs. Spundley, Ware's entries suggest that the school and its teachers were a valued source of aid to many mothers.

Ware's entries reveal that he regularly provided financial assistance to households facing extreme destitution. Despite the LRSU's advice to the contrary, Ware frequently gave or lent money to mothers in need. He aimed to give comfort to those in desperate situations, as he arranged meat deliveries to households facing particularly pressing times. After visiting the Richardson household in December 1860, Ware resolved to give the family four shillings so they could "buy a blanket as her youngest child has the measles & is lying on the ground" (22 Dec. 1860). Furthermore, he likewise sought to equip single mothers to provide for themselves, as seen in the case of Mrs. Leonard, who set up a fruit stall following a loan from Ware (11 Apr. 1850). Mothers evidently recognized the financial help Ware could provide, as many approached him to request his assistance. In 1850, one mother, Mrs. Ryan, "came & begged with a long story about rent &c." Ware gave her the money she asked for, although he noted his concern in his journal: "I hope it will not be 'drawn into a precedent'" (13 Oct. 1850). Mothers likewise called upon Ware's expertise as a barrister. In May 1865, one mother asked him to compose her will; Ware responded that the will that he had "made some time ago would do" before adding "It is in my desk" (21 May 1865). Furthermore, Ware was regarded as a stabilizing and reliable figure by some. A particularly moving instance occurred in 1858, when Ware spoke with a mother whose son was both deaf and dumb. While severely ill with rheumatic fever, she asked Ware "to promise that if she died I would take care of him." Although he felt unable to make such a commitment, he promised to "call & see about him" (23 May 1858).

By far the most common request from mothers, however, was for his assistance with wayward or difficult children—either in the form of school discipline or rehousing children in the school dormitory. The challenging nature of the children's behaviour is well documented in Ware's journals; boys threw flowers in the classroom and launched old vegetables, mud, and stones through the windows. More seriously, Ware noted instances of children smuggling fireworks into the classroom that were spontaneously set off to the delight of classmates and the horror of teachers. Ware recorded on 6 November 1853 that the children "nearly set the place on fire with a Catherine wheel," before adding with reference to one of his colleagues, Mrs. Ward, that she had been scared "out of her wits." Three years later, Ware detailed that the school had been forced to close early "in consequence of a fire being discovered in the wash house." Upon investigation, it was determined that the charred remnants of a firework had been the cause, and young Charles King deemed the likely culprit (23 Mar. 1856).

The conversations recorded in Ware's journals indicate that single mothers could struggle to control or discipline troublesome children. When Ware visited Mrs. East in April 1851 to speak about her son's absence from school, she confessed that she could not "manage him he was so wilful" (13 Apr. 1851). Two years later, Ware called on the Byfield family and found the mother "*ill, nervous, & in despair*" because of "the conduct of her daughter" (Ware's emphasis, 5 June 1853). Similarly, Mrs. Chapman confided her parenting challenges to Ware, and "cried very much" when telling him "that in the last 8 weeks George had 'quite changed'" (20 May 1855). Unruly children could threaten the survival of a household, as Mrs. Restieaux found when she was forced to resort to the workhouse in January 1853 "in consequence of little Walter's troublesome conduct" (7 Jan. 1853). Moreover, it was not only children who were at risk of physical abuse in their homes. In April 1862, Ware noted that Mrs. Ramsay "went into a fit & almost died" after being forcefully pushed down the stairs by one of her sons (5 Apr. 1862). Entries such as these suggest that Ware not only saved children from violent mothers but also saved mothers from violent children.

The threat violent fathers and stepfathers could pose to children is a recurring theme across Ware's entries, which could culminate in the separation of mother and child. Mothers frequently confided their

domestic troubles to Ware during his visits, as Mrs. Connell did when she "lamented the badness of her husband" while Ware "tried to comfort her" (20 Apr. 1851). When Ware called on the Ward family on Christmas Eve in 1852, he found "the mother in a wretched state." After informing Ware that she may have to enter the workhouse, she implored him to care for her son, warning him that the boy's "father was very violent." Two years later, when Mrs. Ward's husband was discharged from hospital following a short illness, she sought Ware's help in protecting her child, asking if he "might be taken back into the Dormitory" (25 Mar. 1854). Perhaps because her son was no longer in the household, and therefore no longer at risk from his father's violence, Mrs. Ward later left "her husband on account of his cruel treatment" (16 Feb. 1856). By housing Mrs. Ward's son, the ragged school protected him from his father while simultaneously enabling the boy to retain contact with his mother. For women like Mrs. Ward, the school represented a haven for their children, a safe place that protected them from poverty and violence alike.

Separation from children, though difficult, was regarded as a necessary evil by some. Although it entailed the separation of mother and son, positions in the navy were sought after by Compton Place mothers on behalf of adolescent boys. When Mrs. Rouen's son, Tom, refused to board his ship, she "had a kind of paralytic stroke from the shock." After seeing her, Ware wrote in his journal that "She can hardly speak," adding that "when she saw him come back 'she was so frightened that she had a fit'" (12 May 1867). Emigration was pursued by a number of mothers, who believed it offered their children opportunities that were inaccessible to them in London. When Mrs. Guy's son told her he was "very anxious to go to Canada or to sea," she visited Ware to ask whether he could help (19 April 1857). Many, however, viewed separation through emigration as either temporary or unnecessary. Mrs. Leonard, unhappy with the infrequent contact with her son in Canada, wished to join him, while Mrs. Restieaux accompanied her children to New Zealand (3 Aug. 1851, 20 Feb. 1856). Such examples highlight women's efforts to resist separation from their children and demonstrate the willingness of some mothers to emigrate in order to be reunited.

Conclusions

Few mothers are passive where their children are concerned. Whether seeking assistance or rejecting intervention, mothers were active participants in a reciprocal, though nevertheless unequal, relationship with child savers. In giving access to his conversations with local mothers, Ware's journal entries allow the nature of the relationships to be explored. Undermining social control narratives, Ware's journals testify to the complexity and diversity of his relationships with local mothers. His entries reveal that mothers drew on the resources that both he and the school could offer in times of need. Mothers actively pursued the help available, as they called on Ware as a disciplinarian, a financial support, and a legal advisor. Compton Place ragged school was regarded as a place of safety by a number of women who used the dormitory as a temporary refuge for their children when necessary. Although such decisions were dictated by pressing circumstances, they nonetheless call into question the notion that poor mothers and child savers were inherently in conflict. In such instances, mothers and child savers worked together to protect and care for children.

Ware's journals likewise reveal the existence of a network of local women, themselves often destitute mothers, who alerted Ware to possible cases of abuse. Ware's entries relating to Mrs. Smith demonstrate that her competency as a mother was questioned by the wider community as well as by Ware himself. The critical role neighbours played in identifying cruelty and enabling John and Margaret Smith to take shelter from their mother's aggression calls into question the binary picture of the dominating child saver and the victimized mother.

The examples of Mrs. Hart and Mrs. Smith show the ferocity with which mothers could respond to intervention. Ware's account of Mrs. Hart's lamentations at the school door on numerous occasions testifies to her deep attachment to her children and her refusal to surrender control. Similarly, Mrs. Smith's anxiety upon the removal of her daughter and her threat that she would seek legal aid demonstrates her keen objection to Ware's actions. In both cases, the mothers publicly articulated their feelings of injustice, ensuring that their voices were heard. Neither mother accepted the removal of her child; rather, they overtly declared their intention to bring them home. In protesting in the street or at the school, both women ensured that Ware, and any

bystanders, knew of their response to his actions. The documentation of their words and actions in Ware's journals signifies their success in communicating their emotions. Moreover, Ware's account of the women's behaviour hints at the intensity of the feelings evoked upon separation from a child. The words he used, such as "frantic" and "raved," betray the desperation felt when their children were removed against their will.

The relationships formed between mothers and child savers are largely inaccessible from promotional literature. The masses of pamphlets and magazines produced by child-saving groups are useful when exploring the portrayal of poor mothers, yet they are strictly limited when seeking to understand their views and experiences. The voices of actual mothers, rather than the much-critiqued "feckless" mothers depicted in promotional literature, are most richly found in material from local schools. Ware's journals allow the actions and words of mothers to shape our understanding of the ragged school movement and its impact on families. His journals provide a rare and valuable account of the experiences and testimonies of Compton Place women, which nullifies the one-dimensional caricature of the wretched poor mother found in promotional literature. In paraphrasing and quoting women, Ware preserved exchanges that would otherwise be lost. The scope of Ware's journals has made it possible to trace relationships over time. In Mrs. Smith's case, Ware's journals detail four years' worth of encounters, and because of this, dramatic events, such as Mrs. Smith threatening to "lame" her son, need not be analysed in isolation. Ware's journals enable events to be placed in their broader context, allowing a fuller and more faithful inter-pretation. While highlighting the diverse responses of women to intervention, Ware's journals also draw attention to the shared experiences of poor mothers in the mid-nineteenth century. Whether they rejected intervention or sought assistance, the mothers of Compton Place ragged school shared a grim experience of poverty. Many suffered exploitation and insecurity at the hands of employers, landlords, and partners, while an unholy combination of charity and pawn tickets was relied upon to make ends meet. For many mothers, the workhouse was an ever-looming threat that could easily be realized and which would, ultimately, result in their separation from their children.

Works Cited

Davidoff, Leonore, and Catherine Hall. *Family Fortunes: Men and Women of the English Middle Class 1750-1850*. Routledge, 1987.

Gordon, Linda. *Heroes of Their Own Lives: The Politics and History of Family Violence*. Virago Press, 1989.

Jackson, Louise. "Children of the Streets: Rescue, Reform and the Family in Leeds." *Family and Community History*, vol. 3 no. 2, Nov. 2000, pp. 135-145.

Hall, George. *Sought and Saved: A Prize Essay on the Ragged Schools and Kindred Institutions*. Partridge and Oakley, 1855.

Hillel, Margot, and Shurlee Swain. *Child, Nation, Race and Empire: Child Rescue Discourse, England, Canada and Australia, 1850-1915*. Manchester University Press. 2010.

Littlewood, Barbara, and Linda Mahood. "The 'Vicious' Girl and the 'Street-Corner' Boy: Sexuality and the Gendered Delinquent in the Scottish Child-Saving Movement 1850-1940." *Journal of the History of Sexuality*, vol. 4 no. 4, April 1994, pp. 549-578.

Mahood, Linda. *Policing Gender, Class, and Family: Britain 1850-1940*. Routledge, 1995.

Platt, Anthony. *The Child Savers: The Invention of Delinquency*. University of Chicago Press, 1972.

Ware, Martin. 1585/1-7. *Ware's School Journals*. Surrey History Centre, Woking.

"Ragged School Union." *The Times*, 8 May 1860.

"Ragged School Union—City of London." *The Times*, 20 Feb. 1857.

"The Weather and the Parks." *Morning Chronicle*, 29 Dec. 1860.

Part III

Having to Live and Mother through It: Economic, Geographic, Political, and Racialized Inequities

Chapter 7

Grieving Absent Children in "Three Seasons"

Kristin Lucas

Frank curled his left hand into a fist. Turning to his cabin, he
wiped the rain and tears off his cheeks with his right palm.

—George Kenny, *Indians Don't Cry*, 9

I want to consider loss and grief: the ways absence contours a life, what it means to express grief, the impulse to hide one's sadness, yet for that sadness to be glimpsed despite efforts to keep it hidden. The loss and grief I am considering are experienced by characters in Linda LeGarde Grover's short story "Three Seasons." It is bound up with Grover's depiction of the Indian boarding school system (Canada's cognate is the residential school system), which systematically removed generations of Indigenous children from family, kin, and community, and the injuries it caused as well the profound resilience her characters live by. Attentive to the multigenerational trauma caused by the colonial school system, "Three Seasons" portrays the grief of children as they depart and of mothers as they experience the loss of them.

The topic of maternal grief for absent children may seem self-evident. After all, who wouldn't feel sorrow over the loss of a child? A sense of the obviousness of such grief, however, belies the particular experience of it. For neither grief's cause nor its expression is neutral. Indeed, in Grover's fiction, grief is simultaneously an all too regular part of the lives of Maggie LaForce and her older sister Henen, and deeply political. "Three Seasons" places maternal love and grief in

opposition to state-induced precarity and asks us to recognize it as such. To read grief in this story is to see affect anchored within and stemming from kinship networks of love and care, and to see its expression as a form of critique and resistance. Far from being a private gesture of defeat or hopelessness, grief marks important relational ties as well as a deep commitment to sustaining them. Through this commitment, grief and intergenerational resilience are entwined.

"Three Seasons" is the second story in Grover's 2010 collection *The Dance Boots*, which won the Flannery O'Connor Award for short fiction. The interwoven stories portray three branches of an Ojibwe family from the fictional Mozhay Point Indian Reservation over successive generations, moving backward and forward in time to detail the ways that the past and memory shape the lives of the LaForce, Gallette, and Sweet families. Significant moments and life events are recounted across the generations, as Shirley chooses her niece Artense to hear the stories of their family. Some of these stories had remained long untold, remembered but not yet passed on—a manifestation of Kristina Fagan's suggestion that silence and not telling are also valuable and considered options (Fagan 114). Artense recalls the following: "When I was growing up in the 1950s and 1960s, how and where my relatives had been schooled was rarely mentioned and never discussed ... I spent my childhood and teen years protected from the sorrows of the past by its invisible swaddling" (6-7).

As the collection opens, the time for silence has come to an end and Shirley begins to tell Artense their family history. "The story she told me," says Artense, "is a multigenerational one of Indian boarding schools, homesickness and cruelty, racism, and *most of all*, the hopes broken and revived in the survival of an extended family" (my emphasis, 8). Artense's words make clear that Grover's collection is by no means solely about oppression. Rather, it articulates a resistance to absence, what Gerald Vizenor calls "survivance"—a significant part of which details different characters' experiences with the education system, from mission school to community college (85).[1] It is also a postmodern book about storytelling and representation. Through multiple narrators and points of view, Grover's fiction explores the nuance of memory, and the balance between a shared history and an individual perspective. The multifaceted narration that characterizes the collection as a whole is found also in "Three Seasons," which has

seven sections and (at least) four narrators. Although I do not take up the story's narrative complexity at length here, it does subtend Grover's depictions of love and grief, and constitutes part of a wider representational practice that counters colonial hegemony. To develop my argument about maternal grief as essential to resilience and a challenge to precarity, I first address relationality and kinship in recent Indigenous literary criticism, especially the scholarship of Daniel Heath Justice. Then, turning to Judith Butler's work on precarity, I make a case for its relevance as a framework within which to consider the representation of affect in boarding/residential school literature. Finally, I develop a reading that demonstrates the political resonance of grief as it operates in "Three Seasons."

Kinship and Grief

Bonds of kinship are vital within Grover's work. At the beginning of *The Dance Boots*, in a story of the same name, Artense reflects on her Aunt Shirley's phone calls: "I began to see that as Indian people our interactions with society and with each other include the spectre of all that happened to those who went before us" (9). The idea Artense articulates—of socially embedded lives where persons are bound to each other through a network of care and responsibility across time and place—expresses, in fiction, the purview of a critical approach detailed in *Reasoning Together*, a collection of essays by The Native Critics Collective. In particular, Daniel Heath Justice, Lisa Brooks, and Tol Foster advocate an ethical Indigenous literary criticism that is grounded, conceptually and practically, in what Brooks terms "relationality." These critics privilege relationships because they "are the primary axis through which we can understand ourselves and each other" (Foster 277). That is, they insist that colonization is not the defining fact of personhood or identity. For Justice, the claims of kinship stand in opposition to Western individualization. As such, attending to kinship, which in its most encompassing includes not only bonds and obligations to other humans but all creation, is a means to oppose "fragmenting Eurowestern priorities" (Justice 150). Kinship is essential to Justice's ethical project because, at its heart, kinship is dynamic, at once responsive and requiring attention. Thinking about kinship foregrounds responsibility, obligation, and care, the varied and

varying affiliations between humans and the world that existed in the past, continue in the present, and will be there in the future. Continuity, neither static nor nostalgic, asserts embodiment against tropes of vanishing and insists on "presence in the face of erasure" (Justice 150). Recognizing expressions of kinship in boarding and residential school literature matters precisely because it is those bonds that were targeted for erasure by the colonial education system and its assimilative mandate. In "Three Seasons," the importance of such bonds is foregrounded in scenes of separation, where both mothers and children feel grief and longing.

For the critics mentioned above, literature itself is one of the ways "relationship is made manifest" (Justice 150). It is what Justice calls the "storied expression of continuity that encompasses resistance while moving beyond it to an active expression of the living relationship between the People and the world." Thus in form and content, literature opposes the "ghost-making rhetorics of colonization" (Justice 150). Colonial rhetoric is, in Justice's startlingly lovely phrase, "ghost-making" because it denies the value and the depth of lives of Indigenous persons. It relies on "simplification," which is "essential to the survival of imperialism" (Justice 154) and tantamount to erasure, either through vanishing or the capture of stereotype. Conversely, complex expression is the enemy of oppression. By conveying complexity and nuance of personhood as qualities to be witnessed and acknowledged, literature can do ethical work: it encourages imagining otherwise.

The critical orientation toward relationality and kinship aligns productively with the recent work of Judith Butler, *Precarious Lives* and *Frames of War*, which also considers the anti-hegemonic potential of representation. Although Butler's writing on precarity is a response to 9/11 and its aftermath, her overarching examination of violence, oppression, and state-induced precarity has salience beyond that particular context. Beginning from the premise that we are "constituted politically" at least in part by the "social vulnerability of our bodies" (*Precarious* 20), her quest for an ethical response to (global and state) violence is based in a distinction between two terms: precariousness and precarity. The former refers to our shared potential for loss and vulnerability: "lives" Butler reminds us, "can be expunged at will or by accident; their persistence is in no sense guaranteed" (*Frames* 25). Precariousness, then, is the fact of having a body, and is a "more or less

existential" concept (*Frames* 3). Precarity, on the other hand, is a "politically induced condition" referring to the heightened exposure of certain persons and populations to precariousness—for instance through racism, gender discrimination, or poverty (*Frames* 25-26). Whereas precariousness is something we have in common, precarity is "differential[ly] distribut[ed]" (*Frames* 25), which is what makes it political. This differential distribution is a cornerstone of Butler's thinking about bodily ontology because it is both a "material" and, importantly, a "perceptual" issue (*Frames* 25). How we regard others has a direct bearing on their exposure to disenfranchisement, violence, and oppression; it has a direct bearing on the exploitation of human vulnerability, and the passage from precariousness into precarity. As we will see, the perceptual facet of precarity surfaces throughout Grover's story, and it is especially evident when the negation of Indigenous children by school authorities is juxtaposed to the care and concern felt for those same children by their mothers, cousins, and siblings.

When people are not regarded as fully human, their vulnerability and suffering are ignored or discounted because they fall beyond some standard for social inclusion or legal protection. As Butler observes, "the epistemological capacity to apprehend a life is partially dependent on that life being produced according to norms that qualify it as a life" (*Frames* 3). The "derealization" of lives is, of course, itself a violence, one that is self-justifying: when "violence is done against those who are unreal, then, from the perspective of violence, it fails to injure or negate those lives, since those lives are already negated.... They cannot be mourned because they are always already lost" (*Precarious* 33). Those perceived as unreal are negated and, through being negated, become ungrievable. Their lives, injuries, and deaths are not worthy of recognition; indeed, they cannot be murdered as they do not exist as persons. Addressing the narrowing conception of what counts as human, Butler—who writes mainly about the depiction of Arab and Muslim persons in the Western media, a depiction primarily based on exclusion and denial— posits that what is needed to counter this paradigm is not simply to permit all excluded persons entry into the "established ontology" but an "insurrection at the level of ontology" (*Precarious* 33).

In "Three Seasons," insurrection comes through kinship and

complex lives, which directly confronts the derealization of persons by the boarding school authorities. Complexity in Grover's work is conveyed through relations of love and care, in poignant scenes of leave taking, and through expressions of sorrow. Moments of grief have a tangible weight in the story, and to begin to access their full register I want to briefly address Butler's account of mourning.

Bodies, for all their vulnerabilities and dependencies, are not "mere surface upon which social meanings are inscribed" (*Frames* 33). Although we are constituted by our precariousness and sometimes suffer because of it, we also feel hope and joy, love and desire. Our vulnerability is not synonymous with injurability (*Frames* 34); it is what opens us to others and creates and maintains relationships of depth and meaning. In Butler's terms, the world is both "sustaining and impinging" (*Frames* 34), and as we respond to others in welcome relationships, we also respond to unwelcome proximity, coercion, and force. Affective response may be animated by such intrusions, which elicit from us anguish or outrage, and these responses are "the very stuff of ideation and of critique. In this way, a certain interpretative act implicitly takes hold at moments of primary affective responsiveness" (*Frames* 34). To understand affect as critique is to think about the ways its very presence calls into question what Butler calls "the taken-for-granted," the dominant social frame or prevailing ideology (*Frames* 34). In this account, grief and mourning are not the surrender or the evisceration of will—they are the manifestations of agency.

Grief also has a more pressingly political dimension. Like other thinkers about the reach of the state, Butler has long been interested in Sophocles's play *Antigone*, the story of a sister who defies the edict of the new ruler, her uncle, and mourns the death of her brother.[2] The play, and its examination of civic order and familial love, serves as a touchstone for Butler's ideas about mourning and what counts as a grievable life. There are people whose vulnerability, injury, and death we apprehend and grieve, and there are those, the derealized, whose vulnerability, injury, and death are ungrievable, and who vanish into "the ellipses by which public discourse proceeds" (*Precarious* 35).[3] Mourning thus demarcates a "we." The divide over grievability, present in "Three Season," is the basis for Butler's contention that expressions of grief and mourning furnish "a sense of political community" (*Precarious* 22). It is especially so when recognition happens in

circumstances where the acknowledgement of loss is contentious or dangerous, when grief asserts the value of a life that has been regarded as no life and excluded from the normative ontology. In Grover's story, grief asserts the value of persons and kinship ties in the face of an educational system that devalues and seeks to dismantle them.

Reading Grief as Presence

In "Three Seasons" schooling requires and produces precarity. Butler has shown that the derealized exists in a kind of limbo, where violence does not (that is, is not perceived to) "injure or negate" because their lives are "already negated" (*Precarious* 33), and in Grover's fiction, boarding school instantiates this limbo. It is a place of punishment and confinement, physical and ideological, where children suffer stigma and abuse. Through language suppression, physical violence, and the use of isolation, the lives of children within the boarding school are marked as ungrievable. The injury done to them is normalized and passes largely without comment from teachers and staff, yet comprises a repeated traumatic scenario in the lives of individual children and across generations.

While Grover depicts the school's various attempts to discipline and assimilate children, she also represents kinship ties, love, and maternal loss, all of which convey the value of persons and insist that they are, in fact, grievable. Maggie's children are not nothing; they are everything. In other words, Grover's fiction portrays the institutional mechanisms of dehumanization and erasure at work and, simultaneously, challenges them through deeply human relationships whose presence and continuance decry colonization. And, crucially, her fiction discloses the spaces in which oppression fails.

Turning now to grievable lives in "Three Seasons," I first consider several scenes of schooling, wherein the institution attempts to enforce precarity and erasure, and the children find ways to assert their presence and guard relational ties, exhibiting resilience despite systemic oppression. I then address the story's two portrayals of departure and maternal grief—the loss of Henen's baby that occurs near the beginning of the story and the enforced return of Maggie's children to boarding school that occurs at the end. Together, these moments are integral to the story's representation of intergenerational

resilience: the experiences within and beyond the school are linked, and convey resistance and continuity through a self that is oriented towards and protective of kin and communal bonds.

In the school scenes of "Three Seasons," erasure is cultivated through various colonial education practices, including the denial of language. Enforcement extends beyond the requirement to speak English and is found even at the level of pronunciation. When Maggie and her sister Henen are girls at the mission school, the nuns insist that Henen abandon the Ojibwe pronunciation of her name and instead use the English pronunciation, Helen. "*Hell-en*," the narrator says, showing us how to stretch out the name to get the tongue around the unfamiliar L-sound (23). Grover explains that "*l* and *n* can be interchangeable when English is spoken" (x) and that Ojibwe names could combine English and Ojibwe spelling, as happens with Henen. By insisting on the "*l*," the nuns aim to reorient her name away from Ojibwe and towards English, assimilating her even at the level of pronunciation. They censor not only language but also the verbal traces that help to identify Henen as Henen, and Ojibwe. As the careful articulation of "*Hell-en*" reminds us, language is inhabited, and to govern speech is always, to some extent, to govern the body.

Whereas Henen makes a strategic effort to adhere to the nuns' preferred pronunciation—it is a compliance that enables her to gain favour and privileges, including tacit permission for her younger sister Maggie to sleep with her in the older girls' dormitory when she is frightened—the next generation navigates the rules a little differently. When the school prefect McGoun catches Sonny and Mickey violating the English-only rule, he asks the boys angrily "Hey! Are you boys talking Sioux?" (30). The boys, who are Chippewa speakers, understand that McGoun "didn't know one Indian from another" (30). Sonny replies first, "No, sir, we weren't talking Sioux," and Mickey adds, wryly, "No, sir, we wouldn't do that" (30). The exchange places McGoun's narrow understanding of "Indianness," which does not admit multiplicity, against the boys' ironic response that understands and exploits hegemony's limitations. Henen's compliance and the boys seeming politeness hinge on relationality. Both appear to comply, and in so doing, moments of linguistic oppression are used to forge solidarity and safeguard care.

A similar dynamic occurs in scenes of violence and punishment.

Cruelty, bruises, and strappings bear witness to the ways children are perceived as unreal. We see such a perception when Louis Gallette, who will later become the father of Maggie's two youngest children, is still a student at boarding school. Recall that an ungrievable life is a life rendered unreal, seen as no life at all. In the story "Maggie and Louis, 1914," Maggie is working at Harrod School as a sewing teacher when Louis, brave and defiant, gets caught trying to run away and is sent to the solitary room for the night. As he is being taken away, the matron says to the men handling Louis, "Tsk. Tsk. What a shame. What a lot of trouble it is to have to spend time on this" (50). In a gesture that recalls the Anglicization of Henen's name years ago (and at a different school), the matron strips Louis of the individuality of his name. Likewise, any implicit acknowledgement of humanness that might be found in the pronoun "him" is repudiated, and the matron instead reduces Louis to "this," his unsuccessful rebellion—an act of grammatical erasure that prefigures the carceral space to which he is taken.

When Maggie finishes eating with the rest of the school staff, she is asked to bring dinner to Louis in the basement where he is confined. The door is "covered by wood strips nailed to the outside that created a latticed grill" similar to "the window into a confessional" (52). The room itself is dark and small, with musty air and a horribly stained mattress. The meal, too, is small and "not enough to fill his stomach, as part of his punishment" (53). All aspects of this man-made purgatory reinforce the worthlessness of the inhabitant, from its location in the basement of the laundry building to its confessional-like door. The room proclaims the deficit of the child put there and the need for that child to reflect on his recalcitrance and amend. The door is padlocked shut, and Louis has to tell Maggie where the key is located. He has been there so often he knows the quirks of the sticky lock, and tells her those too. She tries the lock unsuccessfully and thinks: "What if the laundry building caught fire? The boy would die" (55). She has only just met Louis, but she is aware of his life as a life, as something valuable and vulnerable, subject to injury and death (neither impossible where he is). On her fourth try, Maggie manages to open the lock, cutting herself in the process. If, as Butler says, violence against the derealized "leaves a mark that is no mark," we see in Maggie's bloody finger the mark that is a mark (*Precarious* 36). Her bleeding affirms the shared injurability and humanness that boarding school denies Louis.

Maggie's experience of vulnerability is amplified years later when her own children are taken to that same school. Her response to the loss of them, considered at the end of this essay, is one of sorrow and longing, but it is not the only maternal grief in the story. Henen, too, grieves a lost child.

The second section of "Three Seasons," called "Giiwe-Biboon: Maggie and Henen in Late Winter," comprises an account of Maggie's and Henen's childhood at convent school. Henen, with her beautiful, precise handwriting, is a model student who helps the sisters make the communion hosts, and even, as we have seen, ensures she says her name as the nuns want it said. A favourite, she is treated permissively by the nuns. So it is a surprise when she is found to be pregnant, and with that, falls quickly from favour. The doctor is called to "confirm the result of Henen's sin" (25). He pronounces her "spoiled" (26), and she is sent home for "disgracing herself" (24). But she is made absent even before she leaves. Isolated from the other girls, Henen is housed in the infirmary so they cannot see her (24). The nuns too will not see her. While examining Henen, the doctor asks, "Would you like to see this, Sister?" and, indeed, she does not: "Sister Rock, eyes on a row of canned goods, shook her head" (26). Henen is rendered invisible in the sense that she cannot and will not be seen. Even the doctor, with his reddened and twisted face and his probing fingers, treats Henen more humanely than the nuns. At least, he acknowledges her feelings of exposure and uses a dishtowel to cover her "from ribs to knees" during the exam (26).

The teenaged Henen, however, does not feel the shame the nuns project onto her pregnancy. When she feels the baby move inside her, "she hum[s] a song of gratitude" (27), and when that baby stops moving and dies, she is bereft and inhabits her grief as bodily as the baby inhabited her. Day by day, the fetus shrinks inside of her, and she continually reaches for her belly and "prod[s] a circle around the lump that every time she searched was harder" and smaller, until it disappeared completely (27). It is a slow leave taking, one that continues after the physical traces of the baby are gone:

And then, after that, every day, the spirit of her baby receded from her own and the others that continued to live, growing more and more distant, until when the children came back from school in June it had joined those other baby spirits who, because

they were too small to walk, traveled to the other world on the east wind, which carried them gently in the sky, borne by visions of the Great Ojibwe Migration of long ago. Out of sight, they were mourned by bereft earth-bound mothers like Henen. (27)

I cite at the story length to draw out the disparity between the Christian language of sin and disgrace as well as the isolation and the manufactured invisibility of Henen at the convent school, and the vast network of attachment and belonging that holds both Henen and her child. As the child's spirit leaves that of its mother, it is not alone but travels with others, and, in turn, they all move towards the west, tracing the path of migration their ancestors undertook years ago. The recently departed and the long passed are aligned through the voyage, and Henen, too, is one of many mothers who mourn lost children. None of this is to say Henen thrives (she does not), but she grieves deeply for a child considered to be ungrievable evidence of her ruin. The ghost-making colonial rhetoric and policy are undone by both maternal grief and the spirits of lost children as they, enduring and animated even in death, exceed the confines of stasis, sin, and deficit.

It is June when the baby's spirit finally departs from Henen's own, and the receding of that child coincides with Maggie coming home from school. This season of return brings Henen some solace. It is not that the baby is forgotten—Henen dwells with that loss throughout her life—rather, it is that other bonds are renewed and strengthened. The first thing Henen does is to give Maggie a new blouse she has made, and she then asks her sister about the school year and if she would like to practice her penmanship (24). Acts of care and kindness bring Maggie and Henen together, even as Henen's loss remains unspoken. Though unspoken, it is not unshared and the end of the story sees Maggie and Henen aligned one last time. The idea that maternal grief furnishes a sense of community and intergenerational resilience propels "Dagwaagin: Maggie in Autumn," the brief, concluding section of "Three Seasons."[4]

It begins with a visit from the superintendent of the Indian school who comes armed with the tribal census to verify that Maggie and Louis's second youngest son, Vernon Gallette, is seven years old and should be attending school. He presents Maggie with train tickets for all of her school-aged children to depart the next day. And so the authority of the superintendent and the census, which Maggie has had

some success circumventing, finally prevails and the children walk to the station. Like Henen's gradually receding child, they, too, grow "smaller and smaller" until they disappear from sight (40). After they are gone, Maggie momentarily breaks down, "exposing the ravages of grief that made her look like Aunt Helen's twin" (40). This final invocation joins the sisters once again, palimpsest-like, in grief, where Maggie's face both recalls and enacts Henen's. The grief of Maggie over her absent children, expressed so heartbreakingly at the end of the story, summons the earlier grief of her sister, who is, in turn, allied with all those other earth-bound mothers, and in Grover's fiction depicts the basis for a "we"—an awareness of oppression and a commitment to the love and shelter of relational ties that colonization seeks to deny.

This same scene of leave taking further suggests resistance escalating across the generations. Before Maggie's children round the corner, they look back. George and Girlie smile and wave, performing a cheerfulness that no one feels. Their cousin Mickey, though, behaves differently. When he is young, Mickey is referred to as Waboos (rabbit), but the name and its associations transform as he ages, and as he starts to become a man, Waboos becomes Maingen (wolf). This final goodbye, when Mickey is an adolescent, depicts that shift in him as he flickers between boy and man: "Waboos waved, then become Maingen, who thought of the day that would come, and smiled with bared pointed teeth, that thin young wolf hungry for the day McGoun would get his" (40). Whereas Maggie keeps "her smooth and pleasant mask" in front of her children, Mickey's face changes palpably. No longer able to acquiesce to the mandate of the education system, Maingen offers a burgeoning challenge to the injustice he and his family experience. In the epigraph from George Kenny that begins this essay one hand makes a fist as the other wipes away tears; here, too, a scene of grief is also a scene of anger and each affective response in its own way constitutes resistance. The division itself, seen in Maggie's sorrow and Mickey's anger, further suggests that maternal grief, anchored in the value and dignity of children, has shaped the conditions for intergenerational resilience.

Mickey's face, even as it changes, is rendered precisely in this last scene, but elsewhere it is not, and I want to invoke Butler's work one last time because her engagement with Emmanuel Levinas enables my

reading of the story's concealed faces. In "Three Seasons," displays of grief are hidden. We see moments of concealment when, after running away from Harrod School, Mickey is found at Maggie's home and is taken back by McGoun. And we see it when Maggie composure briefly slips:

> Mickey was too big to cry; he smiled just brave with those snaggly teeth and waved at Ma just before they drove away, but then I could see through the back window that his head was down and I could feel it that he wasn't smiling anymore. (33)

> Maggie kept her smooth and pleasant mask in place until they turned the corner. Her composure slipped for just a moment, exposing the ravages of grief that made her look like Aunt Helen's twin, but then she pressed the crook of one arm to her eyes to absorb her tears, which darkened the print of her cotton work dress sleeve, dried, and disappeared. (40)

To be sure, these are small moments in an intricate story. But they are striking because in a repeated gesture, they convey an attempt to conceal grief and grief's refusal to be wholly concealed. Grief, expressed by the face, is both hidden and apparent, and Butler helps to illuminate the representational significance of this tension. She notes two predominant modes of representation. One is the iconic, where the face of an individual is made to bear a (Western) belief or message, and is often symbolically identified with the inhuman. The other, a "radical effacement" from public discourse, eschews any representation at all (*Precarious* 147). Both modes, capture and erasure, are conveyed in Justice's notion of ghost-making and are, in Butler's account, strategies for derealization and rendering persons ungrievable.

Against these forms of representation, Butler turns to Levinas's ethics of the face and posits another mode, one that aims to represent but fails and "must *show* its failure" (emphasis in original, *Precarious* 144). For Butler (and Levinas), the face embodies the precariousness of another. It does not represent and indeed cannot represent because it is never fully synonymous with what it aims to represent. Humanness itself "limits the success of any representational practice" (*Precarious* 144), and conversely, as Grover's story shows us, the limits of representation avow the human. We see just such limits in Maggie's

masklike face and the sense, felt but unconfirmed, that Mickey wasn't smiling. These moments convey a complex personhood that undermines simplicity by exceeding its own knowability. The fluctuation between concealing and revealing acknowledges the impossibility of wholly discerning another, even, and perhaps especially, those with whom we are closest. Through its hidden faces and hidden grief, Grover's story goes beyond replacing static colonial depictions of Indigenous persons with complex and active ones. It engages with the limits of representation itself.

Conclusion

"Three Seasons" resonates with expressions of love and its counterpart grief, depicting a world where affective ties are always stronger and more dynamic than state-induced precarity. Its two important scenes of maternal grief—Henen mourning her unborn child and Maggie's sadness as her children leave for school—delineate the narrative. These expressions of sorrow convey rich inner lives and complex personhood; they also affirm the value and grievability of children, which poses a direct challenge to their derealization under the boarding school system. In this, the story's depictions of grief are political: they confront static, hegemonic representation, and expose the colonial mandate that sought to dismantle Indigenous families and kinship relations.

Yet Grover's work tilts to the postmodern, and if grief signals interiority, it also evokes the unknowable. The story concludes by overlaying, one last time, grief for absent children and the limits of representation. As the "season of hibernation" approaches, Maggie is on her own (41). Her older children have all gone to school, and her youngest son, Biik, is on the way to Mozhay Point to visit family. It is the kind of scenario where you might expect to find the main character alone, as we say, with her thoughts. But that is not what happens. Readers do not learn what is on Maggie's mind. Indeed, the narrator asserts, twice on the last page, that Maggie keeps busy tidying her home and working at the factory, and she does so "without thought" (41). Maggie's body numbly animates itself through the motions of everyday life, but her thoughts and feelings are not a part of the story's ending. Their suppression, of course, suggests a response to profound

loss. But the point is that her inner world remains private, ostensibly hidden from the narrator, who remarks that Maggie's heart was "heavy and still as her face and as unreadable" (41). This final image of an inscrutable face, and the narrator's inability to convey what is in Maggie heart and mind, is indicative of the story's narrative insurrection. Through its representations of maternal grief, "Three Seasons" asks the reader to be receptive to the fullness of a life and, simultaneously, to recognize that, in its depth and complexity, a life surpasses representation.

Endnotes

1 Vizenor writes that "Native survivance is an active sense of presence over absence, deracination, and oblivion; survivance is the continuance of stories, not a mere reaction, however pertinent" (85). For a thorough account of residential school literature as survivance, see Renate Eigenbrod, "'For the Child Taken, for the Parent Left Behind': Residential School Narratives as Acts of 'Survivance.'"

2 Butler's sustained consideration of Antigone is found in *Antigone's Claim*; Gillian Rose also turns to the story of Antigone in *Mourning Becomes the Law*, see pages 35-36 and 72-73.

3 Butler's work on public mourning is relevant to systematic injustices in Canada. In the repeated calls for an inquiry into missing and murdered Indigenous women and girls, and the vigils for these women and girls, including a recent Amnesty International campaign, we see a longstanding government denial of a human rights crisis positioned against the public mourning of family, friends, and community. The National Inquiry into Missing and Murdered Indigenous Women and Girls was finally launched in 2016.

4 Grover's section headings are suggestive of Louise Erdrich's 1988 novel *Tracks*, whose chapter titles also contain seasonal references in a combination of Ojibwe and English. In *Tracks*, the main character Fleur sends her daughter to boarding school, a decision examined by Elaine Hansen Tuttle in her classic study *Mother Without Child*. Hansen writes that "Fleur is explicitly associated with supernatural powers, and Fleur sends Lulu away only because she must use her

powers to protest and subvert conquest" (141). If Grover's story hearkens to Erdrich's, it also diverges from it. There are no supernatural powers with which to resist the state; the realm of "Three Seasons" is emphatically human, and resistance is expressed through kinship and care.

Work Cited

Butler, Judith. *Antigone's Claim: Kinship between Life And Death.* Columbia University Press, 2000.

Butler, Judith. *Precarious Lives: The Powers of Mourning and Violence.* Verso, 2004.

Butler, Judith. *Frames of War: When Is Life Grievable?* Verso, 2009.

Brooks, Lisa. "Digging at the Roots: Locating an Ethical Native Criticism." *Reasoning Together: The Native Critics Collective*, edited by Craig S. Womack et al., University of Oklahoma Press, 2008, pp. 234-64.

Eigenbrod, Renate. "'For the Child Taken, for the Parent Left Behind': Residential School Narratives as Acts of 'Survivance.'" *English Studies in Canada*, vol. 38, 2013, pp. 277-97.

Erdrich, Louise. *Tracks.* Harper Perennial, 1988.

Fagan, Kristina. "What Stories Do: A Response to Epineskew." *Canadian Literature*, vol. 214, 2012, pp. 109-16.

Foster, Tol. "Of One Blood: An Argument for Relations and Regionality in Native American Literary Studies." *Reasoning Together: The Native Critics Collective*, edited by Craig S.Womack, et al., University of Oklahoma Press, 2008, pp. 265-302.

Grover, Linda LeGarde. *The Dance Boots.* The University of Georgia Press, 2010.

Hansen, Elaine Tuttle. *Mother Without Child: Contemporary Fiction and the Crisis of Motherhood.* University of California Press, 1997.

Justice, Daniel Heath. "'Go Away, Water!': Kinship Criticism and the Decolonization Impulse." *Reasoning Together: The Native Critics Collective*, edited by Craig S. Womack, et al., University of Oklahoma Press, 2008, pp. 148-68.

Kenny, George. *Indian's Don't Cry.* NC Press Limited, 1982.

Rose, Gillian. *Mourning Becomes the Law: Philosophy and Representation.* Cambridge University Press, 1996.

Vizenor, Gerald. *Native Liberty: Natural Reason and Cultural Survivance.* University of Nebraska Press, 2009.

Chapter 8

Mothers' Voices from the Margins: Representation of Motherhood in Two of Mahasweta Devi's Short Stories

Indrani Karmakar

I remember once asking Mother her views on the role a woman
plays in the family. As steam rushes out of a kettle on boil,
so did her words, "It is a hard life for women," she asserted,
"motherhood is a cross the woman carries. It is like committing
Sati *by jumping into the husband's funeral pyre."*
—Pawar 75

Acclaimed Marathi writer Urmila Pawar, thus, reminisces about her mother. Her mother's use of the image of Sati in relation to motherhood resurfaces in her mind the day she sees her wailing, bereaved mother after losing her son. Despite this image of acute abjectness, in Pawar's moving autobiographical account, her mother's struggle for her children's survival and education is remarkably evident. In this essay, I explore this complex terrain of abjectness and agency in two short stories by Mahasweta Devi. Pawar's autobiographical lines not only act as a prelude to and/or contextualize the forthcoming discussion of my chapter, but also forge an intimate

connection with my chosen texts. Pawar herself comes from a Dalit, low-caste community wherein the position of the mother, as she terms, is "lowest of the low" (74). Moreover, she remembers her mother's words, as mentioned in the epigraph, in the wake of a loss. The marginalized space, loss, agency, and abjection—all these will reverberate in the lives of Devi's textual mothers.

Mahasweta Devi—The Champion of the Marginalized

Mahasweta Devi, the recently deceased and renowned literary figure of West Bengal, is also widely known for her commitment to and activism for the indigenous people and tribal communities in India. Her fictions mostly represent the subalterns (a subjugated part of the population isolated from the mainstream) and the wretched conditions many peoples live within, as a result of a discriminatory system that has systematically marginalized them before and after the independence of India (Bandyopadhyay xiii). Devi's texts are particularly important for investigating the dynamics of unequal power relations between the classes and for addressing the issue of gender politics. In this chapter, I focus on the figure of mother without child in two of Devi's short stories: "Bayen" (2004) and "Ma, from Dusk to Dawn" (2004), which were originally published in Bengali as "Bayen" and "Sanjh Sokaler Ma," respectively.[1] In these stories, the thwarted mother-child bond delineates a complex intersection of oppression on the basis of class, caste, and gender. In what follows, I explore how Devi's narratives of the mother without her child chart a trajectory of maternal agency, or lack thereof, operating within a certain location. In so doing, I interrogate how the physical or psychological loss of a child becomes a particular site of victimhood and agency for these subaltern mothers.

To proceed with my exploration of Devi's literary representations of the motherhood of the subaltern, I need briefly to explicate the concept of the subaltern and its relevance to my discussion of Devi's texts. The word "subaltern" was first used by the Italian Marxist thinker Antonio Gramsci (1891–1973). In his Prison Notebooks, written during the fascist regime of Mussolini in 1930s, he used the word "subaltern" to mean "non-hegemonic groups of classes" (xiv). Gramsci's concept of subaltern was further developed and deployed by the subaltern studies

collective, led by Ranajit Guha, in its analysis of the historiography of the nationalist struggle in India. The collective strongly criticized the elitism inherent in bourgeois nationalist historiography, which did not acknowledge the contribution of the nonelites towards India's independence (Chaturvedi 9; Guha 36). However, this particular term "subaltern" later encompassed other categories, as Guha defines it as "a name for the general attribute for subordination ... whether this is expressed in terms of class, caste, age, gender and office or any other way" (viii). Since then, Gayatri Chakravorty Spivak has raised crucial questions on the efficacy of the project of recovering the subaltern's voice in her famous 1985 essay "Can the Subaltern Speak?" She adds another dimension to the argument by highlighting the issue of the gendered subaltern who is doubly marginalized as "the ideological construction of gender keeps the male dominant" (82). She argues that the subaltern woman's voice is underrepresented, whereas her male counterpart seems to have gained dominance in the representation of the subaltern resistance. In such a context, Devi, through her activism and her literary writing, has relentlessly endeavoured to create a space in which the subaltern's voice can be heard. What is particularly important for this chapter is that in these two stories, Devi chooses to represent the doubly marginalized, gendered subaltern who is often neglected in literary representation (Basu 130). Furthermore, through the stories of mothers without their children, Devi retrieves the voices of subaltern mothers whose "actions" speak of their resistance when their powerless position—lower class and caste status—overpowers their mothering.

The Evil Mother in "Bayen"

The protagonist of the story "Bayen" is a Hindu low-caste woman named Chandi, whose ancestral job is to bury dead children. Her motherhood comes in the way of her profession; after the birth of her son Bhagirath, Chandi, being a mother herself, now finds it difficult to bury the dead children. Chandi is forcibly separated from her husband and her son when she is accused of being a "bayen," as she lactates at the time of burying. A bayen is a kind of witch who nurses and suckles dead children and casts evil spells on living children. By convention, a bayen is not killed but is isolated from the community. Separated from

her husband and son and branded as a witch, Chandi spends her life in utter poverty and humiliation. Chandi's life of ostracism comes to an end when she jumps in front of a running train to save the train and its passengers from an armed robbery and an accident, as the robbers blocked the railway track with a huge pile of bamboo sticks. Her courageous act gets government recognition, and she is given a posthumous reward. Receiving the reward on behalf of his mother, Bhagirath declares that she was his mother, not a bayen.

In portraying the distorted mother-child bond in "Bayen," Devi shows motherhood or, more precisely, the maternal body as a site of oppression through repeated reference to Chandi's breastmilk in the text. When people see Chandi next to the dead children's grave at an odd hour of night, she says, "No, no, I'm not a Bayen! I have a son of my own. My breasts are heavy with milk for him" (Devi 11). Chandi here seems to be claiming the ownership of her breastmilk, which she argues is for her son and does not make her a bayen. People suspect her of being a bayen when a drop of her breastmilk drips to the ground when she buries her niece. The repeated allusion to breastmilk has important implication in the text: it encapsulates a struggle between two opposing forces. On one hand, the breastmilk reaffirms Chandi's maternal identity to herself, as she claims its possession in the above-mentioned statement. The narrator mentions Chandi's breastmilk when Chandi is away for work from her son (before being branded as a bayen): "Her breast ached with milk if she stayed too long in the graveyard" (8). This bodily reaction and response to one's separation from the child, in a way, underlines the intimate connection between them. On the other hand, Chandi is eventually forced to separate from her son and, thus, deny him her milk. This absolute negation of one's right over her own breastmilk and the evil connotation being attributed to it by the society emphasize her vulnerability as a mother, and evince the ways social oppression impinges on the very survival of the mother-child relationship. The maternal body, thus, becomes the trope of maternal agency, which is curbed by the community's orthodox and superstitious belief.

To provide a nuanced analysis of the maternal in both texts, I must situate Devi's work in the context of perceptions of motherhood in Bengal, specifically to locate her work within the sociocultural context and also to argue how Devi deliberately breaks away from the

conventional patriarchal, nationalist, and religious ideas of motherhood while foregrounding the mother's inner journey from victimhood to agency. Discussing the anticolonial uprising of 1940s, Jasodhora Bagchi suggests that the mother image it projected was "a combination of the affective warmth of a quintessentially Bengali mother and the mother goddess Shakti, known under various names as Durga, Chandi or Kali, who occupies a very important position in mainstream religious practice" (66). Bagchi, here, indicates the invocation of motherhood in the nationalist struggle in Bengal, where alongside the image of the mother goddess (of the Shakti cult with more fearsome and destructive aspects), there is an affectionate and a caring figure of the traditional Bengali mother.

The pervasive glorification of motherhood stems from the religious traditions of worshipping the mother goddess among all classes in Bengal. Anthropologists have traced the "mother cults in local village level practices … some of these have been related to realities such as fever epidemics" (Bagchi 66). Thus, a powerful idea of motherhood prevails in Bengal, which has varied manifestation in different social classes and castes. In Bengal, the mother goddess has both creative and destructive aspects: whereas Lakshmi represents wealth and prosperity, the goddesses of the Shakti cult—Durga, Chandi and Kali are the ones with fearsome aspects—are destroyers of evil and miscreants. According to Sudhir Kakar, Bengali culture is exceptionally prone to destructive or threatening aspects of the mother goddess. However, Bagchi argues that "The Shakti cult among Bengalis, paradoxically enough, is upheld by the affective qualities of a son's yearning for the mother" (67). Bagchi is indicating the way in which worshipping and the invocation of these fearsome mother goddesses is done through a tender and familiar image of a son's affectionate yearning for his mother (Bagchi 68).[2] Even in using the image of the Bengali "Ma" as the motherland—caring, loving and victimized by colonial power—nationalists also employed this strong and destructive force of the mother goddess. In relation to nationalist vision on motherhood and motherland, Tanika Sarkar argues the following: "The mother, however, is not just a figure signifying enslavement. Feminine cults also represent power, an image of resurgent and fearful strength … there is a curious blending … of the principles of abject victimhood and triumphant strength in the polysemic iconography deployed around

the mother" (253). In other words, the ideals of motherhood invoked by the nationalists carried an ambivalent connotation. Whereas on the one hand, the image was a mother figure colonized by a foreign enemy, on the other hand, it was fierce and destructive female power embedded in the concept of Shakti. This mother image in nationalism was drawn not only from mainstream religious practices but also from rural areas and folklores. Concerning the cult of the mother goddess in lower social classes, Sudhir Kakar states that "The presence of the mother goddesses at the lower reaches of society is usually associated with such poverty and deprivation that many of the mother goddesses were forces of the dark to be propitiated" (67). This complex ideology of motherhood in all sections (both urban and rural areas) of society in Bengal should be kept in mind while examining Devi's texts, as they are firmly grounded in this sociocultural setting. Her characters experience the constructions of motherhood even as they deviate from them. What is more, the subaltern mothers' experiences of multiple oppression and eventual separation from their children, as well as their resistance, demystify and unsettle the construct of motherhood eulogized in nationalist and religious discourse. Thus, they create parallel narratives, which, in an indirect way, resonate with the idea of the powerful and affectionate image of the mother.

Devi's protagonist, Chandi, shares her name with the goddess Chandi, who presides over the Shakti cult. Keeping in mind this glorification and the importance of motherhood in Bengal society and culture, it could well be said that Devi's story uncovers the hypocrisy that lurks behind this normative glorification. A powerful hold of the mother goddess both in upper and lower classes and different castes of Bengal—and its deployment in nationalist struggle—did not empower actual mothers. However, a close reading of the text suggests that Devi's portrayal subtly retains the ambivalent overtones of the mythical and cultural concept, embedding them in a maternal perspective. Chandi is a fearless woman who is proud to be a descendant of Kalu Dom and to have inherited a profession that is unwomanly. The author observes that "the word 'fear' was foreign to Chandi" (6). But Devi shows her tender side as well when Chandi feels the weight of her traditional profession on her maternal body,

> God ... God ... God ... Chandi would weep softly and rush back home. She would light a lamp and sit praying for Bhagirath. At

those times she also prayed for each and every child in the village that each should live forever.... Because of her own child, she now felt a deep pain for every dead child. Her breast ached with milk if she stayed too long in the graveyard. (8)

In the above-mentioned passage, the author reveals Chandi's vulnerable side, quite unlike her fearless nature. Through Chandi's yearning for her son, her lullaby, which hovers over the story indicating her unfulfilled motherhood, and her motherly feelings for every child, the author shows Chandi's qualities traditionally attributed to women. To reflect theoretically, Chandi's motherhood transforms her from within, and she, in her newly acquired maternal identity, goes beyond biological motherhood. However, in this localized account of motherhood of the subaltern, there is hardly any scope for the subaltern mother to reflect upon her maternal consciousness. She has to act to reclaim her motherhood, as Chandi did through her courageous sacrifice.

Chandi's sacrificial death to save the people from an armed train robbery also evokes both the strong and compassionate qualities of a mother, which comes closer to the mythical and cultural religious perception of the goddess—a blending of the archetypal Bengali "Ma" full of love and affection and a fearless woman of indomitable strength. I concur with critic Radha Chakravarty's contention that through her defiance of the social labelling of bayen by saving those who victimize her, Chandi claims a place in history (101). In relation to Chandi's death, Chakravarty writes "she dies, as she lives, alone and larger-than-life, in an act of heroism that once again elevates her above the common mass of humanity" (101). Although it is true that Chandi's sacrificial death accords her an elevated position previously denied because of her class, caste, and gender, the death reflects her victimization as well, as she becomes a figure deified on the ground of her sacrifice. More than the heroic elevation, the decisiveness of her final act, in my estimation, is an attempt to reclaim the lost agency that has been negated through severing the bond between the mother and the son. It is undeniable that the final sacrifice, as Chakravarty rightly observes, endows a posthumous recognition to their mother-son relationship with the son publicly re-establishing their long-lost connection. However, what is striking here is the acute sense of loss that permeates this entire mothering experience. This double trajectory

of loss and gain is enmeshed in the core of maternal narrative in so much as the motif of the mother without child in the text disturbs any simple formulation of the mother as a victim or agent. Therefore, it would be problematic to simply glorify Chandi's sacrifice without being conscious of the peculiar and complex nature of her maternal agency, which has contradictory implications.

Devi positions her protagonist in her history: Chandi takes pride in being the descendant of Kalu Dom, who sheltered legendary King Harischandra and received all of the world's burning cremation grounds in return for his favour. Through invoking this mythical story of Kalu Dom and Harishchandra's gift of all the cremation grounds generation after generation, Devi foregrounds the systematic exploitation of the lower caste—how they have been deprived and oppressed for generations. To highlight the ongoing marginalization, Devi also addresses the present situation. Malindar, Chandi's husband, is the only person in the Dom community who can sign his name.[3] Their son, Bhagirath, goes to a school where the boys from the Dom community are looked down upon and expected to keep a distance. Bhagirath learns from school that the Indian constitution, in its 1955 Untouchability Act, abolishes untouchability and gives equal rights to everyone, but the evident disparity surprises his innocent mind. Significantly, being a woman of this continually exploited caste, Chandi is doubly marginalized. In the story, Chandi's maternal identity has been discarded by the superstitious beliefs and practice despite the conventional veneration of motherhood in the same context, considering the pervasive worshipping of the mother goddess in local village cults. Chandi's maternal exploitation highlights gendered power relationships within this rural setting. Shamik Bandyopadhyay rightly argues that the story not only protests the inhuman superstition, it "touches the larger space of the social forces that separate mother and son in a male dominated system" (xiii). I would add that this separation instigates a peculiar instance of maternal agency that is grounded in the subaltern situation in which a subaltern mother is either not allowed to act (considering the protagonist's life of impoverishment and isolation) or she carries out the final act of resistance through death.

The Divine Mother in "Ma, from Dusk to Dawn"

Contrary to the forced mother-child separation in "Bayen," the absence of the child in the story "Ma, from Dusk to Dawn" is somewhat partial, which makes it even more complex. The protagonist, Jati, is a woman belonging to a nomadic tribe, and she assumes the role of a spiritual mother after the death of her husband. This masquerade of spiritual mother dictates that she should be called "Jati Thakurani" ("thakurani" is a Bengali word used to address a woman with divine power) during daylight hours when she is only a divine mother offering blessing to her devotees and accepting their material offerings (food or money) in return. But during that time, she cannot be a human mother of this mortal and mundane world. She can function as a human mother and can be called "ma" (Bengali word for mother) by her son from dusk until dawn. During the last days of her life, Jati cannot continue the disguise anymore and longs to hear her son address her as "ma."

In this story, Devi's protagonist uses spiritual motherhood as a tool, an instrument for her survival. Being a young widow of a lower class and caste and to protect herself from sexual exploitation and to protect the life of her son, she takes up the disguise of a spiritual mother. Crucially, in her chosen role, she offers spiritual bliss and gets honour and respect from those who would otherwise oppress her. One example of this is the upper-caste Brahmin "Anadi-daktar" (a Bengali word for doctor)—a quack who regularly pays "obeisance to Jati Thakurani's feet with offering of oil-coconut-rice-salt" (Devi 5). This episode illustrates how successfully Jati has not only resisted the potential class, caste, and gender exploitation but also manipulated and reversed the dominant hierarchy. Moreover, as mentioned, this camouflage is actually her means of mothering, as she feeds her son with the income and often remains unfed herself. However, to perform her mothering (in the sense of nourishing and preserving the life of child) she, ironically, has to separate herself from her child. Importantly, this is not a physical separation but one that demands that the mother denies her maternal love for her child. In other words, although they are not forced to live without each other, their love is curtailed and rendered inadequate to feed into the idea of the spiritual mother, which becomes essential for their mere survival. An intense sense of unrequited love characterizes this relationship, as Jati even during the day cannot help but plead to her son, "Call me Ma, Sadhon," whereas Sadhon in a

similar angst says to the doctor, "How my heart bursts out, how I long to call her Ma, sir! Then! When it's dark, I'll put my head in her lap, call her Ma! Ma! Ma! To my heart's content" (8). This yearning of the mother and the child for each other almost enacts a tragedy born out of a hostile situation—divulging the impossible space that the mother without child occupies in her subaltern position. Nonetheless, despite the tragedy, one can discern the struggle and resistance that this repressive context gives rise to and how it forms an alternative version of mothering.

As with "Bayen," Devi situates her protagonist in her historical and social context, and embedded in mythological tales, which the protagonist herself recalls. In her delirium, Jati says, "Our tale is the most incredible! My ancestor is Jara the hunter, himself. Heard of him? ... We say Jaara the hunter. Our tongues sound different" (Devi 12). The Jara are traditional hunters who are believed to be of the community who killed the highest Hindu deity, Lord Krishna, and were, thus, doomed to a nomadic life devoid of a stable habitat. Recalling the myth positions the character within her history and social setting while the readers get to know the specific sector the protagonist inhabits. I would insist on the significance of this specificity of the subaltern, which is important to understand the complex experiences of mothering that are peculiar and unique to different women belonging to different classes, castes, and religions.

What is significant about Jati is the way in which she, as a mother, deploys strategies to combat gender, class, and caste oppression in order to raise her son. The narrator movingly narrates Jati's mothering as sustained by her spiritual disguise and the meagre earnings that this disguise brings her: "Not money, not a single cowrie shell, only a *pali* of rice was what Jati Thakurani asked in exchange. Come dusk, Thakurani would become Sadhan's Ma again. The rice she earned as Thakurani, she would then cook as Ma and feed to her idiot son" (Devi 6). Through these lines, Devi reveals a mother's sheer struggle for her child, wherein her mothering is ironically premised upon the very absence of the child. Crucially, this simultaneous presence and absence of nurturing, both literally and figuratively, does not conform to any convenient category of the maternal—good or bad, successful or unsuccessful—rather it lends itself into the construction of a maternal subject laden with contradiction and ambivalence.

Apparently, Jati's decision and her survival strategy may seem to have empowered her. Although it certainly indicates her strength and stamina—the way she manipulates the system to bow down to the feet of a tribal woman—examining it more closely, we can discern Jati's choice is a result of a constraint and a compulsion. She is compelled to take up this role, which denies her the maternal affection she wants to express for her son, but ironically enough she does this out of profound maternal love for her child and to sustain his life. Jati's motherhood denotes a complex connotation of maternal agency that emerges as a resistance to an oppressive system (patriarchal, unequal, class, and caste divided) but remains circumscribed.

The author attacks the class and caste separation and a pervasive influence of religion in the following passage. After putting on the attire of a spiritual mother wearing a red cloth, Jati travels in a train without experiencing any trouble from fellow passengers. It reminds her of her husband's futile effort to change their last name in order to be considered as upper caste: "Jati had been gazing out through the window, her eyes flooded with tears. How the people respected her, honoured her. Was this what it was like, then? To move up in life? Alas, if only Utsav were present, he could see how no court, no official paper had been needed. Only a cloth and trident had promoted Jati's caste, elevated her class" (28). In this passage, the author, in biting irony, points towards the wide gap between upper and lower class and caste, but, at the same time, she poignantly shows her protagonist developing an understanding of the ways of the world. These two religious symbols, the red cloth and the trident, act as her weapon to protect herself and also to gain respect.

At the end of the narrative, Jati's son Sadhan performs the funeral works of his mother, but he snatches the offering (rice) from the priest he gave in the name of her mother. Hungry as he is, the smell of rice is irresistible for him. In the penultimate paragraph, when a bereaved Sadhan cooks rice and remembers his mother, the author says the following: "The smell of rice, such a lovely smell. The smell brings his mother close, once again. As long as Sadhan cooks rice, eats hot rice, his *shanjh-shokaler Ma* will stay close, safe and secure" (36).[4] For Sadhan, mother and food are inseparable; in the very smell of rice, with his full stomach, his mother will stay close to him. The image of the quintessential Bengali "Ma"—a caring, affectionate, and

sacrificing figure is prominent here—and it also metaphorically denotes the image of the benevolent mother goddess offering food and sustenance and preserving life. Devi endows her character with the value of love and care traditionally attributed to women, but her portrayal seems to destabilize the dominant interpretation of these values (exclusively for women and extensively followed by them) and to prioritize mothering as a strategy for resistance.

As is evident from the discussion, history is an important aspect of Devi's writing. Devi argues the following: "Literature should be studied in its historical setting ... to capture the continuities between past and present held together in the folk imagination, I bring legends, mythical figures and mythical happenings into a contemporary setting, and make an ironic use of these, as I do with the Dasharath story in my *Pindadan*, and legend of Kalu Dome in my *Bayen*" (Devi xii). Devi's comment stresses the importance of considering history while analyzing a literary text as she makes ironic uses of prevalent myths and legends to historicize her character. The legend of Kalu Dom and Jara's alleged killing of Lord Krishna—and more broadly, mythical stories incorporated in the story like oral history—suggest a continued form of exploitation of the lower class and caste. The textual mothers are representative figures of those marginalized sections whose mothering experiences and separation from their children emanate from such exploited conditions. Elaine Tuttle Hansen, in her discussion of the mother without child, writes "Stories of mother without child individually and collectively refuse to let us forget that experiences of motherhood depart from theories that would inform them, and they also insist on embedding mothers in specific historical communities and groups" (17). Paying heed to Hansen's argument, I have attempted to highlight the historical and contextual issues that affect the experiences of motherhood.

Conclusion

If these texts are posited in relation to the larger issue of feminism that prioritizes gender equality, feminist Chandra Talpade Mohanty's argument provides a crucial point here: "To define feminism purely in gendered terms assume that our consciousness of being woman has nothing to do with race, class, nation or sexuality" (12). These texts

validate Mohanty's argument: to focus solely on the concept of gender in these two short stories would yield a partial or incomplete analysis. As such, motherhood in both these texts is intimately linked with the subaltern contexts. In "Bayen," Chandi's forced separation from her son, and her impoverished, inhuman life, owe much to her lower caste status, in which, she, being a woman, is more vulnerable to oppression. Being a member of a socially marginalized tribe, Jati is also susceptible to different oppressions. Their specific situations shape and form their experiences of motherhood and account for their separation from their children.

Emphasizing both the protagonists' lower caste (and class) status is not to generalize their representation; it is rather to indicate the differences that facilitate the notion of the contingent nature of maternal subjectivity and agency. By contingent motherhood, I mean a concept of motherhood that is context specific, flexible, and is dependent on intersectional and interdependent factors of class, caste, religion, and so on. If "Bayen" projects the involuntary and forced separation between the mother and the child, Jati's story complicates this division of voluntary and involuntary. Devi deftly maps the trajectory of her textual mothers in contrasting ways: whereas one is seen as an evil mother, the other is seen as a spiritual mother. However, both of these extreme opposite positions, in a way, deviate from the conventional idea of motherhood, which makes them, to use Susan Rubin Suleiman's words, "mother and outside the father's law at the same time" (166).

In Chandi, the victimhood of the mother is more pronounced; she exemplifies the tragic mother, forever yearning for her child, and whose voice is rendered silent in a patriarchal, caste-ridden society. However, her final act of regaining her maternal identity challenges the idea of abject victimhood. In contrast, Jati's agency is strikingly visible; she voluntarily separates herself from her son only to mother him. The mother without the child in this story illustrates a particular situation wherein the mother emerges as a powerful individual equipped to confront her oppression, but she has to pay high price for this. Motherhood, as presented through these two maternal figures, in fact, occupies a tension-ridden space in which both agency and victimhood stand uncomfortably.

The religious elevation of the mother goddess plays a crucial role in

both the texts, however differently. In the case of Chandi, an evil force, a perverted maternal desire, is imagined to threaten society's collective consciousness. In contrast, the idea of spiritual motherhood serves as an escape route from the oppression. The protagonists' experiences of mothering bring about a transformation in their character when considering Jati's strategic guise of spiritual mother to save her son and Chandi's reluctance towards her inherited profession. Notably, they do not reflect on this transformation but act to respond to the situation that life drives them to. Devi seems to be more concerned with the issue of agency, or the lack of it, rather than to chart the interiority of the mother figures, perhaps because of the crucial and determining factors of class and caste, which impact on the experience of mothering and the formation of maternal consciousness. Devi's representation of the maternal emphasizes how the traditional deification of motherhood has been unable to empower mothers, rendering them materially powerless (Devi's protagonists, male and female, are, however, mostly disempowered); moreover, her texts engage with the more complex issue of subalternization and gender politics operating across different social levels. The two stories offer an ambivalent and contradictory image of motherhood, which renders maternity as a problematic site of oppression and agency. Moreover, they offer a counter-narrative to the prevalent patriarchal nationalistic discourse of motherhood and gesture towards the specific intersecting forms of exploitation to which subaltern women are subjected and how they evolve their strategy to combat exploitation.

Endnotes

1 "Bayen" was later transformed into a play like few other short stories and novel such as *Mother of 1084*. The primary reason for this change of form was to reach a larger audience (many of whom are illiterate and under-privileged) by means of performance.

2 A popular genre of music called "shyama sangeet" consists of religious and devotional songs addressed to Shyama, another name of the goddess Kali. The songs are typically composed as a son's yearning for his mother. Ramprasad Sen, a devotee of Kali in eighteenth-century Bengal, composed the songs, which are still popular both in urban and rural Bengal (Bagchi 67).

3 The marginalised "Dom" community consists of Hindu low castes whose caste-assigned job is to cremate dead bodies.

4 "Sanjh-sokaler Ma" is the Bengali phrase for "mother from dusk to dawn." The translator, Radha Chakravarty, has kept the Bengali phrase throughout the story.

Works Cited

Bagchi, Jashodhora. "Representing Nationalism: Ideology of Motherhood in Colonial Bengal." *Economic and Political Weekly*, vol. 25, no. 42, 1990, pp. 65-71.

Bandyopadhyay, Samik. "Introduction." *Mahasweta Devi: Five Plays*, Seagull Books, 1997, pp. xii-xv.

Basu, Lopamudra. "Mourning and Motherhood: Transforming Loss in Representations of Adivasi Mothers in Mahasweta Devi's Short Stories". *Rites of Passage in Postcolonial Women's Writing*, edited by Pauline Dodgson-Katiyo and Gina Wisker, Rodopi, 2010, pp. 129-148.

Chakravarty, Radha. *Feminism and Contemporary Women's Writings: Rethinking Subjectivity*. Routledge, 2008.

Chaturvedi, Vinayak. "A Critical Theory of Subalternity: Rethinking Class in Indian Historiography." *Left History*, vol. 12, no. 1, 2007, 9-28.

Devi, Mahasweta. "Bayen." *Separate Journeys*, translated by Mahua Bhattacharya and edited by Geeta Dharmarajan. University of South Carolina, 2004, pp. 1-14.

Devi, Mahasweta. "Ma, from Dusk to Dawn." *In the Name of the Mother*, translated by Radha Chakravarty, Seagull Books, 2004, pp. 1-36.

Ghatak, Maitreay, editor. *Dust on the Road: The Activist Writings of Mahasweta Devi*. Seagull, 1997.

Gramsci, Antonio. *Selection from Prison Notebooks*, translated by Quintin Hoare and Geoffrey Nowell, Lawrence and Wishart, 1978.

Guha, Ranajit. "On Some Aspect of Historiography of Colonial India." *Selected Subaltern Studies*, edited by Ranajit Guha and Gayatri Chakravaty Spivak, Oxford University Press, 1988, pp. 37-44.

Hansen, Elaine Tuttle. *Mother Without Child: Contemporary Fiction and Crisis of Motherhood*. University of California Press, 1997.

Kakar, Sudhir. *The Inner World: A Psychoanalytic Study of Childhood and Society in India*. Oxford University Press, 1978.

Mohanty, Chandra Talpade. *Third World Women and the Politics of Feminism*, edited by Chandra Talpade Mohanty et al., Indiana University Press, 1991, pp. 1-47.

Pawar, Urmila. "The Cross a Woman Carries." *Janani – Mothers, Daughters, Motherhood*, translated by Asha Damle and edited by Rinki Bhattacharya. Sage Publication, 2006, pp. 73-79.

Suleiman, Susan Robin. *Subversive Intent: Gender, Politics and the Avant-Garde*. Harvard University, 1990.

Sarkar, Tanika. *Hindu Wife, Hindu Nation: Community, Religion and Cultural Nationalism*. Permanent Black, 2000.

Spivak, Gayatri Chakravarty. "Can the Subaltern Speak?". *Marxism and the Interpretation of Culture*, edited by Cary Nelson and Lawrence Grossberg. McMillan, 1988, pp. 271-313.

Chapter 9

Towards Reproductive Justice: Single Mothers' Activism against the U.S. Child Welfare System

Shihoko Nakagawa

Introduction

Poverty, race, and single motherhood are three key factors that disproportionately affect family involvement with child welfare services in the U.S. In 2011, 70 percent of children with single parents (22 percent of children overall) lived in poverty in the U.S. (Addy et al.). It is undeniable that poverty has negative effects on child wellbeing, particularly manifested through "family and environmental stresses, lack of resources and investments, and the interplay of social class/cultural patterns and poverty" (Danziger and Danziger 263). That being said, historically, single motherhood and neglect were mutually and simultaneously constructed as social problems; many of the defining indices of child neglect were essential to the survival of families headed by single mothers (Gordon 84). As part of welfare rights organizations, single mothers have actively organized to challenge the welfare and child welfare systems.

This chapter explores how single mothers respond with activism to poverty governance executed in the U.S. child welfare system. Poverty governance refers to the ways that governments employ a variety of

policy tools and administrative arrangements in order *not* to end poverty. In this sense, governance secures the cooperation and contributions of poor people through politically viable ways to ensure the smooth operation of societal institutions through civic incorporation, social control, and the production of self-regulating subjects (Soss et al.). The burdens of people who live and work in poverty are indispensable to maintain the quality of life that most people have come to expect (Soss et al.; see also Nakagawa, "Single Mothers"). This chapter explores how the activism by single mothers, especially mothers separated from their children by Child Protective Services (CPS), has challenged the regulation of reproduction and poverty governance through child welfare based on their narratives.[1] It is crucial to note that these mothers overwhelmingly believe they never abused or neglected their children. Few studies have documented and examined organized activism that challenges systemic oppression in the U.S. child welfare system (e.g., Tobis).

Through social welfare policy, the state has long intervened in gender relations. At present, the neoliberal restructuring of welfare includes the creation of workfare—enforcing work while residualizing welfare (Peck 10)—for persons in need of income support. A notable example in the U.S. is Temporary Assistance for Needy Families (TANF). Introduced in 1996, TANF replaced the Aid to Families with Dependent Children (AFDC), which had been in effect since 1935. Through the implementation of TANF, many single mothers lost the income support they were previously entitled to receive as full-time care providers. Now, in most states, single mothers must work unpaid full-time (thirty hours or more) to fulfill the work requirements to receive TANF (Hill 39).

Simultaneous to these welfare policy changes, foster care caseloads expanded rapidly throughout the late 1980s and the 1990s (Berrick 28); they more than doubled from 1985 to 2000 (Swann and Sylvester 309). The growth in foster care caseloads has mainly affected families headed by single mothers, disproportionately impacting racialized mothers for their overrepresentation in the caseloads. Moreover, there is an apparent overlap between families who receive public assistance and those that are involved with child welfare services (Courtney et al.).

Given these interconnected dynamics, the following are some important questions. What is the nature of single mothers' activism

against child welfare services? How have mothers challenged poverty governance in the child welfare system? And what are the implications of their activism regarding reproductive justice?

The remainder of this chapter is structured as follows. First, I give an overview of poverty governance in the U.S. child welfare system and single mothers' activism against child welfare services. Second, I examine mothers' narratives as important examples of activism, and discuss the implications of single mothers' activism on reproductive justice.

Poverty Governance in the U.S. Child Welfare System

In 2011, in the U.S., there were approximately 742,000 instances of confirmed child maltreatment, and approximately 407,000 children were in foster care (USHHS, "Child Welfare Outcomes" 2). Most child maltreatment cases (more than three-quarters), involved neglect and were not classified as abuse (USHHS, "Child Maltreatment" 20). However, as Dorothy Roberts differentiates, "Most neglect cases involve poor parents whose behavior was a consequence of economic desperation as much as lack of caring for their children" (*Shattered Bonds* 34). The welfare reforms initiated in 1996 mark an important shift that has resulted in impoverished single mothers experiencing an even greater degree of poverty, homelessness, and precarity. These conditions lead specifically to a lack of childcare and staying in abusive relationships, which are commonly assessed by the child welfare system as harm or risk of harm to a child. In the current child welfare system, in which the poor are criminalized and punished, these dynamics are used as a reason for the out-of-home placement of children (Nakagawa, "Single Mothers"). The focus on protection by assessing the material wellbeing of children under these contexts results in the likelihood that children placed in foster care come from families with single parents with very low incomes (Berrick 23) and are disproportionately racialized. In the U.S., in 2015, 55 percent of the children in foster care were racialized (USHHS, "AFCARS Report #23" 2). In New York City alone, 96% of the children in foster care in 2007 were racialized children (Tobis xxiv). Children in communities of colour, particularly from poor Black or African American[2] neighbourhoods, are overrepresented in the foster care population

(Roberts, "The Racial Geography of Child Welfare" 127).

This disproportionality in the U.S. child welfare system along class and racial lines has been brought about by poverty governance exercised in child welfare practice. The U.S. child welfare system has become one of the many sites for poverty governance in which the material and symbolic interests of dominant agents and major social institutions are implicated and played out (for example in the criminal justice and workfare systems). Understanding how the child welfare system has been developed and shaped by federal and state policies helps to illuminate how "policy is embedded in the culture that produces it, and is best seen as a cultural practice of governance" (Campbell 7). In this way, policy involves "a dual process of subject formation that simultaneously constitutes those who govern and those who are governed" (Campbell 44).

Since the 1970s, child welfare policy and the shifts in reforms reflect a system that has turned from family preservation to adoption. Adoption has been promoted through two initiatives introduced by the Adoption and Safe Families Act (ASFA) of 1997 (PL. 105-89). These initiatives are: 1) shorter timelines for the termination of parental rights (TPR) (e.g., Smith and Donovan) and; 2) adoption incentive bonuses (e.g., Maza). A third contributing factor is the child welfare funding structure (Schwartz and Lemley; DeVooght et al.), which has promoted the privatization of child welfare services (Freundlich and Gerstenzang). Altogether, privatized child welfare agencies have been incentivized to increase profits by moving more children into adoptive homes. Indeed, federal adoption assistance expenditures rose to 1.3 billion dollars in the fiscal year of 2002 (Hansen 1412) from 43 million dollars in the fiscal year of 2000 (Maza 445).

These policies constitute and are constituted by an underlying discourse about who counts as deserving of motherhood in the U.S. as a cultural practice of poverty governance. Several policies in particular are suggested as intervening into who is deserving of motherhood. For example, "in the 1960s and 1970s, poor women of color were the targets of coercive and punitive sterilization efforts in federally funded birth control clinics and in state legislatures" (Nelson 184). Jennifer Nelson points out the historical connections of this policy to the Hyde Amendment (1976), where Medicaid (federal health insurance program for the poor) excludes most abortions from being funded while

simultaneously funding sterilization. Reproductive rights activists point out that "poor women who want to limit their fertility temporarily might choose to be sterilized because they anticipate not being able to afford an abortion if other forms of nonpermanent contraceptives fail" (Nelson 181-182).

Contemporary child welfare policy is not separated from its historical legacies. Single motherhood and Black or African American women's bodies have become symbolic of so-called bad motherhood in the practice of child welfare policy. This type of socially constructed and situated badness is then leveraged to forcibly separate mothers from their children (e.g., Roberts, *Shattered Bonds*; Nelson; Flavin). Black or African American children are twice as likely to be removed from their homes and are less likely to be given family-based safety services (Rivaux et al. 153).

The cultural frames (re)configured by child welfare practice have created the normative model of motherhood, which is founded on racism, sexism, and classism. Moreover, in the child welfare system, the normative model of motherhood (that is investigated and enforced by CPS) has been significantly shaped by neoliberalism. For example, children's basic needs must be solely met by the parents (Roberts, "Prison" 1490); therefore, child protection interventions focus more on the blame worthiness of individual parents than on oppressive social conditions and a shared accountability for child welfare (Davies et al. 623).

Child protection, then, is closely connected to mother-blame (Davies et al., 623) for their poverty. When single motherhood is widely stigmatized and racialized—such as with "Black maternal unfitness" (Roberts, "Prison" 1486)—anyone who cannot satisfy the expectations of being an economic provider and a caregiver can become a bad mother. This kind of discursive thinking hides the larger social problems and social structures that cause poverty and racialized poverty in the first places.

Within systems that are built upon patriarchal ideologies of gender, race, class, and family, single motherhood in particular is viewed as a problematic behavior. If mothers are single, then they have an increased risk of being confirmed as bad mothers in the child welfare system because their presence challenges heteronormative ideas of relationships, childrearing, and family. Once identified as a bad

mother, women must show compliance and deference to their case plans and workers, who represent the state and the normative way of family life. However, the services for impoverished mothers are mainly related to behavioural corrections. Parenting classes and therapy, concerned with fixing behaviours that cause maltreatment, are examples. Meanwhile, the difficulties in balancing wage and caregiving work, inadequate income from paid employment, lack of housing, transportation, childcare, and/or money for things like food or utilities (Wells and Marcenko 421)—the very factors that are used to justify involvement of child welfare services in the lives of poor and single mothers—remain unaddressed (Swift and Callahan 189). The issue of housing strongly highlights these tensions. In 2015, 27,002 children (10 percent of all children federally removed to foster care) were removed to foster care for reasons of inadequate housing (USHHS, "AFCARS Report #23" 2). It is curious to consider how parenting classes are supposed to improve housing problems and help women to find safe and accessible homes for their families.

Regulating who can and should be a mother is a central component underlying the substance of the child welfare system, which is built on racial hierarchy, such that it is necessary to reinforce racial inequality at the social level through disproportionalities in race, class, and marital status at the system level. As Roberts states, "government authorities appear to believe that maltreatment of Black children results from pathologies intrinsic to their homes and that helping them requires dislocating them from their family" (*Shattered Bonds* 17). Racialized children removed from their homes by child welfare services are usually placed in White foster or adoptive families (CWLA). Thus, Andrea Smith claims that the current child welfare system continues a legacy of the boarding/residential school systems experienced by Indigenous children in the U.S. and Canada. It functions as a racist and genocidal colonial policy that aims to give so-called civilizing instruction to racialized children through cultural genocide (*Conquest* 35-54). It is important to note that the rate of Indigenous children in foster care in the U.S. is also disproportional to nationwide population statistics (USHHS, "AFCARS Report #23" 2).

The U.S. child welfare system reproduces the disproportionality at all levels of policy philosophy, design, and implementation because the system responses the harshest to people that are the most marginalized.

The more mothers transgress the normative model of motherhood (not having resources, being poor, being Black or African American or racialized, and/or being single), the more likely they are to already experience marginalization, let alone being punished by the child welfare system. Capitalist economic systems govern the poor based upon racial and gender hierarchies and exploitations that are historically rooted in colonial, imperial, and slave encounters. The result is a contemporary racial geography of the state's custody of children that attempts to hide both its historical and new gender and racial injustices. It is in this context of poverty governance in the child welfare system that mothers' activism has begun.

Single Mothers' Activism against Child Protective Services

In order to demand reunification with their children and/or to challenge the oppressive child welfare system in the U.S., both individuals and collectives have organized against child welfare services. Even though this is a rich site of resistance to societal injustice, few studies have documented and examined this kind of activism (e.g., Tobis). Welfare Warriors (WW)[3] and Every Mother Is a Working Mother Network (EMWMN) are examples of organizations engaging in activism. For these organizations, welfare rights are clearly women's rights, so welfare rights directly connect to child wellbeing and child welfare (Nakagawa, "More Us").

WW distributes copies of their quarterly newspaper, *Mother Warriors Voice*, across the U.S., so that mothers can share their child welfare horror stories as well as survival guides. This has encouraged some mothers to create their own groups—for instance, Mothers of the Disappeared of Portland Organizing to Win Economic Rights (POWER) (Portland, Maine) and Stand for the Children (Hawaii) (Gowens, "DHS"). Having heard about the organization or having read its newspaper, many mothers from across the U.S. have contacted WW to request reunification help as they believe that they never abused or neglected their children.

Collectively, activist mothers, separated from their children through child welfare intervention, have demanded that their own local child welfare services develop proper legal procedures, such as providing evidence of neglect or abuse, and fair hearings to mothers.

The lobbying by activist organizations prompted representative Gwen Moore to introduce a bill in the House in 2012 "to provide funds to state courts for the provision of legal representation to parents and legal guardians with respect to child welfare cases" (Enhancing the Quality of Parental Legal Representation Act of 2011). Unfortunately, this bill was not passed (H.R. 3873, 112th Cong. 2012). Had the bill passed, the funds could have significantly improved the quality of legal representation for parents and legal guardians (e.g., Tobis).

In addition, mothers' groups have organized many protests, demonstrations, events, vigils, speak outs, and support groups in response to the child welfare system. For example, EMWMN organized the advocacy group DHS (Department of Human Services)/DCFS (Department of Children and Family Services) Give Us Back Our Children in Philadelphia and Los Angeles. In 1992, WW created a weekly support and advocacy group called Mothers and Grandmothers of Disappeared Children (MaGoD). All of these groups participate in an international feminist network called Global Women's Strike, which involves working towards the recognition of and payment for all caregiving work.

As part of their support and advocacy, MaGoD of WW created survival plans for their members. They created a telephone tree so that they could call one another after a visit with their children. This telephone tree was an important source of support, since mothers suffered the loss of their children the most after these visits. In addition, mothers share the names of helpful professionals and attend each other's court cases whenever possible. Although women offering support to one another are not allowed to go inside the court rooms due to children's confidentiality, they still accompany one another to the court buildings (Gowens, "DHS").

WW also tries to inform and encourage mothers (both locally and across the U.S.) to "demand a jury trial, if they take your child." For too many women, by the time they find WW, they have already lost their right to a trial by either judge or jury (Gowens "DHS"). According to WW, most often, the mother is not informed that she has a right to a jury trial within thirty days of the children's removal. Instead, mothers are urged to agree with the court's jurisdiction (48 Wis. Code. Sec. 13 [4]).

To reach as broad an audience as possible, EMWMN created the

film, "DHS (Department of Human Services): Give Us Back Our Children." In the film, mothers and a grandmother talk about their battles to reunite their families after the Philadelphia Department of Human Services took their children (Gowens, "DHS"). This film became an important vehicle in activists' tactics to bring about change (Gowens, "DHS") and to educate people about the reality of the child welfare system. WW and EMWMN also organized the first annual, international week of "Stop the War on the Poor" in July 2014, and demanded the end of what they consider the wrongful removal of children as one of their demands in Washington D.C., Milwaukee, Los Angeles, Philadelphia, San Francisco, Ireland, and London, England.

Although these groups have played a pivotal role in fighting for the rights of mothers and children in poverty, they have received little support from other advocacy groups and activists—they have few activist allies—not to mention the general public. Whereas feminist and welfare rights activists helped shape the U.S. welfare system, more recently U.S. welfare politics has also shaped activism. Resources are usually allocated for particular kinds of feminist or welfare issues, and not for others (Reese 32). Even though WW and EMWMN have influenced policy outcomes less than other welfare rights groups, they continue to contribute to social change from a feminist perspective (see Ernst).

Towards Reproductive Justice: Maternal Activism

This section explores the nature of single mothers' activism against CPS based on the narratives of mothers and their advocates I interviewed during my field work trip from June to July 2013 in Milwaukee, WI. All of them were involved with CPS and/or activism at WW. My analysis of the interviews was directed by critical discourse analysis and narrative analysis strategies based on a feminist standpoint epistemology.

Sense of self is a theme that refers to how mothers' self-identities were affected by their involvement with child welfare services, and how parents engaged in activism in response to their involvement with child welfare services (e.g., to take back control, to try to change their situations, and/or to participate in actions against CPS). The mothers' narratives show that their sense of self was often profoundly eroded

simply from being separated from their children. In this way, mothers could not perform mothering. Moreover, the narratives suggest that mothers experienced conflicts brought about through discourses of mother-blame and the state's version of good and bad motherhood based on mothers' resources. Many times, mothers had to accept these discourses when they were involved in CPS processes, which adversely affected their sense of self and their motherhood practices.

On the other hand, the narratives also suggest that mothers who become involved with activism gained support by maintaining a positive sense of self. Being helped by others and giving help seems to be important for resisting mother-blame. Narratives show that engagement in activism enhanced their senses of self. As Pl[4] claimed:

> I understood through activism that I'm not just a number on some W-2 [Wisconsin Works: TANF in Wisconsin] paper. I'm not, my kids are not just a pay-cheque for the judge and the CPS workers to get rich off of. You know, we're people and we matter. We have rights. And I shouldn't allow anybody to treat me as if I'm less than a human being, regardless of what colour we are.

The mothers I interviewed participated in the MaGoD support group meetings, in addition to marches, protests, and/or events organized by WW. *Mother Warriors Voice* creates an important site for these mothers' actions. Some of the participants were involved in making and passing out the newspapers. A long-time activist mother who now mainly worked on the newspaper claimed that the newspaper gives "people a voice who are out there working against the system, which is broken" (P2). The newspaper articles not only empower the readers but also give instructions about how to deal with the process of child welfare services (e.g., administration, services, and courts). In addition, some participants helped WW by cleaning their Mother Organizing Center by helping the rummage/side-walk sales (their annual fundraising event) or participating in board meetings. Other important actions involved providing support to parents to fight their child welfare cases, for example consulting and advocating their cases, and helping with paper work. Of those who participated in the actions of WW, many narratives reflected that the main goals were to publicize issues with the child welfare system, to raise awareness, and to help other mothers know their rights. Moreover, they fought to have

children who were wrongly removed return home and to stop the war on the poor.

Lastly, participant narratives suggest that activism helped participants in two significant ways: 1) activism provided people with a sense of community; and 2) activism helped to validate people's own feelings. Developing community with people who have had similar experiences provided mothers with an opportunity to share with others who would not judge them by normative standards, which created potential opportunities for mothers to learn from and to support one another. Pat Gowens, WW director, claims that activism contributes to the positive growth of communities and children. Speaking about WW, mothers, and children, Gowens says the following: "They [children] learn that they shouldn't be ashamed of their moms. They learn poor isn't a crime. They learn that there's a war on the poor.... Even if it's temporary, the kids feel a lot better about themselves when they're, you know, out here protesting and they're hearing us insist there's a war on the poor" (Gowens, Interview). This aspect of community building is hugely significant to resisting injustice. Although welfare politics have increasingly (or altogether) faded out from women's rights in welfare rights movements (Reese), Rose Ernst points out that the positive impact of social movement organizations cannot be measured only through policy outcomes but through the overall growth of political communities (137). Ernst contends that "'failed' movements that create or redefine collective subjectivities have the power to make much larger changes than those that pursue and succeed at accomplishing relatively narrow policy outcomes" (137). For example, Ernst examines these kinds of changes in relation to the following: 1) the "not in my lifetime" perspective on social change; and 2) how social movements provide a lot of fun and empowerment (136-137). Ernst's framework for thinking about the role of activism and social change is useful when considering single mothers' activism against the war on the poor; though having less influence on policy outcomes than other welfare rights groups, single mothers' activism has created communities that are building towards reproductive justice.

Activism also helps to validate (oppressed) people's own feelings. This counters the overarching classist and racist system that constantly blames mothers. This speaks specifically to the second part of Ernst's framework. Some mothers claimed that WW gave them courage and

hope and that engaging with activism supported them in feeling positive and empowered. It is important to note how some mothers described public protests as sometimes even as fun. For example, WW gives annual community destruction awards and sings Christmas carols (the lyrics are changed to reflect the protesting) at government (welfare and child welfare) buildings and some big privatized welfare and child welfare services agencies. Gowens notes that this type of fun is important, as it makes victims feel better in life and, at the same time, helps victims to fight back and speak out on behalf of people who have been victimized. According to Gowens, "Doing it [public protest] makes you feel empowered. You actually do feel better because you're not just doing nothing. And you're face ... you know you do need to face your abusers" (Gowens, Interview). Larger oppressive systems depend on each mother's experiences without their children, and the continued effects of their suffering—especially the internalizing force of self-hatred. The regulation of reproduction means the physical and material regulation of bodies. Through welfare and child welfare services, mothers' (and their children's) bodies are materially violated; this violation can cause self-blaming, which continues oppression through the internalization of the colonial project. The colonial project against Black or African American (and also Indigenous and other racialized) women in the U.S. forces mothers to "internalize [racial] oppression ... transformed into a self-hatred" (Bond qtd. in Silliman et al. 14). Therefore, activism has led to emancipation by helping mothers to validate their feelings and experiences, and to contribute to reproductive justice.

As I discussed earlier in this chapter, the war on the poor is exercised through the regulation of reproduction in the area of child welfare. The activism of mothers to challenge such regulation of reproduction must be situated in the larger feminist movement of activist mothering (e.g., Naples). The term "activist mothering" highlights women's gendered conceptualization of activism on behalf of their communities, often defined beyond the confines of their families, households, and neighbourhoods. Similar to the activist mothering by community workers hired in community action programs (CAPs) during the war on poverty, mothers' activism against the child welfare system shows characteristics of community caretaking. Constructing community as a convergence of racial-ethnic

identifications and class affiliations, activist mothering shows self-conscious struggles against racism, sexism, and poverty (see Naples 114). Single mothers' activism reveals feminist struggles to challenge male dominance, violence, and patriarchy, all directly connected to their and other women's economic insecurity. In particular, single mothers' activism demonstrates that "sexism and racism intensified and magnified the sufferings and oppressions of black women" (Hooks 22) in the child welfare system so that "Black women have a self-defined standpoint on their own oppression" (Collins 747) based on their experiences. Therefore, their activism must be situated within larger feminist movements for reproductive justice, especially focusing on racialized women, such as the SisterSong Women of Color Reproductive Health Collective and In Our Own Voice: National Black Women's Reproductive Justice Agenda.

Conclusion

This chapter has examined how single mothers' activism challenges the regulation of reproduction through poverty governance in the U.S. child welfare system. Single mothers have organized to challenge child welfare practices that enforce who is deserving of motherhood that regulates reproduction as part of the war on the poor. In particular, this organizing relies on growing and caretaking communities, and validating their own feelings. In the area of child welfare support, single mothers' experiences without their children reproduce the historical legacies of white supremacy and colonialism, which secure the social order of capitalism through a reproductive agenda. Mothers' organizing from their lived experiences of these conditions actively challenges this system and embodies reproductive justice.

Endnotes

1 This chapter is based on my dissertation project, (Nakagawa *Intersections*). In this chapter, I incorporate a case study for the state of Wisconsin, although each state across the U.S. has a different child welfare system.

2 I use "Black or African American" (and "White") in order to problematize the construction of "race" and to respect and represent their self-identified identities.

3 The Welfare Warriors is a nonprofit organization of mothers and children in poverty, established in Milwaukee, Wisconsin in 1986. They have a mothers' hot line, a monthly meeting, and have organized many demonstrations and events for mothers and children, funded by donations, some grants, subscription fees of *Mother Warriors Voice* and their own fundraising events.

4 I use pseudonyms for research participants as P1 and P2.

Works Cited

Addy, Sophia, Will Engelhardt, and Curtis Skinner. "Basic Facts about Low-Income Children: Children under 18 years, 2011." *National Center for Children in Poverty.* January 2013, 27 March 2015, http://www.nccp.org/publications/pdf/text_1074.pdf. Accessed 6 Dec. 2018.

Berrick, Jill Duerr. "Trends and Issues in the U.S. Child Welfare System." *Child Protection Systems: International Trends and Orientations,* edited by Neil Gilbert et al., Oxford University Press, 2011, pp. 17-35.

Campbell, Nancy D. *Using Women: Gender, Drug Policy, and Social Justice.* Routledge, 2000.

Child Welfare League of America (CWLA). "Transracial Adoption and the Multiethnic Placement Act." *National Data Analysis System,* June, 2007, https://thehill.com/images/stories/whitepapers/pdf/MEPA_Final_IB.pdf. Accessed 6 Dec. 2018.

Collins, Patricia Hill. "The Social Construction of Black Feminist Thought." *Journal of Women in Culture and Society,* vol. 14, no. 4, 1989, pp. 745-773.

Courtney, Mark E., et al. "Involvement of TANF Applicant Families with Child Welfare Services." *Social Service Review,* vol. 79, no. 1, 2005, pp. 119-157.

Danziger, Sandra K., and Sheldon Danziger. "Child Poverty and Antipoverty Policies in the United States: Lessons from Research

and Cross-National Politics." *From Child Welfare to Child Well-being: An International Perspective on Knowledge in the Service of Policy Making*, edited by Sheila B. Kamerman et al., Springer, 2010, pp. 255-274.

Davies, L.J. et al. "Beyond the State: Conceptualizing Protection in Community Settings." *Social Work Education*, vol. 21, no. 6, 2002, pp. 623-633.

DeVooght, Kerry, et al. "Federal, State, and Local Spending to Address Child Abuse and Neglect in SFY 2012." *Child Trends*, 2014, https://www.childtrends.org/wp-content/uploads/2014/09/2014-61 ChildWelfareSpending-2012-2nd-revision-march.pdf. Accessed 6 Dec. 2018.

Ernst, Rose. *The Price of Progressive Politics: The Welfare Rights Movement in an Era of Color Blind Racism*. New York University Press, 2010.

Flavin, Jeanne. *Our Bodies, Our Crimes: The Policing of Women's Reproduction in America*. New York University Press, 2009.

Freundlich, Madelyn, and Sarah Gerstenzang. *An Assessment of the Privatization of Child Welfare Services: Challenges and Successes*. CWLA Press, 2003.

Gordon, Linda. *Heroes of Their Own Lives: The Politics and History of Family Violence*. Viking Penguin Inc., 1988.

Gowens, Pat. "DHS, Give Us Back Our Children: Feminists Organizing to Protect Children from Child Protective Services." *Rain and Thunder: A Radical Feminist Journal of Discussion and Activism*, vol. 57, 2013.

Gowens, Pat. Personal interview. 24 July 2013.

Hansen, Mary Eschelback. "State-Designated Special Needs, Post-Adoption Support, and State Fiscal Stress." *Children and Youth Services Review*, vol. 29, 2007, pp. 1411-1425.

Hill, Heather D. "Welfare as Maternity Leave? Exemptions from Welfare Work Requirements and Maternal Employment." *Social Service Review*, vol. 86, no. 1, 2012, pp. 37-67.

Hooks, Bell. *Ain't I a Woman: Black Women and Feminism*. South End Press, 1981.

Maza, Penelope L. "Using Administrative Data to Reward Agency Performance: The Case of the Federal Adoption Incentive Program." *Child Welfare*, vol. 79, no. 5, 2000, pp. 444-456.

Nakagawa, Shihoko. "More 'Us' Than 'Them': Welfare Reform According to Congressional Hearings and *the Welfare Mothers Voice*." *MP: Feminist Online Journal*, vol. 2, no. 3, 2009, pp. 3-26, http://academinist.org/wp-content/uploads/2009/03/Nakagawa.pdf. Accessed 6 Dec. 2018.

Nakagawa, Shihoko. "Single Mothers' Activism against Poverty Governance in the U.S. Child Welfare System." *Motherhood and Single-Lone Parenting: A Twenty-First Century Perspective*, edited by Maki Motapanyane, Demeter Press, 2016, pp. 335-366.

Nakagawa, Shihoko. *Intersections of Welfare and Child Welfare Systems and Single Mothers' Activism in the U.S.* 2017. York University, PhD dissertation.

Naples, Nancy A. *Grassroots Warriors: Activist Mothering, Community Work, and the War on Poverty*. Routledge, 1988.

Nelson, Jennifer. *Women of Color and the Reproductive Rights Movement*. New York University Press, 2003.

Peck, Jamie. *Workfare States*. Guilford Press, 2001.

Reese, Ellen. *They Say Cut Back, We Say Fight Back! Welfare Rights Activism in an Era of Retrenchment*. Russell Sage Foundation, 2011.

Rivaux, Stephanie L., et al. "The Intersection of Race, Poverty, and Risk: Understanding the Decision to Provide Services to Clients and to Remove Children." *Child Welfare*, vol. 87, no. 2, 2008, pp. 151-168.

Roberts, Dorothy. *Shattered Bonds: The Color of Child Welfare*. Basic Civitas Books, 2002.

Roberts, Dorothy. "The Racial Geography of Child Welfare: Toward a New Research Paradigm." *Child Welfare*, vol. 87, no. 2, 2008, pp. 125-150.

Roberts, Dorothy. "Prison, Foster Care, and the Systemic Punishment of Black Mothers." *UCLA Law Review*, vol. 59, 2012, pp. 1474-1500.

Schwartz, Angie, and Amy Lemley. "Child Welfare Financial Reform: The Importance of Maintaining the Entitlement to Foster Care Funding." *Clearinghouse REVIEW Journal of Poverty Law and Policy*, vol. 44, no. 11-12, 2011, pp. 554-563.

Silliman, Jael, et al. *Undivided Rights: Women of Color Organize for Reproductive Justice*. South End Press, 2004.

Smith, Andrea. *Conquest: Sexual Violence and American Indian Genocide.* South End Press, 2005.

Smith, Brenda D., and Stella E. F. Donovan. "Child Welfare Practice in Organization and Institutional Context." *Social Service Review,* vol. 77, no. 4, 2003, pp. 541-563.

Soss, Joe, et al. *Disciplining the Poor: Neoliberal Paternalism and the Persistent Power of Race.* The University of Chicago Press, 2011.

Swann, Christopher A., and Michelle Sheran Sylvester. "The Foster Care Crisis: What Caused Caseloads to Grow." *Demography,* vol. 43, no. 2, 2006, pp. 309-335.

Swift, Karen, and Marilyn Callahan. *At Risk: Social Justice in Child Welfare and Other Human Services.* University of Toronto Press, 2009.

Tobis, Davis. *From Pariahs to Partners: How Parents and Their Allies Changed New York City's Child Welfare System.* Oxford University Press, 2013.

U.S. Department of Health and Human Services (USHHS). *Child Welfare Outcomes 2008-2011: Report to Congress Executive Summary.* Children's Bureau, An Office of the Administration for Children and Families, 16 Aug. 2013, https://www.acf.hhs.gov/cb/research-data-technology/statistics-research/cwo. Accessed 6 Dec. 2018.U.S. Department of Health and Human Services (USHHS). *Child Maltreatment 2012.* Children's Bureau, An Office of the Administration for Children and Families, 17 Dec. 2013, https://www.acf.hhs.gov/cb/resource/child-maltreatment-2012. Accessed 6 Dec. 2018.

U.S. Department of Health and Human Services (USHHS). *AFCARS Report #23.* Children's Bureau, An Office of the Administration for Children and Families, 30 June 2016, https://www.acf.hhs.gov/cb/resource/afcars-report-23. Accessed 6 Dec. 2018.

Wells, Kathleen, and Maureen O. Marcenko. "Introduction to the Special Issue: Mothers of Children in Foster Care." *Children and Youth Services Review,* vol. 33, 2011, pp. 419-423.

Chapter 10

Towards Solidarity in Mothering at the Borderlands: Suggestions for Better Legal and Social Treatment of Mothers Migrating across Borders without Children to Work

Rebecca Jaremko Bromwich

Introduction

This paper discusses how I gained new perspectives on childcare as a form of labour through my vantage points as a mother who has sometimes been separated from her children, as a lawyer representing women doing caring labour, and as an employer of a mother who was separated from her children, while I was separated from my own children. I start with the Canadian context of international work by women in live-in-caregiver roles and move on to insights from personal experiences as an employer and a lawyer. I end with suggestions for how caregiving could be reconceptualized and social policy reframed. I believe that critical consideration of social political contexts and commonalities and differences in experience related to paid and unpaid

childcare demands a radical reimagining of caregiving done by mothers as labour.

My multiple roles as lawyer, employer, and mother working away from her children have afforded me a variety of lenses through which to assess circumstances of mothers migrating across borders without their children for the purposes of paid work. As a lawyer, I have represented immigration and refugee clients, including many who entered Canada as temporary workers through the live-in caregiver and temporary worker programs. The reported appeal case of *Bagamasbad v. Canada* is one example. I have also spent some time living in the United States with my family and commuting to Canada to work, and, in those years, I myself travelled without my children to work. Finally, the experience of employing live-in caregivers from overseas has provided me another vantage point on the experiences of mothers travelling for work.

On many occasions, I have crossed the Canadian, US, and several European borders without my four children to meet the demands of my job. The transitory solitude of this experience carried with it a sense that my social role and identity as a mother are vulnerable to disappearing along with my connection to my children. While I was doing this work, the caregiver I employed to ensure the safety and wellbeing of my children was a mother herself doing caregiving labour. She was a mother caring for her children by leaving her children, separated for years by tremendous geographical distance.

Live-in caregivers who are mothers and the women who are mothers that employ them share motherhood and female gender as loci of social identity. As such, it is important to acknowledge divergent and intersectional oppressions as well as inevitable paradoxes. Matrices of race, social class, age, and gender complicate an understanding of their relative power.

Queer theory as an analytical frame resonates with my own experiences of relative power and privilege (Sullivan). What especially resonates for me in this context is its appreciation of the artificiality of stereotypical social identities and how simplistic labels can be misleading. My own identities, and those of the mothers I have represented and employed, are intersectional, complicated, and tricky. As socially situated beings, we experience advantages and disadvantages due to our positions in multiple systems. In many contexts, I am

privileged by whiteness, but I am also at times disadvantaged by female gender. For example, while living abroad on my husband's work visa, I was vulnerable in gendered ways, since I would have no claim to reside in the country where my children were if I were to leave him.

Changes in place of residence and work can also reconfigure social locations. Live-in caregivers from Latin America, for example, are sometimes coded as "white" in their home countries and become racialized ("not white") when they arrive in Canada. One of the live-in caregivers I employed was the daughter of the mayor of her home town. When she came to Canada, this high social status was all but erased. Similarly, yet also differently, when I worked in the United States, I was not there as a lawyer but rather as a spouse accompanying my husband who had direct status in the country. My access to a work permit, to the entitlement to remain in the country, to health care, and, effectively, to my children were all contingent on my husband's employment and, ultimately, on my marriage. Then to muddy the water further, there are status systems and social hierarchies within each of these systems (e.g., who counts as a good mother).

In Context: Patterns

Speaking from my social position as a middle-class white mother, my individual experiences and observations are instances at the micro-level of processes that, at the macro-level, form a global economic, political, and social context. The United Nations raised concerns about female domestic migrant workers in its General Recommendation No. 26 on women migrant workers from 5 December 2008. Consider that in Canada, temporary work as a live-in caregiver can ultimately lead to permanent status, but this status is withheld from the nanny until two years after her arrival. Until then, a nanny is required to live in the accommodation provided by her employer (usually the employer's home). This enforced co-habitation leaves nannies vulnerable to round-the-clock work requirements, nonpayment of overtime, confiscation of passports, and other abuses (Choudry et al.). Temporary foreign workers also make less money than permanent residents or Canadian citizens (Statistics Canada). Live-in caregivers have been called "the servants of globalization" (Parrenas).

Although paid domestic labour is often considered to be a relic of

historical inequality and an unsavory aspect of Victorian, or colonial, or American Confederate history, it is an area of significant growth in the late capitalist economies of both Canada and the United States in the early twenty-first century. In fall 2015, the ubiquity of paid domestic labour in Canada was made again visible when a scandal broke about the payment by newly elected Prime Minister Justin Trudeau of two Filipina nannies for his children out of the public purse (Hall). As Pierrette Hondagneu-Sotello (2001) explores, paid domestic labour is an area of economic growth and "has become the domain of disenfranchised immigrant women of color" (xii) who work often illegally with no citizenship rights and "under the table" in the United States. In Canada, the situation is slightly different, as this country has formalized live-in caregiver programs. In exchange for two years of employment as a live-in-caregiver, women, predominantly from the Philippines (Chen), can gain a foothold on Canadian citizenship and the ability to bring their families over to share in the immigrant dream by obtaining permanent resident status.

Canada is not unique in relying increasingly on temporary foreign workers to fill gaps in the labour market. Most, if not all, first-world economies now rely heavily upon labour performed by temporary workers from somewhere else (Ruhs and Philip). Hondagneu-Sotello discusses workers from Latin America employed in the United States, for example. Domestic caregivers around the world are often not citizens of the countries in which they work, and they often hail from the Philippines.[1] In fact, payment of money to family members back home by Filipina nannies working abroad is a major source of the GDP of the Philippines, and a huge percentage of adult Filipinos work abroad and send money home in the form of remittances (Philippine Overseas Employment Administration).

Along with the work of Hondagneu-Sotello, there is an emerging literature about the experience of domestic employment and racial, gender, and global inequalities. For example, Barbara Ehrenreich and Arlie Hochschild (2003) have looked at global migrations of women to fill "care deficits" in wealthy countries, whose absence from their third world countries of origin in turn leaves a "care deficit" back home. More recently, Galerand et al. (2015) have specifically explored the exploitative and problematic nature of Canada's live-in caregiver program. The growing literature on precarious employment (e.g.,

Vosko) also connects with this literature about domestic workers.

Canada's live-in-caregiver programs have been the subject of ongoing political debate. In 2009, a scandal erupted involving the live-in caregivers employed by the Liberal Member of Parliament Ruby Dhalla. The caregivers claimed they had been forced to work long overtime hours, had been restricted in their movements, had been confined to home, and had been divested of their passports by Dhalla. (Hough) An interesting wrinkle in this case was that the privileged employer socially located as a Member of Parliament was, like the caregivers, an individual not possessed of white race privilege—a "visible minority" in Canadian popular parlance. This case highlights intersectionality and the complexity of interactions between domestic workers and their employers, and the nonbinary nature of racial diversity and racial inequalities.

More recently, in 2014, Canadian Immigration Minister Jason Kenney was quoted as saying the Live-in Caregiver Program "ran out of control." His critique was not focused on the abuse of caregiver but on the caregivers who allegedly "mutate" the program into a means for "family reunification." Regardless of the extent to which domestic caregivers are using agencies (quite understandably) to bring their families to Canada, these women are vulnerable to abuse, as they are essentially indentured workers for their first two years in Canada.

Live-in caregivers in Canada are part of a larger demographic group of "temporary foreign workers," which is the fastest growing segment of people in Canadian society (Statistics Canada), although it is not quite correct today that they are part of Canadian society at all. They have no right to vote, and their mobility rights are severely restricted; their work permits often restrict them to a particular type of occupation, to a geographical location, and, in certain circumstances, to a single employer. Although these workers theoretically have the same minimum wage and hours of work entitlements as permanent residents or Canadian citizen, they are disproportionately vulnerable to exploitation and abuse. Poor and isolated women are already vulnerable to mistreatment, but this particular group of women is especially vulnerable because of their precarious status in the country.

Live-in caregivers are often mothers themselves and are sometimes separated from their children by a tremendous geographical distance. The family structure of children at home with relatives and a mother,

and perhaps father, working abroad is not unusual in places such as the Philippines. Indeed, it is a contemporary norm. Many caregivers leave their own children with relatives in countries in the Global South to provide an income stream and a chance for their children to immigrate to the Global North. What could more profoundly be motherwork than to leave ones' children in order to best look after ones' children?

Conversations

Unlike the interviewers in the formal study conducted by Galerand et al. who met with live-in caregivers at neutral locations and were not associated with their jobs, I have never been positioned in a situation where a live-in caregiver could easily explain her feelings about her work to me. The employer-employee relationship, however warm and friendly, involves power differentials and creates barriers. In my personal experiences, I have not been positioned in a place where candid conversations with live-in caregivers are easily facilitated. However, I have made a variety of attempts to discuss the issues of international migration patterns, capitalist exploitation, and paid domestic work with my clients in my work as a lawyer and with women our family has employed, and these are difficult conversations to have candidly.

The response I have most often received from women who work as live-in caregivers is "but I am grateful." It is important to acknowledge the vulnerability to deportation that nannies face if their employment is terminated and how this may impede open conversations between employers and live-in caregivers. Furthermore, the lawyer-client relationship reproduces structural relationships of power associated with government and policing. Still, some women have spoken to me positively and optimistically about the long-term benefits of the circumstances for their children and of their plans for reunion by sponsoring the children into Canada.

I suspect that the live-in caregivers I have employed experience anguish and loneliness, which they cannot comfortably communicate with me. However, what they have uniformly told me is that they, like me, derive satisfaction, a sense of identity, and necessary economic benefit from their paid work. They have also expressed to me that they enjoy more social freedom in Canada compared with their home

country and the countries they travelled through and worked in on their way to Canada, including Taiwan, Hong Kong, and Libya.

When live-in caregiver clients and employees have claimed to me that they are happy with their work and life in Canada, this should be read in context but not discounted. On the one hand, by leaving their small children behind for years at a time, they are performing a profoundly self-sacrificing act. On the other hand, they are agentic actors and career women whose experiences of maternal caregiving for their own children take place in a highly patriarchal society, often in the context of poverty. Their experiences and feelings will not be any more uniform than those of first-world mothers. As subjects, they are as complex and do not need to be rescued. Whatever their feelings are about their work, much more needs to be done to ensure they are treated justly and that they can participate in negotiations about their working conditions—at the micro-level of their own lives and the macro-level of economic and immigration policymaking.

Wherever I network with professional women, conversations about childcare, work-life balance, and "having it all" surround me. Concerns about the competing demands of parenting and paid work reflect unresolved tensions to many Western feminists, as women like me continue to gain professional roles in the paid work force. When considered in the context of the growth of paid domestic labour, these conversations appear to indicate that Canada, the United States, and the middle-class families who live there have, in fact, not solved childcare and labour problems by changing public policy and shifting gender roles. Rather, they have perpetuated and masked ongoing problems with the current conditions through outsourcing.

Indeed, by focusing national attention on the treatment of live-in caregivers by certain employers, the dependency of middle- and upper-class Canadian families on the live-in caregiver program, and the lack of alternatives such as universalized childcare, remains obscured. In creating the live-in caregiver program, the government privatized the issue of unpaid labour to individual households. It imposed sole responsibility for childcare, and blame for any flaws with childrearing, onto individual women within those households, paid and unpaid alike. And it did so through the exploitation of differences in wealth and power between Canadians and people from less affluent parts of the world. The Live-in Caregiver Program reflects and perpetuates an

atomistic and a classical liberal understanding of mothers and children as properly belonging in the home as a private sphere. This understanding of the place and role of women makes it difficult to imagine alternative, collective, and public approaches to caring for Canadian children while enabling women to participate fully in the public sphere.

Women in Canada's paid work force are in a double-bind position. There is a labour shortage. Families often contend with the economic impracticability and the personal undesirability of one spouse becoming a stay-at-home parent. Canada's working mothers also face social stigmatization when they retain domestic labour, even when the products of that full-time labour are valorized and even expected. To resolve their labour shortages in the home, many families simply import a second, temporary, and expendable mother from a less-developed country. This exchange happens in much the same way as when Canadian and U.S. consumers purchase disposable goods, like clothing and toys, made at factories in places like Bangladesh and China. The ideology of intensive motherhood, and all of its expectations, only increases the pressure to have a live-in caregiver (O'Reilly). The masking of problems inherent in Western capitalism with solutions that rely upon third-world labour, dehumanization of third-world workers, and depletion of third-world resources is consistent with a broader pattern evident across many productive sectors, like garment and automobile manufacture, for example. Live-in nannies from the Philippines and telemarketers from Mumbai calling on behalf of American companies are part of the same globalized economic trends that compound the disadvantages faced by the developing world.

Additional Contextual Considerations

It is beyond the scope of this chapter to fully consider the connections between the ubiquity of live-in caregiver mothers from abroad working in Canada and the failure of forty-plus years of tenacious advocacy towards the development of socialized childcare at the federal level. Although I cannot fully explore it here, this connection does bear mentioning and certainly warrants further study. It is also problematic which expenditures constitute business expenses for the purposes of income tax law in Canada exclude payments to a domestic caregiver. In

Symes v. Canada, in 1993, a majority of the Supreme Court of Canada refused to allow a woman law partner (Beth Symes) to deduct her childcare expenses from her net business income as business expenses. Notably, both of the women judges at the time dissented and wrote a minority judgment disagreeing with this decision. As Rebecca Johnson (2002) has chronicled, there was a great deal of social discomfort surrounding the case. This discomfort shows the unease with which Canadian society engages with the phenomenon of paid domestic work.

Canada's Live-in Caregiver Program through an Employer's Lens

Speaking from my social position as a Canadian lawyer who has represented live-in caregivers in immigration matters, I know that the Temporary Foreign Workers Program and Live-in Caregiver Program (now known officially as the Caregiver Program) are ways in which workers find themselves in Canada legally with statuses less than full citizenship. Recent changes to the Caregiver Program were announced on 31 October 2014 and implemented on 30 November 2014. These changes eliminate the automatic entitlement of live-in caregivers to permanent residence, leaving Canada's live-in caregivers vulnerable to increased economic and other exploitation, permanent disentitlement to citizenship, as well as racialized marginalization and disenfranchisement.

Just as live-in caregivers are a growing number of immigrants to Canada, employers of nannies are also a growing demographic (Stasius). These employers tend, on the whole, to be an economically privileged group. However, neither of these statements is an absolute. Women's social locations are complicated. Those who employ domestic caregivers are not uniformly wealthy. There are many families for whom childcare costs are nearly insurmountable. In my own case, employing a nanny from overseas was the least expensive means to obtain care for multiple small children. Even so, the cost of paying for this care exhausted all of my part-time earnings when my kids were young. I was self-employed as a lawyer and not entitled, at that time, to employment insurance benefits. I took no maternity leave. The net result was that I worked outside the home and took home no money. Childcare was an investment in my long-term earning potential, not an economically viable act in the short term.

As a middle-class mother, I experienced contradictions and shaming with respect to how people responded to the employment of a live-in caregiver. Although some mothers might tout their employment of domestic workers as a mark of wealth or status, employing a nanny can be a source of social stigma. Relying on paid help compromises an otherwise privileged woman's ability to attain access to the social location of a so-called good or real mother. Gwyneth Paltrow is, for example, frequently disparaged for being unaware of her privileges in life. She faces public criticism not just for being wealthy or selfish, but she also receives many comments about her legitimacy and authenticity as a good mother. Similarly, I can recollect rolling my eyes when my mother-in-law complained about the nannies her family employed when they lived in colonial Africa. It is ironic, then, that I later found myself being met with similar eye rolls about my "first-world problems" related to our family employing a nanny.

Choosing to Hire a Live-in Caregiver

As I found myself trying to navigate impossible scripts, I did not see a way to keep my career viable without employing domestic help; at the same time, I was uncomfortable with people perceiving that I had a nanny. More than once, I attempted to mask the fact that our family employed full-time domestic help by referring to our nanny as a babysitter. I also felt a social need to mask the ways in which I was socially situated in a status quite unlike that of Gwyneth Paltrow. I did not tell anyone at the time, but the money it cost to retain full-time paid staff was really too much for us to afford. Like those we employed through the live-in program, I was also hanging onto the promise of the belated benefit from the arrangement. To pay our nanny, we went into debt, anticipating that my long-term employability would cover and offset this expense.

I was told by my colleagues and friends that I should feel good about my role as an employer of a live-in caregiver. It is one mainstream middle-class Canadian view that mothers who hire nannies from developing countries as temporary workers are actually doing them a favour. Yet these workers are not granted citizenship but only a promise of its belated possibility—a promise that has, since 2014, become hollow. Furthermore, they can experience oppressions related to race,

class, gender, place of origin, and other social markers. In particular, economic vulnerability and the lack of citizenship contribute to conditions of neoliberal globalized servitude. However, it is the employment of a domestic caregiver to care for my children that has made my role as a woman continuing to work outside the home in the legal profession possible. As noted, it was at the strong urging of former clients from the Philippines who had come in to Canada via the Live-in Caregiver Program that I looked in to the program in the first place.

Hiring a local nanny and a cleaning service would have cost more that my part-time salary would allowed. It was not economically feasible, partly because our calculations were always of my income against the childcare cost. There was never an equation put forward by my husband or me that combined our incomes and looked at the childcare cost as partly supporting his ability to work. This math demonstrates how the exploitation of women employed as live-in nannies (also often women of colour) is produced in the same sexist cultural context that produces tensions for women like me between career and family while masking barriers to my professional participation with the language of choice. This is mirrored by the common assumption that a live-in caregiver from overseas leaves her own family by choice—an assumption that makes invisible the powerful economic and cultural forces that form the terrain on which the caregivers navigate. Accepting mother-work as work—caring labour—would require recognition of unpaid work by mothers caring for their own children and a more nuanced scrutiny of the employment conditions for live-in caregivers. Diverse constellations of childcare— including stay-at-home mothers (or fathers, or other parents, grandparents, or guardians) and paid (albeit often underpaid) childcare workers, both live in and live out—need to be accounted for in more robust processes of analysis of theorizing. It is not just a matter of choice. Children have needs. They present imperatives. Where there are children, there is work to be done. A systematic study involving participant interviews in the respondents' own language would be a useful piece of further research. The subjectivities and participation should be invited into research and writing.

Legal Protections for Live-in caregivers

As I learned through my work as a lawyer, temporary foreign workers in Canada do have some legal rights. There are legal protections for nannies in Canada under the federal Live-in Caregiver Program, even those in Canada without valid immigration status. However, if the authorities find out that a worker does not have valid immigration status, they will report it to Citizenship and Immigration Canada, which means that workers illegally in Canada run the risk of being deported.

In 2009, Ontario enacted the Employment Protection for Foreign Nationals Act (live-in caregivers and others) (EPFNA). Under this Act, recruiters cannot charge applicants fees to be brought into Canada, and employers must pay the travel costs for nannies. Recruiters and employers are not permitted to take or keep nannies' property, including their personal identity papers or passports. The EPFNA is complaint based, so persons concerned that their rights have been violated must themselves bring this to the attention of authorities before the three-and-a-half-year limitation period expires. Furthermore, many of the general labour laws that protect other Canadians also protect nannies. In Ontario, this includes the Employment Standards Act (2000). They are also rights bearers under the Human Rights Code; moreover, if nannies are physically or sexually abused, it is an offence under the Canadian Criminal Code regardless of the victim's status in Canada.

Suggestions for Law Reform

Reform to Canadian immigration laws could help ameliorate some aspects of the vulnerability live-in caregivers experience, although domestic law reform cannot itself entirely eradicate racial, gender, and global inequalities. Personally, I am not convinced that the Live-in Caregiver Program is irredeemable, since women working in this program, and prospective applicants, want it to continue. Equally, the employment of live-in caregivers has benefitted many professional women working in Canada.

We can, however, run the program better. Temporary workers, in general, should have lives that are less precarious. They should not have to fear immediate deportation upon the termination of their jobs. As is proposed by Galerand et al., affording rights of citizenship, or landed immigrant status, to all temporary workers upon arrival in Canada

would be just. Providing a structured and guaranteed period of time where they could remain in Canada and seek alternate employment would also be helpful. Permitting temporary workers to bring dependents, especially minor children, to Canada with them immediately would be appropriate and compassionate as well as just. It would be useful for jurisdictions outside of Ontario to consider enacting protections comparable to the EPFNA and for these protections to be harmonized across Canada. A protocol should be developed for the inspection of domestic workplaces, and there should be a readily accessible complaint mechanism for domestic workers to contact. Furthermore, Citizenship and Immigration Canada should develop a protocol to allow priority processing of work permits for urgent employer needs or caregivers fleeing abuse. Work permits, when granted, could be open rather than tied to a particular employer.

However, the most important re-thinking about how laws could be changed to help mothers who are employees and employers through the Live-in Caregiver Program would take place outside of the immigration law context. Problems with the program could be obviated by the establishment of safe, good-enough, and state-supported childcare across Canada, and, most ambitiously of all, by the revaluing of caregiving as socially productive labour.

Reimagining Mother-Work

The common experiences of fatigue, isolation, and loneliness associated with caregiving labour are often seen through the frames of medicalization and maternal pathology. It is imaginable for mothers to have mental disorders, but somehow less thinkable for them to be workers who are tired. Conversations about work-life balance and childcare obligations infrequently address the working conditions of fathers. Starting with reconceiving childrearing as work not tied necessarily to gender, I would like to suggest that what needs to be addressed is a range of working conditions.

With the benefit of hindsight, Anne Marie Slaughter's 2015 analysis, and the intervening years, I can see that when I was a new mother choosing to travel across borders for work, I was buying into patriarchal assumptions. I did not question that only traditionally male work in the public realm could be truly challenging. I expected without

question that if I could take on historically male roles and professional identities with ease, doing the work traditionally associated with women would be easy. In other words, if I could handle law school, law practice, and graduate school, then I could certainly manage four small children. I am, after all, part of a generation of middle-class white girls whose mothers were second-wave feminists raised to think we could have it all.

However, a 2012 article in *The Atlantic* by Anne-Marie Slaughter, and then her 2015 book, *Unfinished Business: Women, Men, Work, Family*, has raised controversy about how Western economies and societies make having it all impossible for women. Slaughter's "rude epiphany" was realized when she came to see views held of her ability to work as "substandard" when she left Washington D.C. for academic work (2012). She offers insight about how problematic it is that women "feel that they are to blame if they cannot manage to rise up the ladder as fast as men and also have a family and an active home life (and be thin and beautiful to boot)."

Slaughter's insight helped me to realize that it was not a failure on my part to admit that I, too, could not do it all. I had to seek paid domestic help in order to ensure my children's best interests and my emotional health. The un-resolvability of the demands of work and family was not just my fault. However, in my particular circumstances, the demands of paid work were manageable. It was the unpaid work of caring for four children aged four and under that I could not manage completely on my own. I looked for help from my family doctor, but I did not need antidepressants or any other self-help intervention. I now believe I asked the wrong person for support. Why did I frame my struggles as a woman who is a mother as a medical issue? At the time, awareness campaigns about postpartum depression made the struggles of new mothers socially acceptable if framed as mental health problems. In my particular case, it was not primarily pathology I was experiencing but overwork. I did not need help with my stress management skills or coping mechanisms. What I needed help with was the piles of laundry and the dirty diaper pails. I also needed three consecutive hours of sleep.

Taking account of the situation of paid caregivers in the home provides an opportunity to get beneath the binary opposition of at home mom and working mom. A home where a paid caregiver and parents share tasks of childrearing and housekeeping traditionally associated with the mother's role is both entirely traditional and a radical space

where constructions of working mom, stay-at-home mom, gender roles, and what work means can be reconsidered. Studying the employment context of domestic workers can unmask the constructed nature of the notion that it is natural and historically traditional for the biological mother of children to be their sole caregiver.

Homes where domestic caregivers are employed are places where the public-private sphere divide can be undermined. The private space of the employer's home is the public space of the caregiver's work, and it is the public space of a managerial role for the employers. Such homes are also sites where continued colonization or neocolonialism becomes visible. Nannies were part of colonial households through the regions colonized by European nations in the nineteenth and twentieth centuries. Paid staff positions for childcare workers were also the norm in many households in England, Canada, and the United States for many years. This working relationship has often been racialized, with women of colour retained in large numbers in many contexts to care for the children of white families.

Conclusion

This chapter has looked at my own experiences in the context of some of the challenging conditions faced by mothers who cross international borders without their children to work abroad, especially to do paid domestic work under Canada's Live-in Caregiver Program. It has drawn links between the diverse conditions of mothers working abroad without their children to argue first for law reform and second for new reimaginings in the discourse and policy of caregiving work as labour. Such reimaginings reveal how the interests of those who do mother-work as workers and those who do the same sorts of work as unpaid family members are aligned.

I have argued that advocacy for fair labour practices for live-in caregivers should go hand in hand with advocacy for the Western mothers who employ them. Advocacy for fair tax treatment of family employers' payments to nannies should be part of what is considered legitimate in supporting mother work. Work towards securing citizenship and other human rights of domestic caregivers should be a central goal of maternal feminist activism. Safe, good-enough childcare should not only be available to the wealthy. Work towards assuring

quality childcare that is made widely available benefits parents, children and society. Attention needs to shift away from the simplistic labelling of identity production in the context of childcare labour to look instead at the conditions of that work. As per Anne-Marie Slaughter's 2015 contention, caregiving labour should be structured publicly in ways that meet the needs of parents and children. It should be counted, supported, and recognized.

Endnotes

1 The Philippines is an overrepresented source country of nannies, as it supplies domestic caregivers to many countries around the world. The trends in who are represented as temporary workers over time in Canada are inseparable from domestic policy and global politics. For a discussion see Altman and Pannell.

Works Cited

Altman, Meryl, and Kerry Pannell. "Policy Gaps and Theory Gaps: Women And Migrant Domestic Labor." *Feminist Economics*, vol. 18, no. 2, 2012, pp. 291-315.

Bagamasbad v. Canada (Citizenship and Immigration). 2004, CanLII 69376 (CA IRB).

Choudry, A., et al. *Fight Back, Workplace Justice for Immigrants.* Fernwood, 2009.

Ehrenreich, Barbara, and Arlie Hochschild, editors. *Global Woman: Nannies, Maids, and Sex Workers in the New Economy.* Metropolitan Books. 2003.

Galerand, Elsa, et al. *Domestic Labour and Exploitation: The Case of the Live-in Caregiver Program in Canada.* PINAY, 2015.

Hall, Chris. "Trudeau Children's Nannies Being Paid for by Taxpayers" *CBC News*, 1 Dec. 2015, https://www.cbc.ca/news/politics/justin-trudeau-nannies-taxpayers-1.3344533. Accessed 7 Dec. 2018.

Pierrette Hondagneu-Sotello. *Domestica: Immigrant Workers Cleaning and Caring in the Shadows of Affluence.* University of California Press. 2001.

Hough, Jennifer. "Canada's Live-in Caregiver Program Ran Out of Control." *National Post*, 24 June 2014, https://nationalpost.com/news/politics/canadas-live-in-caregiver-program-ran-out-of-control-and-will-be-reformed-jason-kenney. Accessed 7 Dec. 2018.

Johnson, Rebecca. *Taxing Choices: The Intersection of Class, Gender, Parenthood, and the Law.* University of British Columbia Press. 2002.

Vosko, Leah. *Managing the Margins: Gender, Citizenship and the International Regulation of Precarious Employment.* Oxford University Press, 2010.

O'Reilly, Andrea. *Matricentric Feminism: Theory, Activism and Practice.* Demeter Press, 2016.

Philippine Overseas Employment Administration. "Stock Estimate of Overseas Filipinos As of December 2012." https://www.cfo.gov.ph/program-and-services/yearly-stock-estimation-of-overseas-filipinos.html Accessed 7 May 2015.

Rhacel Salazar Parrenas. *Servants of Globalization: Women, Migration and Domestic Work..* Stanford University Press. 2001. Print.

Ruhs, M., and Philip M. "Numbers vs. Rights: Trade-offs and Guest Worker Programs." *International Migration Review*, vol. 42, no. 1, 2008, pp. 249-265.

Slaughter, Anne-Marie. *Unfinished Business: Women, Men, Work, Family.* Random House, 2015.

Slaughter, Anne-Marie. "Why Women Still Can't Have It All." *The Atlantic Monthly*, July 2012, https://www.theatlantic.com/magazine/archive/2012/07/why-women-still-cant-have-it-all/309020/. Accessed 7 Dec. 2018.

Stasiulis, Daiva, and Abigail B. Bakan. "Negotiating Citizenship: The Case of Foreign Domestic Workers in Canada." *Feminist Review*, vol. 57, 1997, pp. 112-139.

Statistics Canada. " Foreign Workers Working Temporarily in Canada." *Statistics Canada*, 2011, https://www1150.statcan.gc.ca/n1/pub/11-008-x/2010002/article/11166-eng.htm. Accessed 7 Dec. 2018.

Sullivan, Nikki. *A Critical Introduction to Queer Theory.* New York University Press, 2003. *Symes v. Canada.* (1993), 4 S.C.R. 695.

Part IV

Motherhood Reconfigured by Death

Chapter 11

Grieving in Silence: Repercussions of the Family Ideal on Women with Pregnancy Loss

Sheri McClure

As soon as my husband and I discovered I was pregnant, we went to our local Barnes and Noble and purchased *The Mayo Clinic's Guide to a Healthy Pregnancy*. Pregnancy was new territory for us; why wouldn't I want a map of the terrain? And who better to guide me than the famed Mayo Clinic? At the time, the book was helpful—comforting even. The future didn't seem as scary if I knew what to expect. However, in retrospect, the book was not a map but an immense, flashing caution sign. Pregnancy transformed me into a vessel for a future generation. The question was whether it (I) was worthy.

Prior to pregnancy, I did not envision myself as a vessel; however, I was often made aware of my unfulfilled maternal potential. Unsurprisingly, friends and family were the most constant source of procreation pressure once I married, but there was also external pressure from unexpected places. Bottles of wine cautioned me about the risks of drinking while pregnant. Amusement park rides urged me to be certain I was not pregnant before riding. There was even the occasional warning regarding raw fish in restaurants to remind me of my obligations to this potential child of mine. I am certainly not arguing that knowledge is harmful or that women should ride roller coasters while pregnant, but these warnings illustrate an important

change regarding how women were told to think about their bodies. In *The Rhetoric of Pregnancy*, Marika Seigel argues that the early twentieth century saw a shift away from female-driven experiential knowledge about pregnancy and towards a medicalization of the pregnant body (42). According to Seigel, pregnancy guides and prenatal technologies (i.e., ultrasounds) have continued to perpetuate prenatal pieties: rules, often implied, that determine acceptable behaviour. In her book, she analyzes a sampling of pregnancy texts to expose three specific pieties, which she believes present the pregnant women as incapable and risky:

- Pregnant women's bodies are invisible.
- Medical knowledge about pregnancy is expert knowledge.
- Prenatal care can solve political and social problems (Seigel 75).

In other words, the messages pregnant women receive through verbal, textual, and visual mediums convey that a woman's body and concerns are secondary to the fetus's. There is also an implied promise that the prenatal system can fix any harm the woman's body may do to the unborn child. Such rhetoric advances the idea that healthy babies are the answer to current sociological ills. If a woman is unable (or if, God forbid, a woman is unwilling) to reproduce, then she is held culpable for failing herself, her child, and society.

This messaging is problematic in many ways, and I am interested in the amount of pressure it places on women who cannot carry a pregnancy to term. Approximately 15 percent of known pregnancies end in miscarriage.[1] This statistic means about one in seven women will lose at least one pregnancy. This figure is shocking but not because of its truth; it is shocking because it goes unspoken. There are also women like me who do not have the language to describe our losses. A miscarriage occurs early in a pregnancy. In a stillbirth, the baby is born dead. And perinatal loss, which is the most applicable description I have found for my own experience, simply refers to fetal loss near the third trimester or after birth. I have since learned that medical institutions tend to classify all of these losses as fetal demise, which is both gut wrenching in its insensitivity and frustrating in its ambiguity. And a lack of clear nomenclature makes it even more challenging for women to talk about their experiences, thus encouraging more silence. This silence means that many women experience their child's death in isolation and steeped in guilt. They feel at fault for their baby's death

and, therefore, withdraw from others, which is counterproductive for the woman's psychological recovery. In their study, C.E. Scheidt et al. followed thirty-three women after perinatal loss for nine months, with reassessments at four weeks, four months, and nine months to determine if stronger social support systems decreased the bereavement period and/or intensity. They determined that "social support and the quality of current partnership can be considered as potentially protective factors of coping with bereavement after perinatal loss" (Scheidt et al. 379). In addition, Nikčević et al. concluded their study with a correlation between an extended search for meaning and an increased grieving time after perinatal loss (59). While beyond the scope of their project, I believe isolation contributes to this prolonged search for meaning. When I lost my pregnancy, I felt alone. I could not believe that anyone else understood the way I felt, and I knew some people would blame me and my body for our riskiness. It was not until I began to blog and speak about my loss that other women came forwards and spoke of their own. Those conversations have helped me process my grief, which raises the question: why do so few women speak of miscarriages and stillbirths when they are so common? I believe the reason lies in how narratives about pregnancy idealize both the process and result: a healthy child. Childbearing and happiness are conceptually linked in our society (Ahmed 57-59; Warner 7), and I suggest that understanding this linkage can help people learn to both grieve and change the culture of silence currently surrounding involuntary pregnancy termination.[2]

In this essay, I use autoethnography to explore and consider possible reasons for the silence around grief and loss. Using my own experience with stillbirth, I focus on two photographs of my children that illustrate a tension between what I argue is natural grief and a kind of heightened grief, which results from increased pressure to procreate to achieve happiness and fulfillment. While I by no means attempt to lessen the impact of pregnancy loss, I seek to use Seigel's *The Rhetoric of Pregnancy* and Sara Ahmed's *The Promise of Happiness* to make sense of my experience for myself and to begin a larger conversation about involuntary pregnancy termination. I do not attempt to speak for all women who have lost pregnancies. If scholarship and personal experience have taught me anything, it is that all grief is different (Brier 461; Harris 1; Scheidt et al. 381). However, I hope that my

experience will resonate with some and open up fruitful conversations about how to better facilitate care and support when a pregnancy terminates.

Methodology: Why Autoethnography?

Personal narratives are powerful rhetorical tools that can be used to empower and inform, or manipulate. Ashley Shelby and Karen Ernst examine how advocates for and against the antivaccine movement have used narratives to support their perspectives. They argue against simply demonizing the other side of the debate and to instead use narratives along with evidence-based information to engage their audiences and inform them of important information, thus developing the ethos necessary for a successful campaign (1798). In addition, narratives are accessible outside of academic readership (Sparkes 211). Autoethnography works in a similar way. Often dismissed as limited memoir-esque writing, autoethnography is really a "personal narrative and ethnographic analysis [used] to illuminate the relationship between lived experience and culture" (Foster 447).

When done well autoethnography promotes the reflexive research methods embraced by feminist researchers. Instead of self-indulgent writing founded on an "N of 1," Foster argues "that analytical autoethnography is rigorous when it employs personal narrative to synthesize, to illustrate, to interrogate, and even to critique current research" (447). The reflection necessary to critically examine one's experiences looks far beyond the original experience and into the larger societal implications. For example, Katrina Powell and Pamela Takayoshi use the act and scene structure of a stage play to present and analyze narratives about decolonizing practices, thus building upon and adding to Tuhiwai Smith's work. In *Decolonizing Methodologies*, Smith asserts, "The past, our stories local and global, the present, our communities, cultures, languages and social practices—all may be spaces of marginalization, but they have also become spaces of resistance and hope" (4). Storytelling is more than sharing tales. When couched within an analytical and reflexive framework, stories can empower the marginalized and disrupt systems based on faulty or biased assumptions. In many ways, true reflection cannot occur without storytelling. According to Oliver:

> Dialogue with others makes dialogue with oneself possible ...
> Having a sense of oneself as a subject and an agent requires that
> the structure of witnessing as the possibility of address and
> response has been set up in dialogic relations with others.
> (Oliver, Witnessing 87)

In other words, people truly understand the implications of their experiences when they become part of a larger conversation. Witnessing makes history complex and dynamic, which reveals societal issues to both the witness and her audience. Storytelling also facilitates resilience (Buzzanell 4) and when used as "an act of retrospective sense making" (Gingrich-Philbrook 299), autoethnography reveals and allows for reflexivity on systemic practices. Even deeply personal writing is important—arguably necessary—because it "can inform, awaken, and disturb readers by illustrating their involvement in social processes about which they might not have been consciously aware" (Sparkes 221). My goal through telling my story is twofold: to encourage empathy and to build awareness of how a heteronormative family narrative affects others, specifically women who have not been able to carry a successful pregnancy to term. I want to make my reader uncomfortably aware of the currently invisible issue of pregnancy loss.

Pregnancy = Happiness

After almost a decade of what Kristin Park termed "voluntary childlessness," my husband and I decided to get pregnant. Unfortunately, our bodies did not comply with our wills, and in August of 2011, we decided to undergo in vitro fertilization (IVF). Many people were surprised by this choice because I had, up until this point, expressed no intention of becoming a mother. As a child, I did not own a doll. In fact, I did not hold a baby until my best friend had her first child. I was twenty-two. But when my eight-week ultrasound showed twins, I felt conflicted. When the ten-week ultrasound revealed triplets, I was beside myself. After a decade of intentionally not conceiving and a year of failed conception attempts, I held three developing human beings in my body. Once the shock subsided, we headed back to Barnes and Noble.

I heard that many women cry at their first ultrasound. The sight of their fetus resonates with them on a deep maternal level, and they are

filled with joy. I did not cry at any of my dozens of ultrasounds. I did not glow with anticipation. I simply did not feel the way a pregnant woman should feel (according to every pregnancy book, television show, and baby formula commercial), especially one who spent a small fortune to get pregnant. I became obsessed with pregnancy information. Surely, the more I knew, the more I would feel; and I have to admit that it helped, but why? At the time, I would have replied that the books, apps, and documentaries were making the pregnancy real. They were helping me to become emotionally invested in something so intangible, so unfathomable that I simply could not wrap my head around it. I did not realize they were doing even more. According to Seigel, pregnancy rhetoric moves beyond the necessary emotional rhetoric of parent-child love to an unhealthy idealization of family. This idealization began in the beginning of the twentieth century when J.W. Ballantyne, a botanist turned obstetrician, initiated prenatal care. His goal was admirable: to counter the sharp population decline by increasing successful pregnancies. However, positioning babies as the solution to social and political issues turned procreation into a panacea and the family unit into the ultimate goal (Seigel 39-40). An entire century later, these associations remain. Immersing myself in this rhetoric helped me to feel a sense of purpose, but that was because I was already "in the family way"; however, the same rhetoric also enforces an ideal that may be impossible or undesirable for some.

Many queer studies scholars question the underlying idealization of (traditional heterosexual) childrearing and the politics it entails (Berlant and Warner; Butler; Cohen; Park). The argument is not that children are bad, but that the expectation of childbearing— and the expectation it will bring happiness and fulfillment to all—is not just fallacious but damaging because it enforces particular assumptions about kinship (Butler 21) and family (Cohen 455-457). When the nuclear family is considered normal, then anything outside of normal is marginalized: the single mother, the same-sex couple, the voluntarily childless, the career woman, (Park 25) and the woman who miscarries. Policies, practices, and even tacit behaviours form in support of these assumptions, all of which penalize those who live outside the norm. But queer scholars are not all against reproduction, and my argument is certainly not that it is wrong to have children or to want children. What is problematic is the overt and covert messaging that children are

required for happiness and normalcy. Ahmed explains, "Certain objects are attributed as the cause of happiness, which means they already circulate as social goods before we 'happen' upon them, which is why we might happen up on them in the first place" (28). In our current society, children are social goods that are imbued with happiness and those who cannot or choose not to have children are denied that happiness. Queer studies scholars have problematized this correlation, but I believe the academic community has overlooked an important demographic of those affected by this narrative: women whose pregnancies have terminated.

Significant research has been done on the female body and its reproductive potential, as well as the physical and psychological effects of involuntary pregnancy termination (Carp; Geyser and Seibert; Koerber; Martin; Seigel). However, there is (to my knowledge) no significant research on the rhetoric of miscarriage or stillbirth. Even Elaine Tuttle Hansen's important work *Mother without Child* spends only a few pages on involuntary pregnancy loss. Understandably, scholars who have tried to understand perinatal grief have used assessment standards developed for "normal" grief—including A Stage Theory of Grief (Hutti 453), the Adult Attachment Interview (Scheidt et al. 377), and the Hospital Anxiety and Depression Scale (Nikčević et al. 54). Marianne Hopkins Hutti et al. used assessments like these to develop a specific grief measurement for miscarriage, titled the Perinatal Grief Intensity Scale (Brier 454), but these attempts to quantitatively measure perinatal grief consistently return to a singular problem raised by Norman Brier's definition of grief as "the affective, physiological, and psychological reactions to the loss of an emotionally important figure" (452): what constitutes an emotionally important figure?

Many of these same scholars turn to attachment theory in attempts to answer this question and understand their research results. Scheidt et al. were the first to postulate the connection between attachment and grief in their 2012 cohort study, which followed thirty-three women after perinatal loss. They concluded that the stronger the degree of attachment between parental figure and unborn child, the longer the bereavement process (376). Janice Harris noted that the depth of grief may "vary for each couple depending primarily on the level of perception by the parents of the baby assuming 'personhood' (para. 3). Though articulated differently, Scheidt et al. and Harris argue that the

more parents identify the fetus as a person, the more attached they become and the more prolonged the grief becomes.

Many who have not experienced involuntary pregnancy loss struggle to understand how deeply a parent can grieve a child who never truly lived. This is where attachment theory and Ahmed's theories on happiness prove useful. Brier argues the following:

> Grief following miscarriage seems somewhat distinct from grief that typically occurs following other losses in the preponderant emphasis on time ahead rather than remembered times. Thus, after a miscarriage, the individual seems to dwell on images of an anticipated future and the hopes and dreams about what was to be rather than on past experiences. Yearning after a miscarriage also seems somewhat different in that it is primarily centered on the individual's mental construction of a relationship and future rather than actual, past, directly shared experiences. (Brier 460)

The attachment between mother and child is not simply a biological one fostered in utero; it is created through a lifetime of association between childbearing and happiness. For some, attachment towards their child began long before pregnancy, as the idea of the child and parenthood became "happy objects" (Ahmed 27). In these cases, the "happy object" reached beyond the child itself and into the woman's identity as mother. But when a child is lost in utero or within hours after birth, as Hansen asks, is the woman without her child really a mother? What about a woman who has conceived a child but never comforted her, heard her laugh, or felt his chest rise with breath? Does the act of mothering make a mother? If so, what are women who give birth but never take on the role?

Questions about what it means to be a mother are incredibly complicated, and parsing them is not within this chapter's scope, but the questions illuminate the complexity of perinatal grief. They also begin to explain why some people are more thoroughly devastated by involuntary pregnancy loss than others. For those who, like me, had a difficult time buying into the heterosexual family ideal, the grief should be less intense. People who spend their whole lives envisioning themselves as parents may more readily attach to their unborn child and, quite understandably, mourn its loss more fully. This is not to say that the loss of a child apart from this narrative is not devastating.

However, child loss within it represents more than the loss of a child—it represents the loss of an ideal.

Two Pictures of My Children[3]

I lost three babies over the course of three days. Despite our best efforts, neither a skilled medical team nor I could prevent my body from delivering them early. Although it may seem strange to refer to my body as a separate entity, I have come to realize that there was no connection between my will and my body's actions. It is far too common for the woman to blame herself for her baby's death (Kohner and Henley) especially when the female body is perceived as the linchpin of a heteronormative family ideal. Within this logic, if her body is unable to reproduce, then she is at fault for the lost ideal. In some ways, losing triplets made it easier to avoid feeling guilty. From my ten-week ultrasound onwards, every doctor told me my odds of birthing three healthy babies were not high. My body was risky. Unlike other women who have the odds in their favour, my loss was somewhat expected. In fact when my perinatologist visited me in recovery he said, "It's just a triplet thing." It was the wrong thing to say to someone in my position. It was callous, and it represented the tension between the medical community, the patient[4], and the pregnant body. I was something my doctors could not predict, which meant my pregnancy (and my children) were, in many ways, unmanageable. At the time, my perinatologist's words brought me no comfort; but over time, his ideology did. My doctor's words echoed Ballantyne's early rhetoric. It was my body that was risky, not me. Medical science has yet to solve the so-called triplet problem, so we were all pardoned of fault. If my pregnancy had been "normal"—a singleton versus multiples—then it would have been harder to evade guilt and blame. But as it was, as biased and harmful as the narrative may have been, my riskiness helped me avoid the self-blame many other women who lose their children cannot.

Let me be clear. Avoiding self-blame does not mean avoiding grief. It is natural and necessary to grieve. After the loss of my children, I grieved deeply for about six months before the pain began to lessen and I began to see the world around me again. As time passed, I was even able to look at my grief more critically. It was at this time that I returned

to the heartbreaking photographs that were taken of our children while I was in the hospital. One set always appealed to me more than the other, but I could not articulate why. I began to understand that they represented very different kinds of grief. Here, I want to explore two photographs, one from each set, to articulate the differences and why they are significant. The first photograph captures my husband and me with our firstborn, Ewan, during the few hours of his life. The second was taken of all three babies after Ewan's twin Sebastian and their sister Amelia were born, which was two days after Ewan's birth and death. To me, the first illustrates an authentic moment of grief, complex and raw. The second, on the other hand, represents the loss of an ideal—the happiness associated with our children—not the shock and sorrow itself. Together, the photographs present a bizarre juxtaposition of the grief we felt and the ideal we were expected to grieve.

Photo One: Ewan

The loss of our firstborn was traumatic in many ways. I was admitted to the hospital at twenty-three week's gestation after what I thought would be a routine check at the perinatologist. It turned out that I was in labour. Although babies can be viable as early as twenty-five weeks, the goal is to prevent birthing for as long as possible. The problem was that my body was ready to deliver. My doctors placed me on a high dosage of magnesium sulfate, a common drug administered to women in preterm labour to slow contractions and delay birth. We were hopeful. After four days in the hospital, they deemed me stable and moved me upstairs in anticipation of an extended stay. They were wrong. Moments after my transfer, my water broke, and Ewan was on his way. At only twenty-three-and-a-half-weeks gestation, our hope began to wane. We were then faced with a terrible decision: birth all three babies and almost certainly lose them all or sew up the embryonic sack and hope to buy the other babies more time in utero. We chose hope.

There was no crying when Ewan was born. They did not rush for neonatal intensive care unit (NICU) support. The nurses wrapped his little body, and a nurse asked, "Would you like to hold him?" She expected a "yes," but I almost declined. No one had prepared me for this. I had never even felt my babies kick, and now one was wrapped in a gauzy blanket being placed in my arms. Did it even matter if I held him? I had no idea at the time that other women had grappled with this

same decision. In their remarkable book, *When a Baby Dies*, Nancy Kohner and Alix Henley give voice to parents who experienced late stage pregnancy loss. One woman, Anne (a pseudonym), was not as lucky to have the supportive medical staff we did:

> The young doctor asked if we would like to see Philip, but we declined the offer—a decision I will regret to my dying day. If only someone could have talked to me, could have explained how important it was to say goodbye to our baby, could have told me how it would help with the grieving process, could have just gently taken me by the hand and supported me. (47)

Not only did we hold our son, we were encouraged to take pictures. It felt unnatural—unreal—but the nurses insisted. They were right.

The picture of my firstborn is one of love and grief. In it, my husband, still dressed for work, leans tenderly over me as I hold our son. Ewan's skin is dark from transparency, and his delicate arm is nestled by his face. Our eyes are on him, but his eyes are still fused shut. My hand hovers over his body. It is not a beautiful picture by traditional standards, but it illustrates a beautifully tragic moment— one we would not be able to revisit without the nurses' interventions.

Not long after Ewan drew his final breath, my husband sent a simple tweet: "We've lost the moon." It was, and still is, poignant in many ways. It was the beginning of the end of my pregnancy and our three children. Like the famed Apollo 13 astronauts, we were losing our orientation, and we felt adrift. We had just started to attach ourselves to a new future—one where we were the parents of three children. These children had become our "happy objects" (Ahmed 27). I had a few pregnancy "belly pics" to track my changing body, and we had ordered the cribs. Family friends had even gifted us an incredibly expensive stroller for three, which my husband had already assembled. We had started to literally and figuratively buy into the pregnancy. However, it was not until we lost Ewan that we discovered how much he, and this idea of happiness, meant to us. Ahmed explains that the complexity of happiness lies not just in our possession of it but also in its absence. John Locke terms that absence "uneasiness." As Ahmed further discusses Locke, "His argument is not simply that happiness makes us uneasy. He suggests that something does not become good for us "until our desire ...makes us uneasy in the want of it" (Locke qtd. in

Ahmed 31). In other words, we are pushed forwards to obtain the happy object because of its absence, even if we did not originally fully desire it. In this moment, we truly mourned our child, but we also began to feel the "uneasiness" of his removed potential existence.

I know that even for those who have not experienced pregnancy loss, the term "uneasiness" used in this context is probably unsettling, even angering. Please do not misunderstand me. I am by no means implying that neither I nor any other parent in this situation only felt grief because of unfulfilled potential. Ahmed and Locke have simply provided me with a way to articulate my grief and understand how it began to affect me after Ewan's death. Attachment theory is also helpful. As Scheidt et al. explain, "During pregnancy the growing relationship to the unborn child is accompanied by an increasing readiness and capacity to form an intimate attachment relationship ... Bereavement due to pre- and perinatal death is taking place during a period of a specifically heightened vulnerability" (376). Put in a more personal context, our grieving began because our son died. However, his death came at a time in my pregnancy when we were actively nurturing attachment to our unborn children. This attachment made our grief more extreme, and since we could not actually know our child, he represented more than our relationship actually was at the moment of his death. His death made us realize how deeply we wanted not just the child himself but what that child represented. As difficult as it is to admit, the hope we preserved by sewing up the embryonic sack partially illustrated this uneasiness. Although losing Ewan was tragic, my husband and I still hoped we could preserve happiness through the other two children, and we were not alone. On countless occasions in the following years, well-intentioned people would ask without thinking if we lost all three children. Even if only one had survived, the loss would have been less tragic. My pregnancy would have been a success, albeit not as successful as it could (or should) have been. We would have been a family.

Photo Two: The Triplets

My body held out for two days before it became clear that the other babies were coming. At some ungodly hour of the morning, my amazing OBGYN was paged and after finishing a Caesarean section one town over, sped downtown to deliver our second son, Sebastian. As Ewan's identical twin, he was the most at risk because he shared the

same ruptured embryonic sack. Our attempt to prolong the inevitable had failed. Despite the odds, I still hoped to not deliver Amelia. Unfortunately, the uterus is prone to infection after a woman's water breaks, and mine was no longer an inhabitable space. However, there was a brief glimmer of hope when she was born. Unlike her brothers, she managed a tiny cry. The NICU was called, but it was a false alarm. We held them both for the duration of their short lives, and I was wheeled into another room.

Later that day, a nurse approached me after I awoke from my first real sleep in the hospital. I had been heavily drugged for six days, and I was grieving deeply. To say I was not entirely coherent would be an understatement. She asked if I would like pictures of the babies. Some of the nurses had begun offering the service years ago for grieving parents. She offered to dress the babies and photograph them for me. I had no answer. I did not protest, but I did not fully consent. Instead, my mom spoke on my behalf. In a well-intentioned gesture, she asked if Ewan could be retrieved and photographed so that we could have pictures of the triplets together. Although an unusual request, they consented.

It is impossible to predict how anyone might feel in this situation. I was there, and I did not know how to feel. Some parents wish to continue holding their child after her final breath, in some ways to prolong the inevitable, but also to spend as much time as possible with their little one. Good hospital staff will give grieving parents time and space, but Kohner and Henley report horror stories of parents, like Anne, who were not able to grieve in their own ways (47). The authors strongly encourage parents to request whatever they need in that moment. In this instance, the hospital complied, and I appreciate their accommodations. However, had I been more coherent, I would have refused the photographs. Undoubtedly, some parents find comfort in these final photographs, but I did not.

The picture of my triplets, for me, does not represent grief but the uncanny. The uncanny can be invoked when it is difficult to tell if an object is a living or inanimate thing (Freud 233). Though briefly animate, my children were no longer. In this photograph, all three babies rest shoulder to shoulder with their tiny hands folded on their chests, like so many deceased who have come before them. They have been clothed in miniature hospital gowns and are wearing colour-

coded hand-knit beanies: Amelia in pink, Sebastian in mottled blue and green, and Ewan in blue. They are resting on a baby blue crocheted blanket and a yellow silk sunflower is centred above them—a small gold cross has been embedded in its dark centre. What cannot be seen from the picture is that they are positioned in a small alcove in a hospital room. Although the room is dimly lit, the alcove has bright lights positioned on their bodies like a photographer's studio in a grotesque dollhouse. At a glance, they look almost alive, but a longer look reveals a waxy sheen to their skin and their eyelids still fused shut. With mouths slightly askew, they could almost be drawing breath, but their chests would not move beneath their folded hands. What unsettles me about this image (and this service) is that the babies are posed like living newborns on soft blankets with little hats and props. Instead of mourning the tragedy of their deaths, it mourns the loss of their potentials. Since they would never have an artistic newborn photo shoot, they received this hollow imitation of one.

In a traditional funeral, people share stories about the deceased and reminisce over old photographs. Family, friends, and loved ones will not simply miss the idea of the deceased; they will miss her presence, smile, or laugh. I have few memories of my children, and discussing those memories brings more sorrow than fondness. I still struggle with Hansen's questions about the mother without her child because, as she postulates, "the position of the mother without child is not only a traumatic present reality but also a logical impossibility, a taboo, and therefore a site of instability that facilitates thinking about motherhood and women beyond official logic and conventional possibility" (26). I remember feeling at odds with the label "mother" after losing the triplets, especially on Mother's Day. People wanted to honour my experience and the memory of my children, but it felt artificial to don the title. I had never fulfilled the role; I never had the chance. Also, accepting the label of "mother" opened me up for questions—innocent questions—about my children and how we would celebrate the day. These were questions I was not ready to answer. "Mother" was neither a term I had earned nor an identity I was comfortable adopting. My maternal role lasted only a few hours and was best preserved in the first picture. The same unease I felt about the second picture applied to my identity as "mother." It held some elements of truth, but it was forced and falsified. It represented more than I could honestly claim, and the

pressure to embrace the title only heightened the tension.

A failed pregnancy is, for many, a paradox. When pregnancy rhetoric shows positive outcomes and a myriad of ways the medical system can "troubleshoot" the pregnant body, women expect a healthy baby at the end of their pregnancies (Layne; Seigel). It seems a modest and realistic expectation, but for many women it is not. When the only narratives we are shown are of fruitful pregnancies and happy families, it is no wonder that women who fail in these areas keep quiet. But, at the same time, women who experience pregnancy loss often desperately look for meaning (Nikčević and Nicolaides). How could they not? And how much more difficult is a quest for meaning when it is undertaken in isolation? When viewed in this light, it is easy to see why the nurses at my local hospital began photographing preterm babies postmortem. The narrative was in place; the expectations were set. What else can be done when parents are faced with this terrible twist of fate?

Conclusion

If I have learned anything, it is that all grief is different. We want to understand it. We want to predict it. We want to quantify it in some way to give it meaning, to make it more manageable, but we cannot. As someone who has experienced deep grief and who has spoken to many others who have also experienced it, I am not surprised by grief's slipperiness. And as much as I respect the variability of grief, I cannot escape the idea that we are missing a vital piece of the analysis.

My own grieving process has not been easy. Even after over four years, the reflection necessary for this chapter has been difficult. Grief is sneaky. It digs into the soft recesses of your being only to emerge when you feel certain it has gone. But that is to be expected. One never fully recovers from great loss: it leaves a permanent mark. However, despite losing three babies right on the cusp of viability, I was somehow able to move forwards more steadily than many others. Why? I wish I could provide a proven formula for grief recovery, but I believe that everyone's story is different. Also, I believe the strong association between family and happiness is damaging to many women. Although there is no shame in desiring a child, the pressure created by idealizing heteronormative childrearing compounds the pain of not being able to successfully carry a pregnancy to term (Berlant and Warner; Butler;

Cohen; Park). Placing future happiness in this often unattainable ideal can throw women into despair when, after conception, their bodies betray them and their unborn child. For Ahmed, this imagined ideal is problematic:

> To think of happiness as involving an end-oriented intentionality is to suggest that happiness is already associated with some things more than others. We arrive at some things because they point us toward happiness, as a means to this end. How do we know what points happily? The very possibility of being pointed toward happiness suggests that objects are associated with affects before they are even encountered. An object can point toward happiness without necessarily having affected us in a good way. (Ahmed 27)

Even before many women know that a baby will make them happy, they set it as their happiness goal. Setting an expectation like this one can lead to many ends. Some women find it to be true: they delight in their families. Others struggle with the pressure to reproduce for other reasons, like sexual orientation or nontraditional goals. Equally tragic are those who felt pressured to marry and conceive only to wonder why they are still unhappy. And then there are the women who repeatedly try and fail. They are perpetually mothers without their children.

Systemic change is never easy, but there are always ways to disrupt problematic discourses. I believe the first step is to embrace a polyphony of narratives. When up to a quarter of pregnant women lose their pregnancies and no one talks about it, there is a problem. Here I risk sounding like someone who seeks to perpetuate risky pregnancy rhetoric, but I am not. Seigel argues for new system-disrupting documents that use empowering narratives to show the pregnant body and woman as capable, not risky. Although I wholeheartedly endorse this shift, I fear that we may shy away from authentic stories of loss in the attempt to seem less risky. I do not advocate perpetuating the current troubleshooting style of pregnancy books, but focusing only on success stories can make women who experience involuntary pregnancy loss feel even more at fault. Narratives of strength during successful labours strengthen female agency, and stories of healthy grief and recovery can facilitate resilience.

Endnotes

1 Miscarriage statistics vary by site, age, and known versus unknown pregnancy. The averages appear to be 12 to 20 percent with lows of 10 percent and highs of 25 percent for known pregnancies. Unknown pregnancies (i.e., very early miscarriages) reportedly occur in up to 50 percent of pregnancies (Hurt et al.).

2 I will use the terms "involuntary pregnancy termination" and "pregnancy loss" interchangeably to represent any loss of a child during gestation, which includes pre-term labour with infant mortality, miscarriage, and stillbirth. Although I believe abortion raises many of the same issues I discuss in this chapter, it includes other factors of grief, guilt, and social pressures outside the scope of this project.

3 This subheading is inspired by Dorianne Laux's poem "Two Pictures of My Sister" from Laux's What We Carry.

4 Medical rhetoric, psychology, and biomedicine have begun producing research on patient-centred medicine. This conversation informed my position and analysis for this chapter. For more information about this conversation, see Barton; Ellingson; Buzzanell; Roter and Hall; Segal; Sharf and Street; Tong.

Works Cited

Ahmed, Sara. *The Promise of Happiness*. Duke University Press, 2010.

Barton, Ellen. "Discourse Methods and Critical Practice in Professional Communication: The Front-Stage and Back-Stage Discourse of Prognosis in Medicine." *Journal of Business and Technical Communication*, vol. 18, no. 1, 2004, pp. 67-111.

Berlant, Lauren, and Michael Warner. "Sex in Public." *Critical Inquiry*, vol. 24, no. 2, 1998, pp. 547-566.

Brier, Norman. "Grief Following Miscarriage: A Comprehensive Review of the Literature." *Journal of Women's Health*, vol. 17, no. 3, 2008, pp. 451-161.

Butler, Judith. "Is Kinship Always Already Heterosexual?" *Differences: A Journal of Feminist Cultural Studies*, vol. 13, no. 1, 2002, pp. 14-44.

Buzzanell, Patricia. "Resilience." *Journal of Communication*, vol. 60, 2010, pp. 1-14.

Carp, Howard J.A. *Recurrent Pregnancy Loss: Causes, Controversies and Treatment*. 2nd ed. CRC Press, 2015.

Cohen, Cathy J. "Punks, Bulldaggers, and Welfare Queens: The Radical Potential of Queer Politics?" *GLQ*, vol. 3, 1997, pp. 437-465.

Ellingson, Laura L., and Patricia M. Buzzanell. "Listening to Women's Narratives of Breast Cancer Treatment: A Feminist Approach to Patient Satisfaction with Physician-Patient Communication." *Health Communication*, vol. 11, no. 2, 1999, pp. 153-183.

Foster, Elissa. "Communicating Beyond the Discipline: Auto-ethnography and the 'N of 1.'" *Communication Studies*, vol. 65, no. 4, 2013, pp. 446-450.

Freud, Sigmund. *The 'Uncanny'. The Standard Edition of the Complete Psychological Works of Sigmund Freud, Volume XVII (1917-1919): An Infantile Neurosis and Other Works*. Vintage, 2001.

Geyser, P. J., and I. T. Seibert. "Early Recurrent Pregnancy Loss: Case Report. *Obstetrics and Gynaecology Forum*, vol. 25, no. 1, 2015, pp. 28-31.

Goubil-Gambrell, Patricia. "A Practitioners Guide to Research Methods" *Technical Communication*, vol. 39, no. 4, 1992, pp. 582-591.

Hansen, Elaine Tuttle. *Mother Without Child: Contemporary Fiction and the Crisis of Motherhood*. University of California Press, 1997.

Harris, Janice. "A Unique Grief." *International Journal of Childbirth Education*, vol. 30, no. 1, 2015, pp. 82-84.

Hutti, Hopkins Marianne, et al. "A Study of Miscarriage: Development and Validation of the Perinatal Grief Intensity Scale." *Jognn Clinical Studies*, vol. 27, no. 5, 1998, pp. 547-555.

Hurt, K. Joseph, et al. *The Johns Hopkins Manual of Gynaecology and Obstetrics*. 4th ed. Lippincott Williams and Wilkins, 2012.

Koerber, Amy. "Rhetorical Agency, Resistance, and the Disciplinary Rhetorics of Breastfeeding." *Technical Communication Quarterly*, vol. 15, no. 1, 2006, pp. 87-101.

Kohner, Nancy. and Alix Henley. *When a Baby Dies: The Experience of Late Miscarriage, Stillbirth and Neonatal Death*. New York: Routledge, 2006.

Laux, Dorianne. *What We Carry*. BOA Editions Ltd., 1994.

Martin, Emily. *The Woman in the Body: A Cultural Analysis of Reproduction*. Beacon Press, 1987.

Nikčević, Ana V., and Kypros H. Nicolaides. "Search for Meaning, Finding Meaning and Adjustment in Women Following Miscarriage: A Longitudinal Study." *Psychology & Health*, vol. 29, no. 1, 2014, pp. 50-63.

Oliver, Kelly. *Family Values: Subjects Between Nature and Culture*. Routledge, 1997.

Oliver, Kelly. *Witnessing: Beyond Recognition*. University of Minnesota Press, 2001.

Park, Kristin. "Stigma Management among the Voluntarily Childless." *Sociological Perspectives*, vol. 45, no. 1, 2002, pp. 21-45.

Plummer, K. "The Call of Life Stories in Ethnographic Research." *Handbook of Ethnography*, edited by Paul Anthony Atkinson, et al., Sage, 2001, pp. 296-406.

Porter, Lindsey. "Miscarriage and Person-Denying." *Journal of Social Philosophy*, vol. 46, no. 1, 2013, pp. 59-79.

Powell, Katrina. M., and Pamela Takayoshi. "Revealing Methodology." *Practicing Research in Writing Studies: Reflexive and Ethically Responsible Research*, edited by Katrina M. Powell and Pamela Takayoshi, Hampton Press, 2012, pp. 1-28.

Roter, Debra L., and Judith A. Hall. *Doctors Talking with Patients/ Patients Talking with Doctors: Improving Communication in Medical Visits*. 2nd ed. Praeger, 2006.

Scheidt, C.E., et al. "Are Individual Differences of Attachment Predicting Bereavement Outcome After Perinatal Loss? A Prospective Cohort Study." *Journal of Psychosomatic Research*, vol. 73, 2012, pp. 375-382.

Segal, Judy. *Health and the Rhetoric of Medicine*. Southern Illinois University Press, 2008.

Seigel, Marika. *The Rhetoric of Pregnancy*. University of Chicago Press, 2013.

Sharf, Barbara F., and Richard L. Street Jr. "The Patient as a Central Construct: Shifting the Emphasis." *Health Communication*, vol. 9, no. 1, 1997, pp. 1-11.

Sparkes, Andrew C. "Autoethnography: Self-indulgence or Something More?" *Ethnographically Speaking: Autoethnography, Literature, and Aesthetics*, edited by Carolyn Ellis and Arthur P. Bochner, Alta Mira Press, 2002, pp. 209-232.

Spry, Tami. "Performative Autoethnography: Critical Embodiments and Possibilities." *The Sage Handbook of Qualitative Research*. 4th ed., edited by Norman K. Denzin and Yvonna S. Lincoln, Sage, 2011, pp. 497-512.

Tong, Rosemarie. *Feminist Approaches to Bioethics: Theoretical Reflections and Practical Applications*. Westview Press, 1997.

Tracy, Sarah J. *Qualitative Research Methods: Collecting Evidence, Crafting Analysis, Communicating Impact*. Wiley-Blackwell, 2013.

Tuhiwai Smith, Linda. *Decolonizing Methodologies*. 2nd ed. Zed Books Ltd, 2012.

Warner, Michael. "Fear of a Queer Planet." *Social Text*, vol. 29, 1991, pp. 3-17.

Chapter 12

The Immigrant

Maya Bhave

Preface

The poem "The Immigrant" was written many years after my first-born son, Andrew, was stillborn at term on 17 March 1997. For a long time, I wrestled with feeling like a postmother or a nonmother without my son nearby. I wasn't at all sure what to do with my pain or my emptiness. It was only after the passing of time that I recognized that my dissonance was truly about feeling like an outsider to this new world of motherhood, identity, and loss. My hopes and desires for Andrew's life did feel like an obfuscated past, and I did feel like a child bobbing in the water unsure if I would sink under from the emotional chasm. Only a few people wanted to speak his name, for fear of upsetting me, yet that only upset me more. Literally, the cemetery was where I felt I could be my true self, as his mother. I spent countless hours there in the first few years after his birth/death. To this day, whenever we travel back to Chicago, it is one of the first stops we make as a family—his dad, me, and Andrew's two younger brothers.

Exhaustion pushes down on me,
I blink—my bleary eyes
attempt to bring it all into focus.
I'm not sinking just
drifting aimlessly,
like a child in a swim vest,
uncertainly safe, my head bobbing barely above the water level,
terribly afraid I'll slip out and drown in this abyss
any second now.
I gaze out at my new homeland—
desolate drawers and spaces
once laden with treasured stuffed animals, onesies and diapers,
now pristine and vacant.
Did you ever really exist?
How did I get here?
The past few days seem hazy and obscure—
maternity hospital registration,
ultrasound machines discreetly hidden behind maple cabinets,
beeping monitors, IV lines—tubing draped around my writhing body,
old, etched yellow linoleum floors,
medical staff briskly sweep in,
ID badges swing
Retreating hastily like late October snow.
Flummoxed stares, mumbled phrases, pursed lips,
awkward pats on shoulder,
eerie silence as they leave me hooked to the apparatus—alone.
I am immigrant.

March 20, first day of spring
Stepping out on into the busy Chicago street
uncertain of which way to walk,
muddled voices, quizzical looks.
Will they understand my story,
—my secrets?
My still-swollen belly beckons their glares.
Strollers, infant carriers,
I hear babies cry at every corner.

Their wailing sounds—
make it stop, make them stop,
why are they coming from everywhere?
I close my eyes, ball my fists,
afraid to open and catch a glimpse.
The darkness my companion of silence.
Desire, truths.
I am immigrant.

I walk aimlessly,
unsure of which road to take.
It all seems so diffuse this obfuscated past.
I head for familiar ground,
shops, people, noise.
The shiny, glass elevator propels me upward.
Doors open. Floor six, the familiar path.
The neon sign "BABY GAP" glares down with shame and compunction.
My feet feel unsteady.
Beads of sweat drip slowly between my aching breasts,
my cement feet embedded in the floor,
frozen as happy pregnant shoppers move immediately past me,
their eyes fixed on what they believe lies beneath.
I am other, foreigner here.
I have no business being here.
I am immigrant.

North up Lakeshore Drive to the cemetery.
Left at Irving, right at Western.
Serenity and calm behind the looming steel gates.
No crowds.
Only strewn plastic flowers, soggy teddy bears and bronze candles.
Taylor
Seminowicz
Park
Lee
Znaniecki
Immigrant names, their stories, too, untold.
Section 119

ANDREW ANANT BHAVE
MARCH 17, 1997
Here he is.
Dots of white excrement cover the newly etched grey granite.
Those damn Canadian geese.
But they stay.
What is it they know about this resting place?
I don't know for sure.
But I do know that despite the dirty stains,
the pain, the uncertainty and stifled expectations,
It is here that I find comfort.
I am no longer immigrant.
Here I belong.
I am home.
For here, I am Mother.

Chapter 13

Figure Drawing

Rachel O'Donnell

Priors

1. Solitude and quiet. Time to read.

2. Everyday life without the unease of the unknowing.

3. Misunderstandings, judgments, loneliness.
 All this has disappeared.

Defeat

4. She is dead at forty-two weeks, and you have killed her. Motherhood without a baby is like going to the ocean and seeing no water. The sand is not even wet.

5. In the shower, the water falls at an angle but hits and then falls over your belly and disappears. When you brush your teeth, the toothpaste drips onto the round shelf of flesh and does not fall to the floor. In between your breasts, which point more to the sides and fall under your armpits when you lie down, a series of moles speckles your torso like a constellation. Once, they are fingered by the primary care physician, one partially removed by the dermatologist. He picked up each breast to look underneath for hidden dark spots. After the milk was gone.

6. Your swelled ankles meet up along the sides of purple veins and red lines that stretch and spread awkwardly out to the round sides. The dark areas on your face could almost pass for freckles from far away, and there are long stripes that run along the sides of your back from it stretching. It must have stretched. You cannot remember.

Succeeding

7. A bodily understanding: there was life, there was death, and then life again. All in this body, all outside this body, all created from the inside and some dead, some growing. You mix up the births: a birth where there is no life, a birth where there is life, a moving and growing actual child.

8. Things that don't matter: the pain, the sleeplessness, the lines, the thinning hair, the lined elbows, black rings that sink inward under each eye. Things that do: breasts full of milk that will be suckled and absorbed, a warm body, a tiny head on your chest, hands in the sand. No one will ever love you this much again, no one will ever touch you with an entire body this way, naked and warm against your nakedness and warmth.

9. Two living, one dead, four total, one house. A body of shame, fear, sleeplessness, checking for breathing, getting food and water.

10. In the pool, the new child, the living one. He yells, "Mom look at me!" Kicking and scooping water in his cupped hands. Face down, you turn circles in the water, turn circles and breathe out, this is what she must have done with the last few moments of her life.

Chapter 14

Suppress and Express: Breastmilk Donation after Neonatal Death

Katherine Carroll and Brydan Lenne

Preamble

"Where is the baby?" I asked myself as I sat in the lounge room of a woman who had donated her breastmilk to a breastmilk bank in Colorado. Unlike the previous fifteen mothers I had interviewed that month about their experiences of milk donation, this mother, Melissa (a pseudonym), was not nursing a baby on her knee, nor was she distractedly listening for waking cries echoing down the hallway from the nursery. Resisting the urge to ask Melissa if her infant was in day care, I began my research interview. Melissa explained that her second son, born alive, lived for less than four hours and had died in her arms just a few months ago. Born at twenty-five weeks, he was too small to survive.

Melissa told of how she returned home from the hospital, waking painfully that night with full breasts, unprepared for both the intensity of grief or for the beginnings of her lactation. She fumbled through boxes in her attic looking for her old breast pump but could not find it. "I never really got the hang of hand expression," she told me, "and I basically never needed to pump because I breastfed my first son." Melissa rang the milk bank the next day, hoping she could borrow a hospital-grade breast pump to provide relief. Initially, she did not consider donating her milk; however, she later decided to donate her frozen expressed milk, knowing that vulnerable infants would receive it. Melissa pumped for a period of ten days. She remarked: "that just made me feel proud,

to be able to have that freezer-full, and to hand it off to the bank." According to Melissa, it was not so much the act of donation that was healing; instead, expressing milk gave her time for herself, which allowed her to grieve and cry in private. Pumping milk for the purposes of donation helped her to begin to heal physically, emotionally, and spiritually: "People kept saying, 'Oh, you're so generous to donate,' and honestly I just feel like I am the one who benefited, because it just helped me on all of these different levels."

After encountering Melissa's story, and that of another bereaved mother in the U.S., we decided to further research the topic of bereaved donation. This chapter draws upon Katherine's study with bereaved mothers who donated milk to a milk bank in Colorado and Katherine and Brydan's study of bereaved mothers and their lactation experiences from Melbourne, Australia.[1] We do not seek to compare Australian and American women's experiences. Instead, we contrast the collective richness of women's experiences of lactation after neonatal death (infant death within first twenty-eight days of life) to more broadly normalize lactation after loss and to advocate for the proactive provision of lactation education and donation options for bereaved mothers. We conclude by using the concept of "selective forgetting" embedded within the feminist theory of corporeal generosity (Diprose 8-10) to understand how it is that so many health services overlook the diverse needs of bereaved mothers for lactation education.

Introduction

The fecund female body occupies a highly constructed, regulated, and ambiguous position in contemporary Western society; a woman's body is both celebrated as being nurturing, asexual, and sacred, and, at the same time, is condemned as polluted, impure, morally contaminated, and, therefore, a threat to social order (Ussher). Similarly, breastfeeding and breastmilk continue to be celebrated as the most important means of providing ideal infant nutrition, but they are also construed as risky and as needing containment, regulation, or monitoring. An example is the medical concern over the passage of environmental contaminants or pathogens to so-called pure infants through breastmilk feedings (Boswell-Penc; Hausman). This notion is used to support normative feeding practices, whereby breastmilk is provided only by the infant's biological mother (Shaw) unless it has been screened and pasteurized by a human milk bank and prescribed as donor milk by medical doctors

(Carroll, "Body Dirt"). Another example is the social pressure on lactating women to hide or contain leaky breasts through the use of breast pads and breastfeeding covers, or to ensure that breastfeeding and the expression[2] of breastmilk occurs away from public view (Bramwell; Benn and Phibbs). The idealized standard is a controlled reproductive body, where all leaks, seepages, and bleeding that accompanies women's reproductive capacity are kept hidden from public view and discussion (Ussher).

In this chapter, we focus on another taboo of women's reproductive bodies: the production and donation of breastmilk after neonatal death. Lactation support and milk donation programs for mothers of living infants are evident, but their availability stands in stark contrast to the lack of lactation education and policy as well as milk donation services for bereaved mothers. These have been found to be repeatedly overlooked as meaningful components of care in women's reproductive health (Britz and Henry; Cole; Moore and Caitlin; Seresthi et al.). In this chapter, we highlight this gap in health service delivery through an open and frank discussion of the meaning bereaved mothers' place on their lactation and subsequent milk donation experiences after one type of infant loss: neonatal death.

Lactogenesis and Lactation Suppression after Neonatal Death

In cases of stillbirth, late term abortion, and neonatal death, women will experience the onset of milk production (Britz and Henry). Similarly, when an older breastfeeding infant dies, the mother will continue to produce breastmilk. Thus, while contending with profound grief, bereaved mothers must immediately learn to manage lactation. In this chapter, we draw on women's lactation experiences with one type of infant loss, neonatal death, which is defined as death of an infant within the first twenty-eight days of life (Australian Institute of Health and Welfare).

The production of breastmilk after neonatal death can be emotionally painful and psychologically distressing for some bereaved mothers (Cole), and sore, engorged breasts and leaking milk can compound the grief experience (McGuiness et al.). Breastmilk expression is one method available to women to help maintain comfort

and prevent engorgement; it can help prevent subsequent breast infections from retained milk, such as mastitis and abscess (Moore and Caitlin). To reduce breastmilk production to the point of the cessation of lactation—particularly for mothers who may have been breastfeeding or expressing milk during their infant's life—women will need to reduce the frequency, length of time, and volume of milk expressed. The cessation of lactation will usually occur within two to three weeks. In addition to providing physical comfort and the prevention of breast infections, a bereaved mother's agency and autonomy may be bolstered through education on lactation management as a routine part of postpartum care (Britz and Henry).

Conversely, rather than seeking to immediately suppress lactation, some bereaved mothers may deliberately sustain their lactation to donate their breastmilk to a human milk bank over weeks or months. Like the donors of other tissues (Waldby), milk donation can have a profound impact on one's identity as a mother (Gernstein Pieneau), and through milk donation a bereaved mother's identity may also be meaningfully shaped by supplying life-giving tissues to preterm infants (Welborn, "The Experience of Expressing"). Although the majority of breastmilk donors are mothers with living infants, a recent study involving representatives from Australia's milk banks and neonatal intensive care units found four different potential categories of breastmilk that could be donated by bereaved mothers: (1) frozen stores of breastmilk expressed during the infant's life; (2) freshly expressed breastmilk obtained during lactation suppression; (3) freshly expressed breastmilk expressed for a surviving infant (e.g., twin); and (4) freshly expressed breastmilk obtained from maintaining lactation after infant death (Carroll et al.). Unfortunately, few milk banks offer specific programs for bereaved mothers, and research has found that there is a need to increase support to make the option of breastmilk donation after loss more accessible (Welborn, "The Experience of Expressing").

Regardless of the duration of lactation and the volume of milk expressed, bereaved mothers must decide what to do with their breastmilk. Our study draws on two qualitative studies of women's experiences of lactation and donation after neonatal loss: one focusing on women who experienced a neonatal death in Australia and the other on women's donation experiences in the U.S. Participants in both studies were diverse in terms of their lactation and donation decision

making and their access to milk banks. Building on these experiences, in this chapter, we position the proactive provision of the full spectrum of lactation support and donation options to bereaved mothers as key health services for these women. Moreover, we argue that these services are integral to bereaved mothers achieving reproductive autonomy over their lactation during the postpartum fourth trimester (defined as the first 12 weeks after the birth of a baby).

Data Construction

The research reported for this chapter was guided by a constructivist-feminist approach, in which data is conceived of as being co-produced by both the researchers and participants (Karnieli-Miller)—an approach we hope readers will find both descriptive and transformative (Cook and Fonow). Bereaved mothers have largely remained unrepresented in the literature, often due to concern that engaging bereaved parents in research is potentially harmful (Dyregrov; Hynson et al.). Yet there is also harm in suppressing people's lived experiences. Guided by the literature on researching with bereaved parents, we ensured research participants could maintain a distance from the research team until consent was provided for contact, choose their own interview times and locations, and select the mode of engagement.[3] Thus, to conduct research that could contribute toward inclusive health care practices we did not shy away from including bereaved mothers' first-hand experiences of lactation after loss.

The broader US-based study examined the motivations and experiences of milk donors affiliated with a milk bank in Colorado.[4] Participants were recruited through the assistance of milk bank staff and their database of current donors. Of the twenty-five American milk donors interviewed, two milk donors were bereaved mothers. The transcripts from these two interviews detail the unique experiences of bereaved mothers, and these were selected for closer analysis in conjunction with an Australian-based study.[5]

The Australian study deliberately sought the lactation and donation experiences of bereaved mothers who had experienced a neonatal death. Therefore we purposively recruited bereaved mothers with the assistance of the two participating Melbourne-based hospitals: a neonatal intensive care unit (NICU) and a department of newborn

intensive and special care (NISC). Table One provides details of the seven participants, including the pseudonyms used in the remainder of this chapter.

All semi-structured interviews were audio recorded, transcribed, and then read for accuracy and anonymized. The iterative process of data analysis involved the authors independently reading the transcripts and open-ended survey responses for familiarization and then marking them through a process of open coding. The authors met to discuss and compare initial codes before agreeing on a codebook and coding the data. For the purposes of this chapter, we focus on women's lactation and donation decisions as coded into two main groups: those who decidedly suppressed their milk production as quickly as possible and those who chose to continue to express milk for weeks or months after infant death. As Table One shows, not all participants had access to human milk banks to donate any fresh or frozen breastmilk.

Table One: Study Participants

Participant Pseudonym	Deceased Baby's Pseudonym	Nationality (Country of Residence)	Human Milk Bank Available	Method of Data Collection
Jessica	Bothania	Anglo-Australian (Australia)	Yes	Semi-structured interview (in-person)
Linda	Emilie	Dutch (Australia)	Yes	Open-ended survey
Sheela	Debra	Australian (Australia)	Yes	Open-ended survey
Betsy	Anita	South African (Australia)	No	Semi-structured interview (phone)
Georgia	Ayman	Australian (Australia)	No	Semi-structured interview (phone)
Melissa	Christopher	American (U.S.)	Yes	Semi-structured interview (in person)
Alison	Cole	American (U.S.)	Yes	Semi-structured interview (in person)

Lactation Suppression after Infant Death

Georgia, a mother who gave birth to twins, found the initial stages of lactation to be positive as well as something functional that she, a mother, could do during her twins' NICU admission: "It was incredibly healing for me, I guess ... it was the only thing I could really do for my babies at that point in time, so it was something that I had to focus on, which was good." However, after the death of one of her infant twins, Georgia's attention turned to providing milk for the surviving twin, which, Georgia explained, distanced her from her grief. Georgia would have been open to donating her excess milk had this option been available to her; however, she stressed that had she birthed only one child who had passed away, she would not have continued to express and donate milk:

> Had Ayman been a single child, and he'd passed away, I really feel that the best path forward for me would have been to move on as quickly as I could, so if I continued on expressing to donate for mothers, as altruistic as that sounds, I don't think, mentally, that would have been healthy for me. I would have needed to have closed the book and moved on as quickly as possible.

Georgia links lactation, expressing milk, and working through grief as processes that are intertwined. These associations were also shared by Betsy, who spoke about her time pumping for her infant as something proactive, functional, and positive during a time of uncertainty, anxiety, and perceived powerlessness:

> For me, it represented what I could do. There was a lot I couldn't do. There was a lot that was out of my hands. But giving her breastmilk, I could do that. So while the doctors were working out how to get her heart to close, or how to get her kidneys fixed ... this was the thing that for me, being able to give her milk was, as significant as them providing solutions to some of her problems ... I think as a mum, it gave me ... that, "OK, I can do this for you, darling." The milk was a gift for me, and my ability to give it to her was my gift to her.

Yet with the death of Betsy's infant, these motivating factors become irrelevant and lactation was perceived as a hindrance: "The day we decided we would stop the life support, the same day I took the [pill] to stop the milk. And fortunately for me, somehow it just ... it worked immediately."

Georgia also explained her feelings behind the importance of immediately suppressing her milk supply and directly linked milk production after the death of her infant with emotional pain: "I won't be dealing with breasts and milk three or four days or a week after, and all the things that will add worse [sic] to what I had to deal with. So I just took care of it immediately, and thank god, it was fine. It didn't stick around to cause me emotional pain."

A third participant, Linda, felt similarly that ceasing lactation was required in order to work with her grief: "After Emilie passed away, I really eased off expressing and had to stop within about three days after she had passed. It was important for me to stop expressing, as I wanted to focus on grieving for Emilie and not on expressing my milk." Sheela also actively sought to suppress her lactation by practicing minimal expression and seeking pharmaceutical means to stop her milk supply. It was not so much that lactation was a reminder of motherhood, as Sheela stated, "My body in general did that!" But it was that lactation was felt as "frustrating" for Sheela: "It made my nipples constantly cold and I felt self-conscious that people could see the wet / damp patches on my shirts".

For these bereaved mothers, milk production was intricately connected with the survival of a living infant. Infant death, therefore, rendered milk production nonfunctional, burdensome, and a factor preventing them from moving on. For these mothers, lactation was contingent, and suppression became an intentional embodied act as a result of their motherhood being transformed by neonatal death.

This timely control over lactation is supported by broader research on information provision to newly bereaved parents. It reveals that bereaved parents are empowered by having access to accurate and timely information, knowing what to expect, and being prepared and able to make choices (Branchett and Stretton). Despite this, there is a paucity of attention paid to lactation management after infant death, with many bereaved mothers—such as in the opening case study of Melissa—arriving home without consultation from health pro-

fessionals and without the necessary education to handle their lactation (Moore and Cailtlin; Cole; Britz and Henry; Seresthi et al.). These women's experiences highlight the importance of access to timely anticipatory guidance and lactation education by health professionals so that bereaved mothers can choose to suppress lactation as they face their grief without risking the unwarranted incidents of breast engorgement or infection.

Realizing Pride and Productivity through Lactation after Infant Death

As Georgia previously explained, lactation and the provision of breastmilk have been shown to enhance feelings of self-efficacy among NICU mothers and a sense of greater maternal control over the infant and her feeding when there is little else a mother can do for her care (Swanson; Carroll, 'The Milk of Human Kinship'). Similarly, for some women, lactation when no living infant is present can be transformative; lactation can be a source and a display of strength, generosity, and resourcefulness to oneself, one's family, and the wider community (Giles). Some bereaved mothers in our study chose to continue lactation after their infant passed away and described expressing milk as something they could turn to, focus on, and do at the time of significant loss:

> That was good because it's good to feel there's something you can do, even when there's nothing you can do, if you know what I mean. (Jessica)

> I think it just helped me to kind of bridge something, you know? Because it was like, here, I have just lost this child, and I'm at home, and it gave me something to do! [Laughs] It's like, I don't even know what to do right now, but I'm pumping and I know that this milk is going to help somebody. And so that was very helpful. (Melissa)

> It gave me something to do. It helped with my sanity. Not for the lack of sleep thing, because I was pumping every four hours, but it was definitely—it gave me a mission to focus on ... because you've got those long night sweats and all sorts of things as your

body gets back to normal. And having something you have to get up and do. It was good to get through those first couple of weeks, to have something to focus on like that. (Alison)

Mothers who continued to lactate and donate also pointed to their experience of positive affect as a side benefit of producing and donating breastmilk. Jessica, for instance stated, "It did give me a good feeling when there weren't always lots of those good feelings around! To be able to come and drop off [to the milk bank], you know, ten litres, that made me feel good!" Melissa further explained the positive feelings associated with being able to help other infants through milk donation: "I thought, 'Wow, this is fantastic!' That made me really happy because I saw all those little babies in the NICU when Christopher was born, and so just knowing who they were and that this milk would be able to help them ... to this day, I will cherish that."

These findings build upon research that suggests bereaved parents seek to make sense of infant death through altruistic acts (Uren and Wastell). Through milk donation, some bereaved mothers identify with motherhood and maintain a physical link with both the deceased baby and the feeling of loss which, in turn, assists with healing and acceptance.

Bereaved mothers in our study also reported feeling positive and proud to produce and donate breastmilk. Jessica stated, "I think it's a good legacy to have, and I feel really proud that I did it, even though at the time it was hard work, because I donated over seventy litres." Melissa proudly announced her milk donation to her parents:

Filling one of those little bags and just knowing that, like, this is life-giving milk that helps babies grow and heal, and every time I would fill that little bag—and my parents were here at the time, and I would give a little announcement [laughs] like, how many ounces, and every time—I don't know that just made me feel proud to be able to have that freezer full and to hand it off to the human milk bank.

The reported pride, sense of positivity, productivity, and purpose indicates that these bereaved mothers experienced their lactation as more than care for their own child. In fact, lactation in the absence of an infant is potentially transformative: it can reveal a mother's value to herself and to others (Giles), is something that mothers have control

over, and it can be a way of recovering agency and enhancing self-determination (Giles). Although the lactation and donation choices were different from the mothers who chose to immediately suppress their lactation, the bereaved mothers who continued their lactation and, subsequently, donated experienced a similar bolstering of agency.

In the accounts provided by both groups of bereaved mothers about their lactation, it is clear that lactogenesis is not only a product of the relational tie between a mother and her infant but a symbol and reminder of it. By drawing on the varied embodied lactation experiences of bereaved mothers, we highlight how different forms of lactation management intersect with, and are integrated into, a motherhood transformed by infant death. We use these experiences to highlight how timely attention to lactation management and donation options after infant death have real and significant impacts on women's postpartum lactation and bereavement experiences (Sereshti et al.). Therefore, we argue that lactation decisions and practices form a crucial part of women's reproductive autonomy in the postpartum fourth trimester (Grattan; Matambanadzo).

Discussion

Indicative of several layers of discomfort or even taboo surrounding lactation and milk donation after loss, bereaved mothers are often discharged home with insufficient or no lactation counselling, and some milk donation programs may fail to include bereaved mothers as potential milk donors, particularly those who may wish to prolong lactation as a way of working through grief (Carroll et al.). Not only are these practices symptomatic of discomfort regarding lactation after infant death, they also perpetuate the silence surrounding non-normative lactation practices. This, in turn, may prevent bereaved mothers benefiting from the full complement of lactation education and related health services, which, as our study shows, provide bereaved mothers with enhanced agency and control over their lactation, and a sense of pride, positivity, and productivity among those who choose to donate their milk.

Rosalyn Diprose's theoretical work on generosity and selective forgetting provides insight into the social norms and values that act on and through bereaved and lactating bodies and that contribute to

injustices associated with the lack of lactation-specific healthcare delivery for non-normative lactation practices (Gribble), such as after infant death. Diprose defines generosity as an openness to others. However, in practice, this openness to others is hampered by what Diprose describes as "selective forgetting." She explains that as a result of social norms acting on and through bodies, only some bodies are memorialized as generous and rendered as possessing property worthy of giving, while others are positioned as empty, devoid of property, and they, therefore can "only benefit from the generosity of others" (Diprose 9). Most milk donors are mothers with living infants, and these bodies are rightly recognized and celebrated for providing milk to human milk banks. Moreover, mothers with living infants have a growing abundance of lactation-specific guidance and education from health professionals in the "breast is best" era. Yet by applying the theoretical principal of selective forgetting to health service delivery specific to bereaved lactation, it reveals that bereaved mothers are selectively forgotten, which occurs in two main ways. First, bereaved mothers are often forgotten as bodies worthy of health professionals' time and attention regarding managing lactation after loss (Britz and Henry; Cole; Moore and Caitlin; Seresthi et al.). Second, bereaved mothers who have the desire to be milk donors may also be selectively forgotten when they are positioned solely as beneficiaries from care rather than, or in addition to, being seen as women who find strength, productivity, and agency through their lactation and donation. The application of Diprose's selective forgetting functions to reveal the mechanisms by which bereaved mothers are overlooked despite the transformative power that both milk suppression and expression have for women's grief experiences.

However, there are signs of change. In both Australia and the U.S., where our studies were conducted, there is growing support for the bereaved milk donor. In 2007, Australia's federal government produced a policy document that touches on the despair felt by mothers who have excess milk and are forced to dispose of it because they are unaware of donation options; it also discusses the need to create opportunities for mothers to donate this precious resource (Australia Parliament House of Representatives Standing Committee on Health and Ageing). Moreover, despite not having or promoting any specific bereavement program, all five of Australia's milk banks do accept milk from

bereaved donors (Carroll et al.). Of the twenty-two active milk banks affiliated with the Human Milk Bank Association of North American (HMBANA), nine have dedicated bereavement donation programs and the HMBANA has produced a "toolkit" for use by health professionals and human milk banks when working with bereaved mothers' lactation (Welborn, *Lactation Support*).

By framing lactation in the fourth trimester as an issue of reproductive rights and bodily autonomy (Grattan; Matambanadzo), it is clear that we need to overcome the selective forgetting that surrounds the sparse provision of lactation healthcare to bereaved mothers. The women in our study have shown that grief, control over their own lactation, and milk donation are powerful and transformative experiences. The transformative power of lactation for women, we must remember, does not stop with the death of the baby.

Endnotes

1 Funding for this research was received from a 2013 University of Technology, Sydney Early Career Researcher Grant and a 2011 Australian Research Council Discovery Grant.

2 To reflect the two nations in which we conducted research, in this chapter we use the terms "pumping" (American) and "expressing" (Australian) interchangeably.

3 In the Australian study, we provided options for study participation: (1) face-to-face interview, (2) telephone interview, or (3) written open-ended survey. All methods of participation covered five topics: (1) birth stories; (2) lactation during NICU admission; (3) lactation after infant death; (4) milk donation after infant death; and (5) discussions on the option of milk donation.

4 The particulars of this larger study are detailed elsewhere (see Carroll, "Body Dirt").

5 Ethics approval was granted by the Human Research Ethics Committees from two Australian Metropolitan Hospitals and the University of Technology, Sydney.

Works Cited

Australia Parliament House of Representatives Standing Committee on Health and Ageing. *The Best Start: Report on the Inquiry into the Health Benefits of Breastfeeding.* Commonwealth of Australia, 2007.

Australian Institute of Health and Welfare. *National Perinatal Mortality Dad Reporting Project,* 2014, Cat. No. PER 66, AIHW.

Benn, Cheryl, and Suzanne Phibbs. "'Milk for Africa' and 'The Neighbourhood' But Socially Isolated." *Exploring the Dirty Side of Women's Health,* edited by Mavis Kirkham, Routledge, 2007, pp. 90-101.

Boswell-Penc, Maia. *Tainted Milk: Breastmilk, Feminisms, and the Politics of Environmental Degradation.* State University of New York (SUNY) Press, 2012.

Bramwell, Ros. "Blood and Milk: Constructions of Female Bodily Fluids in Western Society." *Women and Health,* vol. 34, no. 4, 2001, pp. 89-101.

Branchett, Kate, and Jackie Stretton. "Neonatal Palliative and End of Life Care: What Parents Want From Professionals." *Journal of Neonatal Nursing,* vol. 18, no. 2, 2012, pp. 40-44.

Britz, Stephanie, and Lydia Henry. "Supporting the Lactation Needs of Mothers Facing Perinatal and Neonatal Loss." *Journal of Obstetric, Gynecologic, and Neonatal Nursing,* vol. 42, no. s1, 2013, pp. S105-S106.

Carroll, Katherine, et al. "Breast Milk Donation After Neonatal Death in Australia: A Report." *International Breastfeeding Journal,* vol. 9, no. 1, 2014, p. 23.

Carroll, Katherine. "The Milk of Human Kinship." *Critical Kinship Studies,* edited by Charlotte Krolokke, et al., Rowman and Littlefield, 2016, pp. 15-32.

Carroll, Katherine. "Body Dirt or Liquid Gold? How the 'Safety' of Donated Breastmilk Is Constructed for Use in Neonatal Intensive Care" *Social Studies of Science,* vol. 44, no. 3, 2014, pp. 466-485

Cole, Melissa. "Lactation After Perinatal, Neonatal, or Infant Loss." *Clinical Lactation,* vol. 3, no. 3, 2012, pp. 94-100.

Cook, Mary and Judith Fonow. *Beyond Methodology: Feminist Scholarship as Lived Research,* Indiana University Press. 1990 Print Diprose,

Rosalyn. *Corporeal Generosity: On Giving with Nietzsche, Merleau-Ponty, and Levinas*. State University of New York Press, 2012.

Dyregrov, Kari. "Bereaved Parents' Experience of Research Participation." *Social Science and Medicine*, vol. 58, no. 2, 2004, pp. 391-400.

Giles, F. "From 'Gift of Loss' to Self Care." *Giving Breastmilk: Body Ethics and Contemporary Breastfeeding Practices*, edited by Rhonda Shaw and Alison Bartlett, Demeter Press, 2010, pp. 236-249.

Gernstein Pieneau, Marisa. "Giving Milk, Buying Milk: The Influence of Mothering Ideologies and Social Class in Donor Milk Banking" *Breastfeeding: Global Practices, Challenges, Maternal and Infant Health Outcomes*, edited by Tanya M. Cassidy, Nova Publishers, 2013, pp. 61-76.

Grattan, Elizabeth. "The Reproductive Rights Discussion No One is Having." *Elizabeth Grattan: A Woman with a Voice. And Something to Say*, http://www.elizabethgrattan.com/. 24 Nov. 2014, Accessed 14 Dec. 2018.

Gribble, Kathleen. "Mother-to-Mother Support for Women Breastfeeding in Unusual Circumstances." *Breastfeeding Review*, vol. 9, no. 3, 2001, pp. 13-19.

Hausman, Bernice. *Viral Mothers: Breastfeeding in the Age of HIV/AIDS*. University of Michigan Press, 2011.

Hynson, Jenny, et al. "Research with Bereaved Parents: A Question of How Not Why." *Palliative Medicine*, vol. 20, no. 8, 2006, pp. 805-811.

Karnieli-Miller, Orit, et al. "Power Relations in Qualitative Research." *Qualitative Health Research*, vol. 19, no. 2, 2009, pp. 279-289

Matambanadzo, Sarudzayi. "The Fourth Trimester." *University of Michigan Journal of Law Reform*, vol. 48, no. 1, 2014, pp. 117-181.

McGuinness, Denise, et al. "An Exploration of the Experiences of Mothers as They Suppress Lactation Following Late Miscarriage, Stillbirth or Neonatal Death." *Evidence Based Midwifery*, vol. 12, no. 2, 2014, pp. 65-70.

Moore, Debra, and Anita Catlin. "Lactation Suppression: Forgotten Aspect of Care for the Mother of a Dying Child." *Pediatric Nursing*, vol. 29, no. 5, 2003, pp. 383-384.

Sereshti, M., et al. "An Exploration of the Maternal Experiences of Breast Engorgement and Milk Leakage after Perinatal Loss." *Global Journal of Health Sciences*, vol. 8, no. 9, 2016, pp. 234-244.

Swanson, Vivien, et al. "Developing Maternal Self-Efficacy for Feeding Preterm Babies in the Neonatal Unit." *Qualitative Health Research*, vol. 22, no. 10, 2012, pp. 1369-1382.

Shaw, Rhonda. "Perspectives on Ethics of Human Milk Banking." *Giving Breastmilk: Body Ethics and Contemporary Breastfeeding Practices*, edited by Rhonda Shaw and Alison Bartlett, Demeter Press, 2010, pp. 82-97.

Uren, Tanya, and Colin Wastell. "Attachment and Meaning-Making in Perinatal Bereavement". *Death Studies*, vol. 26, no. 4, 2002, pp. 279-308.

Ussher, Jane. *Managing the Monstrous Feminine: Regulating the Reproductive Body*. Routledge, 2006. Print.

Waldby, Catherine. "Biomedicine, Tissue Transfer and Intercorporeality." *Feminist Theory*, vol. 3, no. 3, 2002, pp. 239-254.

Welborn, Jessica. *Lactation Support for the Bereaved Mother: A Toolkit*. Human Milk Banking Association of North America, 2012.

Welborn, Jessica. "The Experience of Expressing and Donating Breast Milk Following a Perinatal Loss." *Journal of Human Lactation*, vol. 28, no. 4, 2012, pp. 506-510.

Part V

Navigating and Resisting Exile

Chapter 15

"You're Not Really There": Mothering on the Border of Identity

Marilyn Preston

Every time they leave, I feel a little part of me stomped out on the floor. I feel kicked in the stomach. I wonder if it is stress and grief of goodbye that causes the invariable virus/cold/relapse. Time goes on, and I calm down, get into rhythm and then find myself crying silently watching children on trains. My arms physically aching from needing to wrap them around my babes. Missing their jokes and banter, the slow paces in front of me that nearly always causes me to trip. Their hot, stinky, disgusting breath in the morning recounting their bizarro dreams of dragons and mascots and curly fries. Their evidence everywhere, sticky counters, sticky plates, sticky floors, sticky bathtubs. Underwear in a ball in the corner. Crayons upon crayons just laying out every which way. It is like life came through, stormed through, made a carnival of chaos, fun and love and joy and then was swept out, leaving only old wrappers, half their fortunes, crumbled unfinished poems and me crying at the emptiness of it all.

—Blog Entry, August 2013

My heart breaks once each week. I realized this a while ago, when a Skype session with my twelve-year-old daughter ended because she was too busy and distracted to stay on the line. Most of the year, my daughters live 1125 miles away from me. They live in a place that is so far and so foreign that when I visit I often feel like I am in an alien landscape—even the trees and grass and sky are different. I am a nonresidential, part-time custodial mother.

I live on the border of mothering. For eight short weeks a year, my children live with my wife and me. We have normal mother-child arguments, family dinners, and vacation time. Then they are gone. I work sixty hours a week. I socialize with friends; I live a life of a childfree woman, my children haunting my own experiences in large and small ways.

I hold a doctorate in family studies and human development. As a so-called expert in family, I know the trends and realities of blended families and shared custody, best practices for co-parenting, and the ways that stereotypes and cultural myths damage mothers by creating impossible standards. This knowledge matters little when my heart breaks each week and I think to myself, "What kind of mother are you to take up so little physical space in the lives of your daughters?"

In our culture, there is no place for childless mothers. Mothers are supposed to live with their daughters. We are supposed to guide them and hold them and make them clean their rooms. I am supposed to show them how to use razors and make up and where to find tampons and pads. I am supposed to nag them and chastise them when they pick on each other and refuse to do homework. Mostly, though, we are just supposed to be physically there. Mothers who are not physically there are accused of abandonment, abuse, and neglect. How could a mother not live with her children?

In this chapter, I will use autoethnography to explore my own experience as a mother without her children. An autoethnography is a form of research and storytelling wherein the researcher becomes the researched. I have combed through my own detritus of life, stories and journals—thoughts jotted down, memories unearthed—to examine reflexively how my lived experience ascribes and reascribes the social world. How do the studies and theories of mothering from afar relate to my own experiences? How do my stories shape those theories? This essay will use this form of narrative methodology to explore how my

own experiences framed by memories, journals, emails and blogs shape and are shaped by scholarship on noncustodial mothers. What does it mean to be me—a mother without her children?

Locating Childless Mothers in Research

Letter to V 1/3/11

I left the marriage feeling like a failure as a mother—and thinking I should just abandon it to him because I was clearly doing no favors and in fact fucking the kids up—it took therapy and all sorts of reflexivity to realize that that was not the case, but I still sometimes fall into that trap—thinking they are better off without me or that I am just harming and not adding to their experiences. It's awful! I feel like I have to be on top of it all the time—thinking is this real or is this a social construction of my abilities or my worth as a mother ... and where does it come from and how much effort do I put into correcting it to others versus just acknowledging the wrongness of the discourse and going about my business.

Every year or so, I reread a book by Mellissa Hart titled *Gringa*, which tells the story of Hart's adolescent search for her self after her mother lost custody of her sister, Hart, and her brother. The book comforts me because it tells the story I live but from a daughter's point of view. I feel relief in how Hart writes of missing her mother, of trying to soak up her presence during visitations, and of anxiously trying to find herself in her mother's everyday life. I am saddened by her growing distance from her mother and by the way that her movement towards adulthood involves moving away from her mother—that they are strangers at the end who have to reassemble their identities as mother and daughter.

There is so little information out there for mothers whose children live apart from them. As an academic, I am used to poring through thousands and thousands of pages of scholarship before I can begin to know the field that I am exploring. When I began to explore the research around noncustodial mothers, I found a woeful dearth of information—a few small studies in England, one small study in the

United States. The majority of the scholarship focused on women who had involuntarily lost custody of their children and how they worked to regain custody and develop a mothering identity (Bemiller; Kielty; Snowdon and Kotze).

Much of the research explores how noncustodial mothers come up against the stigma of being a so-called bad mother. They are faced with a culture that defines "good mothering" as catering to her children's needs, providing emotional and financial supports, and always placing her child's needs and desire before her own (Hays 79). This "intensive mothering" cannot be done from afar. One cannot be, in our cultural mythology, both a noncustodial mother and a good mom. In working against, or through, this mythology mothers without custody must rewrite or retell the story of their mothering in ways that both affirm their status as mother and work to challenge the hegemony of the "good mother." This takes a bit of mental and emotional aerobics.

Letter to V 1/3/11

> I have had to fight the urge to be the "fun parent" because of the restrictions on the amount of time I spend with them ... I want them to feel like being with mom is part of daily life, not some fun adventure because that is not respectful of the way our relationship should be, but I want to be able to entertain and do fun things with them ... but I also make sure that they have a bedtime, relaxation time, a pretty regular life at my house so that it isn't just a party in an attempt to show how "fun" mommy is.

As I scoured the scholarship on these mothers, I found myself performing these aerobics again, but this time I turned inwards. Am I still trying to compete with the mythological "good mother" even though I understand the trap that it is? Are my attempts to discuss mothering as a constant in my life, when it certainly doesn't always feel that way, evidence of my investment in that myth? As I read my own stories and letters, I notice my own commitment to the ambivalence—the desire to resist the narrative at the same time that I embrace it.

Letter to V 3/10/11

I know I am not the typical mom. I know I won't ever be, and most days, I actually like that. But today, I wanted to be able to be the mom who, when her kid was sick, was able to stay home all day, let her watch movies, give her some treats, whatever. My mom couldn't do that ... by the time I was my daughter's Rebecca's age, I mostly stayed home by myself if I was sick, but I wanted to be able to do that for Sailor [my younger daughter] and just couldn't—I just couldn't sacrifice all the time. And I feel really guilty for it. And this isn't the cultural shit either; it is the real. I want to be able to stay and cuddle my baby stuff because I won't be able to do that much longer. I find myself lingering over them ... also spoiling them a bit more ... one of the reasons I went to get the food stamps is because I know that I cannot afford the food that they will eat and love on my own (because my children have become high-end consumers of salmon and goat cheese— my children are odd) and that is a dumb reason to get food stamps, but I want to be able to do that, at least while I still can with them.

The research on noncustodial mothers tends to focus on the experience of women who lost custody of their children, either via court systems or child services, and how they come to view their role and their status as mothers. In the 1980s, the courts shifted to incorporate gender neutrality in their custody decisions, accepting the fact that men and women are both capable of parenting children and that women aren't inherently better at nurturing or caregiving. This shift, however, did not match the dynamic in society that continued to place the expectation of nurture and caregiving disproportionally onto women. This schism between the courts and the social fabric and norms had two affects. First, it privileged fathers' rights over mothers' rights because of the potential for economic security. In a heterosexual divorce, women lose a significant portion of their income compared to men (Zagorsky 421). This means that during custody cases, men are more likely to have a higher income than their former wives, and the higher income is interpreted by judges to mean that fathers they can provide a more stable home. Second, although the courts system rooted

the new paradigm of gender neutrality as a way of justice-based jurisprudence, society's grasp on individual judges, or individual stakeholders, was still rooted in essentialist notions that men who are invested in any time with their children are to be commended, whereas women who are not wholly invested are to be condemned (Chesler 83).

There is little research on women who voluntarily give up primary or physical custody. These women, women like me, remain hidden— making the struggle with a mothering identity even more difficult. Women who voluntarily give up their children are, in society's eyes, perhaps some of the most flawed mothers. This status as a shameful mother, which is even below a bad mother, comes from the idea that mothers should fight for their children no matter what. The fact that these women might choose this situation demonstrates, to our culture, how very little they invest in their mothering identity. Research demonstrates that noncustodial parents are perceived negatively, but noncustodial mothers are stigmatized even further than noncustodial fathers (Kielty, "Similarities" 85).

The months following the first time I moved more than one mile away from my children were some of the most difficult months of my life. I suffered from anxiety and depression, questioned myself and my decisions every day, and grieved the absence of my children in my daily life. I also struggled to articulate this to anyone, friend or stranger. I vividly recall visiting a park with a close friend and her colleague. When my friend mentioned my daughters, the colleague asked me where they were. I don't remember my answer. I do remember how shamed I was, how I struggled to hold back tears and left soon after so I could return home to cry alone. I had no way of articulating why my children were so far away or how it felt without engaging in the self-shame that being a mother without her children may bring.

How Did I Get Here?

Letter to V 12/22/10

I was a terrible mom at first because I tried, really hard, to be the perfect model of mom—whose whole fulfillment came from her children ... and I failed miserably at that. In fact, it wasn't till A and I separated, I moved into my own place, got through my

insane grieving and acting-out, that I felt like a good mom. Now, even though I am sure A would sometimes still disagree, I feel better at parenting than I ever have ... although now I face the very real possibility that in the next year A will move (He is a doctor now!) and I will too, and that the girls will go with him, because of the stability he has through his much more lucrative career and life, and I will be the vacation-mom ... and by the way, this is really hard for me to consider and to think about, even as I know it is probably the best way for my weird postmodern family to move forward.

I was married young and became a mother at age twenty-three. I truly wanted to have a child, and I had been informed that my body might not be capable of childbearing, so my response was to get pregnant as soon as I could. My daughter, Rebecca was born within a year of my decision to start trying. I had just finished my bachelor's degree and moved to the Midwest from California; I was jobless when I brought her home from the hospital. She was a tiny baby, a mirror image of her father. I was an anxious parent, and my husband was terrified of her.

My first memories of mothering were right after Rebecca was born, still in the hospital, and, as I recall them, they narrate the complexity I felt and still feel about mothering. I had an epidural during labour, and it lasted a long while. After Rebecca was born, she was moved to a corner of the room for her APGAR[1] observations. She screamed and screamed, her little body turning bright red and thrashing her limbs. I was still lying on the hospital bed, my birth team having left me alone to catch the sight of Rebecca's first few minutes of life. I remember wincing, suddenly feeling a huge void, and ambivalence—her screams hitting my ears like a terrible comedown. I felt alone, tired, and overwhelmed.

I also remember how, later that day, I sat up on my hospital bed, holding Rebecca and exploring her body in the way that new mothers often do—running my hands over her tiny legs, exploring each finger and toe, the tiny creases of her thighs and belly. I sang to her, a Joni Mitchell song, and played with her incredibly long toes, which she wrapped around my finger like a monkey. In that moment, I felt that kind of love that is the basis for books, movies, and poems. I fell deep

in love with her and felt an almost animal instinct to keep her near me.

Within two years, I had a second daughter, Sailor, and was moving two states away with my little family to begin graduate school. The time between Rebecca's and Sailor's birth was a difficult time for me as well as my husband. We struggled with money. I suffered from an undiagnosed, and totally foreign to me, neurodevelopmental disorder that plunged me into fatigue, pain, and depression after Rebecca's birth and did not lift until well after Sailor's.

After our move for graduate school, my husband and I worked opposite hours in order to avoid the cost of childcare. I worked weekdays, into the evenings, and he worked overnight weekends. We both struggled to single parent and began to resent the other person's time and supposed freedom. Within a few months, he also began school and working, and the girls were in daycare. By then, however, our relationship was already irretrievably broken.

My ex-husband was a solid father. He was lost initially, crying the first time I left Rebecca alone with him, but as I sank into pain and depression, he stepped up and became a model father—working and caring for our daughters, keeping a tight schedule, and doling out hugs and love when needed. I began to fade into myself. I felt lost in graduate school, disconnected at home, and increasingly doubted my success as a mother. My ex and I began fighting, spending every night yelling at each other, and unable to move beyond our own individual pain and disappointment. His frustration with me was articulated in the ways he remarked he did not trust me as a mother, and in my fear and confusion, I believed him.

When I asked him for a divorce two years after moving for graduate school, I was too afraid to bring the girls with me. I moved out to a tiny apartment two blocks from our house, now his and the girls. I was terrified and exhilarated. I had never lived on my own as an adult before. I did not know how to co-parent, and I did not trust my own mothering instincts, but I loved my daughters voraciously. I wanted for them to feel empowered and to lessen the blow of the divorce. I was positive that allowing them to decide whether or not to spend the overnight at my house each week would allow them to maintain consistency and feel like their choices matter.

In hindsight, I know it was one of my major mothering missteps, and one of the few regrets I carry with me. I missed the girls incredibly

at the same time that I was overwhelmed with the new freedom of part-time parenting. My world was shattering at the same time that it was filling with colour. I swung from grief to pure joy with no warning.

It was physically impossible, at first, to sit in the silence of my own home. I would call friends, go out, go to my office, and do just about anything to avoid the way that being alone began to feel like being erased. I remember the day I moved into my little apartment falling on the floor weeping. It felt too small, too empty, and to cavernous to be able to ever feel joy or a sense of home in that space. This transition to finding my own sense of self postmarriage was coupled with trying to find out who I was as a mother.

As the woman who left her family, the circulating myth about me worked its way around the social circle, I felt marked and obvious. I was scarred. I hated to see how others viewed me, and I had no idea how to view myself. My own mother asked me one day, "What kind of mother leaves her children?" Actually, I hadn't left them, but at the time, I was doing what I thought was right. It took me five years of therapy to figure out that I had been wrong, that I had been scared and insecure, that I was not a terrible mother, and that my daughters did need me. By then, decisions had been made that felt irreversible—their father, having been awarded primary custody, grew in his career, as I did in mine, moving from state to state until the distance between us grew from one block to a half a country.

Reflexive Journal 4.9.2009

So why do I continue to have crisis after crisis about my own caregiving? Why do I continue to let others dictate how I feel about my role as a parent? It is one thing to recognize the societal structures that shaped how one comes to conceptualize motherhood, another to do away with them without guilt. I have not yet done this, and because of this, I continue to feel terrible when I miss out on my children's lives. I continue to allow their father to dictate my space in their lives, and I am not sure why or how to go about breaking that habit. I am not even sure how to verbalize what is wrong and my own feelings about it. I feel terrible when I hurt anyone's feelings, and I notice that even when my mood is low and I need someone to give care to me, I easily shake that off to care for others. Will I get past this? Can I

shake off the stigma of bad mother? When their father had a Seder for the girls, despite not knowing anything about the holiday or the Jewish rituals that accompany it, he informed me that I was not invited because his friends wouldn't have come if I had been invited. Why did I recede? Why did I not fight to be included in this, my girls' cultural heritage that they get from me? Why didn't I say, "Forget it, I will host a Seder?"

Mothering from Afar/Transitional Objects

The data on noncustodial mothers suggest that mothers whose children do not live with them struggle to give credence to their mothering identities (Bemiller 133). They work to both resist and accommodate the myths of mothering that circulate our culture. Mothers, like me, whose daughters and sons are missing from their daily lives deal with daily stigma that can lead to internalized feelings of stress and guilt. I know what this feels like.

Letter to V 2/16/11

I am so scared that I won't see them or notice the small changes; everything will be so big because we will be so distant. I am so sad about this. What am I going to do when they are so far away? How can I be the mom I want to be for them, the one who protects them, when I cannot even protect them now ... four hours is so far after four blocks. I just want to soak them up, hold them forever. This isn't me feeling bad mom feelings; this is me having a deep and very real and realizable fear that I won't be there for the small things—the notes home, the small tears after a bad day, the small triumphs. How am I going to do this?

In Michelle Bemiller's (2010) study of noncustodial mothers, she finds that the women in her research work hard to maintain a mothering identity. They speak of ways in which they continue to practice intensive mothering despite the distance; how they cook healthy meals for their children when they are in their homes, how they buy the right clothes and say the right things. I see myself in their narratives (138). I, too, work to make my daughters feel comfortable

through an intense form of mothering when they are in my care. I work as little as I can when they are with me and maximize our time together. I cook their favourite healthy meals, spend time baking and crafting with them, and celebrate milestones we missed throughout the year. I work hard in those few weeks to normalize our time together— to make it special while not making it feel "special." It is a heart wrenching conflict for me.

When they are with me and we go out about town, I am proud to show them off. They are beautiful girls, gracious and loving. I have worked hard, both in their absence and their presence, to build a community they can feel at home with when they are with me, complete with chosen cousins and friends, aunts and uncles. While I work to create weeks of solid and consistent family time, I am also constantly aware of the countdown to the end of their visit. I ask them if they have any questions for me, about life or relationships or love, because they only have so much time face-to-face to ask their questions. I notice that the last twenty-four hours of their visits are tension filled, all of us anxious and grieving, all of us breaking into tears and anger flaring as we try to simultaneously cope with our ongoing loss and our last moments of time together.

Then they leave. I watch as their plane takes off and then walk silently back to my car, holding the remnants of their visits, coats and scarves, or books. I come home to a quiet house. I do not enter their rooms for weeks. I do not even go upstairs to where their rooms are. I do not want to be surrounded by physical reminders of their absence. I do not allow myself to feel the loss any more than I have to.

Then, I keep going. I go to work and come home. I cook with my wife. I go get coffee with friends, and I see movies on my own. My life resumes its rhythm punctuated only by phone calls and Skype dates, and lately, online messaging daily from my daughters. I teach.

Donald Winnicott, a developmental psychologist, coined the term "transitional object" to describe the importance and use of comfort objects for infants. He wrote of how items like a stuffed animal or security blanket allow infants to cope with the gradual separation and growing independence from their mothers (Winnicott 91). The item, then, comes to represent the mother and nurturing, and the infant's ability to self-nurture. It allows for the infant to learn to be separate from the mother; at the same time, it serves to comfort the infant

during that transition to independence.

I am a teacher. My work and my passion are pedagogy and social justice education. I love what I do with a vigor that surprises me regularly. In that way I often feel like the luckiest person I know. This means my life is a series of contradictions, pure joy and pure grief. I feel both. As I have come to consider myself and my teaching through reflection, I have begun to understand the ways in which my teachings and my students serve as transitional objects for me. I strive to build classrooms that contain community and build a sense of belonging. I work to embody a teaching identity that at its core involves nurturing intellectual and individual growth. Many teachers do this, and I do not see what I do in terms of pedagogy as particularly special or unique, but I have begun to see my relationship with teaching as different from my peers. When my classrooms serve as transitional objects, I work to fulfill my role as mother while at the same time facilitate my independence from my daughters.

Blog Entry Undated

But making that decision pulls me back to that myth—but overpowering the myth of motherhood is the mythology of superwoman—I feel as though I have to be everything, for everyone. And in making this decision, I am disappointing everyone. Last night, I taught a class—the topic was moral development. I love this class, these students. They are the only thing sometimes that gets me through the week. Last night, I asked them to define morality—to see how it is culturally constituted—to look for it. It may be, we decided collectively, that true morality is the ability to be connected, our interconnections with others, our relations and how they, like invisible strings, hold our hearts together.

Like the mothers in the literature on noncustodial mothers, I fight between trying to meet the cultural ideology of a good mother and to resist that dominant rhetoric. I struggle to define myself, both internally and to others, as a mother without her children. I find my instinctive need to mother and nurture transfers into my classrooms. Perhaps the most telling example that I have is that when my daughters are with me my focus on my students and the classroom activity lowers,

sometimes to the point of absence. My children need my mothering during those times, and I am there to give it.

Endnote

1 APGAR is a standardized assessment for newborns.

Works Cited

Bemiller, Michelle L. *Mothering on the Margins: the Experience of Noncustodial Mothers.* Dissertation. University of Akron, 2005.

Bemiller, Michelle. "Mothering from a distance." *Journal of Divorce & Remarriage* 51.3 (2010): 169-184. Web. 1 February 2016.

Chesler, Sandra. *Mothers on Trial: The Battle for Children and Custody.* Lawrence Hill Books, 2011.

Fischer, Judith L. "Mothers living apart from their children." *Family Relations*, vol. 32, no. 3, 1983, pp. 351-357.

Hart, Mellissa. *Gringa: A Contradictory Girlhood.* Seal Press. 2009.

Hays, Sharon. *The Cultural Contradictions of Motherhood.* Yale University Press, 1998.

Kielty, Sandra. "Non Resident Motherhood: Managing a Threatened Identity." *Child & Family Social Work*, vol. 13, no. 1, 2008, pp. 32-40.

Kielty, Sandra. "Similarities and Differences in the Experiences of Non-Resident Mothers and Non-Resident Fathers." *International Journal of Law, Policy and the Family*, vol. 20, no. 1, 2006, pp. 74-94.

Snowdon, Jenny, and Elmarie Kotzé. "I'm Not a Bad Mother–Stories of Mothering-on-the-Edge." *Australian and New Zealand Journal of Family Therapy*, vol. 33, no. 2, 2012, pp. 142-156.

Winnicott, Donald Woods. "Transitional Objects and Transitional Phenomena." *The International Journal of Psycho-Analysis*, vol. 34, 1953, pp. 89-97.

Zagorsky, Jay L. "Marriage and Divorce's Impact on Wealth. *Journal of Sociology*, vol. 41, 2005, pp. 406-424.

Chapter 16

Newborn Custodial Loss from the Perspective of a Midwife

Andrea Lea Robertson

(I thank both Dr. Charlotte Beyer and Dr. Amy McGee
for valuable feedback on this chapter.)

As a midwife, I have been the primary care provider for a number of clients who knew while they were pregnant that their babies would be apprehended from their care within the first hours after birth. There are always reasons: mental health instability, substance dependency, abusive partners, attachment difficulties, and conditions of neglect. But reasons do not make it any less terrible, and, in fact, reasons raise questions rather than provide answers. Although I understand the legal duty to protect children from harm, I am troubled by the inherent violence in forcibly separating mothers/birthing parents from their newborns. Others are troubled too, and some care providers intentionally avoid this kind of work because it is too heartrending. The trauma, however, belongs first and foremost to the people who give birth and would like to parent and are told they cannot. In addition to their trauma and related grief, which remains largely under-recognized, they must also continuously navigate stigma for failing motherhood (Clumpus; McKegney; Novac et al., *A Visceral Grief*; C. Reid et al.).

Through this chapter, I hope to encourage readers to consider newborn custodial loss as something that most often occurs within

trajectories of disparity and trauma. As someone with the privilege of parenting my own children, I acknowledge there is an unbridgeable gap between my experiences and those of the mothers and parents who lose custody of their newborns at birth, no matter how caring, respectful, and attentive I endeavour to be in my work. I have also come to understand that my parenting privilege is not something simply earned through merit, but it is conditioned and sustained by a constellation of other privileges—including but not limited to white settler status in Canada, housing and food security, access to postsecondary education, a supportive long-term partnership, and multiple generations of family continuity without state-sanctioned interference.

I feel a great debt of gratitude to many people, including midwifery colleagues, many health and social change advocates of various sorts, and most significantly, the people who have accepted my midwifery services in the context of pregnancy and custodial interventions. For the purposes of this chapter, I have decided against retelling, as much as possible, fragments of the individual experiences of those who have suffered custodial loss. Like other feminist researchers and practition-ers, I am committed to supporting people in creating opportunities to do their own telling, and I hope in the future that we will hear directly and more often from people with first-hand experience with newborn custodial loss. At the same time, as a midwife who has worked with clients contending with custodial losses, I feel accountable to help bring greater awareness and, thereby, challenge the existence of incredible disparities in life opportunity and control over one's body, reproduction, and parenting, which many people face. In this chapter, I offer some reflection on my own acquisition of ideas about pregnancy and mothering. I draw on some literature findings to situate newborn custodial loss as a phenomenon inseparable from sociocultural contexts, to describe some challenges encountered by people attempting to improve care for people at risk for and/or experiencing newborn custodial losses, and to encourage continued consciousness raising and systemic change. In a novice and modest way, I hope to bring together autoethnographic, reflexive, and critical and queer theory components to focus attention on harmful situations and to call for opportunities for first-hand telling, purposeful listening, and tangible changes (Adams and Jones 111).

Thinking about how to prevent custodial loss in the first place, and how to care better for someone when a custodial loss happens, requires thinking critically about what happens before, during, and after custodial loss. Institutionalized classism, racism, sexism, hetero-normativity, cis-genderism, sanism, and colonialism are all constituent in opportunities for, and barriers to, good enough mothering. For example, Sylvia Novac et al. note that rather than young maternal age being directly associated with harm to children, it is low maternal education, poverty, and lack of supports, or conditions associated with impoverishment (*A Visceral Grief* 5). Julia Krane and Linda Davies also contend that risk assessment tools conceal gender, race, and class assumptions, wherein maternal efforts to care for their children can be misperceived as risk behaviours, such as frequent moving (42). It is not surprising, then, that when women experience screening based on negative stereotypes that increase their vulnerability to intervention, they are more likely to actively avoid screening (Zadunayski et al. 119).

Mothers and birthing parents who are deemed by the state as unfit to have their children in their care and custody, experience, tremendous loss, but this loss is largely underacknowledged and poorly serviced. Existing grief services generally do not take custodial loss into account, which can add to trauma rather than facilitate recovery (Novac et al, *A Visceral Grief*: Wiley and Baden). Compared with other losses, such as stillbirth, parents tend to be held blameworthy for their loss, both by themselves and others, and blameworthiness obstructs entitlement to express grief and receive care for grief (Barrow and Laborde; Clumpus; McKegney).

Like everyone, I maintain ideals about pregnancy and mothering in general and in particular about the relationships and outcomes I hope to have with my children. Good enough mothering can reflect personal standards and goals, but it is also something that shifts over time and place, and is subject to community and legal surveillance. Although I continue to embrace some ideals, I also hold some in suspicion, and I worry about ones I cannot bring into consciousness on command. It is important to attempt this tracing, however, as I share a sociocultural milieu with others—a milieu in which many people get to parent their offspring right from the moment of birth, and some do not. How does this happen? And how does it happen that in the same conditions in which some people lose custody of their newborns, they also tend to be

treated without the respect and compassion that would normally be afforded to other kinds of mothers and parents, with other kinds of loss? Custodial losses are justified at political and legal levels and require formal systemic and structural supports for implementation. Unconscious beliefs can support compliance with oppressive practices, and oppressive practices can include practices with good intentions, such as protecting newborns from harm.

As my friends and I approached puberty in Southwestern Ontario in the 1980s, we were alerted to both the possibility of and the threat of pregnancy. This awareness was more tethered to female embodiment than to motherhood. At the same time, there was an understanding that young pregnancy led to young motherhood, and both were somehow undesirable, and girls were more at fault than boys. Such ideas emerged through a noisy and confusing barrage of contradictory expectations related to femaleness, sexuality, pregnancy, and, ultimately, mothering.

Below is a partial list of cumulative and overlapping background noise in my life, with samples from preadolescence through young adulthood, as well as some reiterations and variations in my working life. Of course, there are things I will not have noticed or cannot remember. Important influences present in other people's lives and memories from the same times and places inevitably will be missing. There will also be omissions related to race privilege and my hetero and gender normative family of origin. Still, I am hopeful this list helps to illustrate how tricky it can be, even before motherhood, for any person to navigate femaleness, sexuality, and pregnancy in a particular body and in a particular place and point in time.

Background Noise

She says she's on birth control for medical reasons. We know that's not true.

Boys know that if a girl doesn't put out on a first date, they can just move on to one who will.

Girls should be experienced, but virginal at the same time. Otherwise they are slutty.

There were never any pregnant girls at x school, at least not that I know of.

Fully a third of the girls at y high school dropped out and had babies. That's just the reality.

Can you believe she walked to the hospital from school, gave birth, left the baby, and went back to class? What was wrong with her?

There are too many abortions. Girls are careless.

I don't know what's wrong with these girls today. They almost never put their babies up for adoption. It's too acceptable to be a young, single, and living off the system.

She should adopt if she can't have children. There are so many kids who need homes.

I wouldn't adopt a baby from the children's aid; you don't know what you're getting into.

She really wants to have children; it is too bad that she can't.

She's so selfish, not having babies.

Having two moms isn't the same as having a mom and dad, but I guess it is better than just one mom.

She's ruining her career by having babies.

Women are waiting too long to have babies, and that's why there's so much infertility.

It's so unfair that she is such a good person and can't have a baby when all those drug addicts don't have any trouble getting pregnant.

You need to know, she lost her pregnancy. She'll be out of the hospital soon. I wanted you to understand so that you don't ask her about it.

A woman can ruin a man's career by accusing him of sexual abuse.

I can't believe she doesn't love her baby enough to leave him.

Why does she keep having babies when she knows she can't keep them?

When I consider where my ideas of good enough mothering come from, I also think of my mother, who a generation before me, was subjected to pressures familiar to me and pressures unknown to me. For example, she experienced divorce at a time when you had to live separately from your partner for three years before divorce could be finalized, and during that time interval, women were subjected to high levels of moral and social scrutiny. During this time interval for my mother, she endured stigma for getting divorced and becoming a single parent, and then for becoming pregnant (with me) outside of marriage and for moving further away from her faith-based upbringing.

Of course, there is a great distance between my mother's story and the stories of the women who lose custody of their newborns. I reflect on it here because this part of my mother's story was perhaps my first tangible opportunity to consider and appreciate the ways in which time, place, and context matter, and how even if one does not agree with cultural norms, one is still inescapably subjected to them and must contend with them. I got to ask questions like how could there be a right or wrong way to marry someone and who makes up the rules about marriage and divorce and having sex and babies. And precious to me, I inherited a sense that difficult things can be possible—such as separating from someone when you are not a good fit, deciding to do things without the full approval of your loved ones, and building a family by choice.

There are always external factors that come into play. My mother made the best decisions she could, within her own context, whether or not this was well understood by other people or supported by dominant structures. I believe, that in large part, she could do so because of multiple prior opportunities to exercise discernment between meaningful choices and, thereby, to develop trust in herself and her decision-making skills (McLeod and Sherwin). I also note that even though she transgressed conventions to some degree, she did not transgress so much that parenting was disallowed. I now continue to hold in tandem two beliefs that like my mother, most people make the best decisions they can for themselves at any given point; however, opportunities to choose between meaningful choices, and to have one's autonomy affirmed and supported are unevenly distributed. This unevenness is most pronounced in cases of newborn custodial loss.

It is possible to miss something else very important: my mother was

raised by her mother, and I by mine, and I am now raising my own children. We have flaws to be sure, but we are not disenfranchised from motherhood, and some portion of this can be attributed to luck and happenstance and good people—but not only. A whole constellation of factors, which are too often experienced as natural or invisible, must come together for family and cultural integrity to flourish without serious challenge. Ignoring this can foster feelings of deservedness and distinctiveness from those mothers who are told they are not good enough, which does not account for the profound obstacles to parenting and family integrity.

In Canada, factors associated with newborn custodial loss include acute poverty, unstable housing, a maternal history of being abused as a child, intimate partner violence, addictions, mental illness, and minority group membership (Novac et al., *A Visceral Grief*; Novac et al., "Supporting Young Homeless"; S. Reid et al.). Racism is also a significant factor. Both Black and Indigenous children are over-represented in the Ontario child welfare system. Although Indigenous people make up about 2 percent of the population in Ontario, the number of Indigenous families with Children's Aid involvement and the number of Indigenous children removed from the custody of their parents is highly disproportional compared with the broader population. This reality is inseparable from projects of colonialism, including multiple generations of children forced to attend residential schools (where they were often subjected to genocidal abuses), the Sixties Scoop (mass adoption placement of Indigenous children with non-Indigenous families), and contemporary conditions of isolation and poverty in many settings (Commission to Promote 11). I point readers towards the extensive work of Dr. Cindy Blackstock who focuses on child welfare and Indigenous resiliency, knowledge keeping, and healing. There is a growing perception that Indigenous insights in healing intergenerational trauma and Indigenous-led revisions to child protective services are likely to benefit Indigenous and non-Indigenous families.

My mother has said as a person in the world she could never commit murder, except that she could and would if she had to to protect her children from imminent and life-threatening danger. And that she would even accept her own death. This is a common sentiment, and it may not even be accurate, but I contend it is not a dismissible cliché.

When I first heard this, I understood that my mother's love for me and my siblings was intense, could even be fierce, and I internalized that strong attachment and protectiveness can be part of the love for one's children. This sensibility inevitably informs my outrage over the level of inattention given to the corporeality of birth, and both the anticipated and actualized feelings of bondedness, when mothers/birthing parents are forcibly separated from their newborns. Whether the cleavage is temporary or long term, how can it be predominantly conceptualized as something other than violent? And if there are times when there seems to be no alternatives (although I would like to challenge this thinking), how could it be that anyone would be treated with less than the utmost care and compassion?

I cannot imagine giving birth and then having my baby wrought from my arms, yet this happens, and most labour and birth settings are touched by such events. Most care providers I know are kind, and they are distressed by the incongruity of forced separation, their own participation, and their angst over not knowing how to better attend to the needs of birthing and grieving persons. Although I know it is important not to project my feelings onto others, and not to generalize, at the same time, I do not apologize for an emotive plea that there needs to be an acknowledgement of the size and scope of hurt and despair that I have observed. No one sets out in life to be the person who will lack the resources, skills, or opportunity to care for their own baby. We need to ask difficult questions about how people arrive at such situations or about how these types of situations become inevitable in the constellations of some people's lives. We need to ask about how custodial loss reveals deficits in opportunities and resources rather than lack of will and about how current conventions may perpetuate the limitations on possibilities for prevention and meaningful support in the face of loss.

Do I mean to suggest that care providers are not paying attention to inequalities or that there is a near total lack of caring? I do not. I know of many providers, in diverse disciplines, working hard to reduce the incidence of newborn custodial loss and to reduce trauma to people when they experience newborn custodial loss by keeping them informed and by acknowledging their loss and grief. Despite people trying to do this work well, independently, or in teams, there remains an overarching cultural context in which some mothers are labelled

better or worse than other mothers, and individuals who fail accepted motherhood standards experience harsh recriminations (C. Reid et al.). In this context, it is difficult to secure interest in and sustain long term funding and resources for projects that investigate contributing factors to newborn custodial loss; the same is true regarding investments into interventions and infrastructure to protect and extend mother/parent-child connections, such as child friendly, affordable, and accessible addictions recovery programs, as well as grief and loss resources tailored to trauma connected to previous or current custodial losses.

The need for birthing person-centred and family-centred policies and practices is also urgent. Currently, in Ontario, there is no require-ment for a pregnant person to always be told in advance if a child protection agency worker intends to take custody of their newborn immediately after birth. Discretion can be exercised based on perceptions of risk of hiding or flight by the mother. There needs to be an inquiry into the ethics of this practice. How is it possible for a person to be pregnant, give birth, and not know about a preplanned and imminent apprehension of their child by authorities? There does not seem to be evidentiary support for the fear that telling pregnant people about custodial interventions in advance will decrease cooperation or increase risk. Fortunately, in many settings, people are working together to make sure women and birthing parents not only have an opportunity to be informed about custodial concerns but also have opportunities to modify and ameliorate factors associated with custodial loss. It is not uncommon for some midwives and physicians to encourage self-referral to child protection services and in their roles as midwives and physicians to communicate with child protection services (with consent) about attendance at clinical appointments and engagement in such activities as counselling, harm reduction or cessation programs, and parenting courses. Such collaboration requires effective working relationships between service providers and trust building with prospective parents, who may have strong reasons to distrust child protection services, especially if they have themselves been wards of the state and experienced abuse while in care. Parental participation in intervention planning can be complicated by many factors, including lack of trust by parents in workers who ultimately have decision-making authority (Healy et al.; Darlington et al.). It is

also sometimes the situation that a maternity care provider is unaware of child protection planning or they only become aware when intervention is imminent. This may be more likely to occur when someone does not present for maternity care until late in pregnancy or when they are actually in labour.

For children older than newborns, conditions of abuse and/or neglect need to be established before children can be removed from the home. In contrast, newborns are generally apprehended prior to risk being confirmed. A typical stay in the hospital, following an uncomplicated birth, is now less than forty-eight hours. It is not possible for an intake of the newborn to occur and an investigation to be completed during this period. At the same time, it can be deeply traumatizing to the person who has just given birth to be separated from their newborn, and depending on their previous experiences, this may be coupled with fear and doubt, which can in turn compromise their ability to sustain the changes they have made towards maintaining custody of their newborn, such as abstinence from substance use. Systemic expectations and inattention to personal and structural obstacles can further compromise the likelihood of reunification. For example, whereas other new mothers are encouraged to rest and recover during the first week postpartum, mothers with custodial issues are expected to be mobile; they often have to attend multiple appointments, including an initial court date. It is possible that someone may not show up to court due to the burden of logistics of getting there, feelings of fear over further loss, or internalized feelings of inability or undeservedness perpetuated by social and personal context (Novac et al., *A Visceral Grief*).

Rather than perceiving not showing up to court as proof of disinterest or parenting inability, it may be better understood as a possible expression of trauma, of love, loss, grief and fear— unimaginable to people who have not had a similar experience. Similarly, before birth and at the time of birth, avoiding prenatal care, declining coordination of services, nondisclosure of risks, and flight-based attempts to keep a newborn may be better understood in some situations as expressions of a strong desire to parent, regardless of resources and the capacity to do so. Anger and retaliation, as well as detachment and disinterest, may also be better understood as expressions of deep despair and being overwhelmed.

Of note, some social workers and other primary care providers work in collaboration with child protection service workers to make resources, which are typically available to mothers with other kinds of loss experience (such as stillbirth), available to persons experiencing newborn custodial loss (Robertson and Kinsella). These things can be simple, such as mementos from the birth, hand or foot prints, and digital or printed photographs. Not all birthing units provide such resources in cases of newborn custodial loss, and I have even heard it said that women who lose custody of their children could have prevented their losses, and, therefore, they do not warrant the same care and attention as women who experience pregnancy loss and stillbirth.

When a custodial loss occurs, it is not unusual for the baby to be discharged into foster care or kinship care prior to the mother's discharge, and when apprehended babies require an extended stay in the hospital for any reason, mothers are not usually permitted to use the resources available to other mothers, such as boarding rooms for families with babies in the special care nursery. Infant feeding can also be a challenge. Some noncustodial mothers would like to able to breastfeed their infants during scheduled visits and for breastmilk to be collected and delivered to the custodial home of newborns, but, again, people in positions of power relative to the birth mother/parent often make decisions against the intentions of the birth mother/parent.

For the people experiencing newborn custodial loss, custodial loss tends to exacerbate pre-existing marginalization, stigma, and isolation. For example, even though substance-using women may have substance-using peers, they may lose their community connections when they become pregnant. Also, as noted earlier, although grief counselling resources exist, there are currently no programs specifically tailored to birth parents who have experienced previous and current newborn custodial loss. Many people do not have access to well-coordinated care when there are multiple service providers involved in their care, and sometimes providers are not appropriately trained for the challenges being faced by their clients, or they lack the resources they need to do the job well (Darlington et al.).

A 2010 Canadian study found that when newborns of opioid-using mothers were roomed-in with their mothers instead of being cared for separately in an intensive care nursery, they displayed fewer symptoms

of neonatal abstinence, with statistical significance (Abraham et al. 1727). An incidental finding was that more babies also were discharged in the care of their mothers (1728). In 2015, Adam Newman et al. at Kingston General Hospital in Ontario reported similar findings of reduced neonatal abstinence syndrome when babies roomed-in with their mothers (e560). For the Kingston group, rooming-in care is now the standard of care for opioid-using mothers without other complicating factors. Unfortunately, when mothers are flagged for newborn custodial loss, they are excluded from the rooming-in program and, thereby, excluded from any potential benefits to both the mother and newborn. The Kingston group is hopeful that other Canadian hospitals will follow suit in providing rooming-in care to opioid-dependent women and newborns and that further research will explore the quality of mother-infant bonding when there is involvement of child protection services.

If rooming-in can make such an important difference, what other changes can be equally significant? I would like to challenge myself and others to work collaboratively with people affected by newborn custodial loss to improve custodial loss prevention and quality of care if custodial loss still occurs. A widespread general principle in midwifery care is that caring for the pregnant client is a way of improving outcomes for both the pregnant client and the newborn. In other words, a high regard for the safety and wellbeing of babies should not override an equally high regard for the safety and wellbeing of the mothers/birth parents. However, new resources may be required. We need to hear directly from parents about their needs and then develop resources responsive to their needs. For example, it could be useful to consider whether care by a dedicated support person in labour and in the postpartum period—someone trained in trauma and grief and someone not implicated in the custodial loss process—would be meaningful to people experiencing losses.

Intentionally (and unintentionally) working with people experiencing newborn custodial loss is often described as hard work. In general, care providers are encouraged to be self-aware and to engage in self-care to prevent burnout and to maintain a high quality of care for their clients. Ideally, care providers should attempt not to carry forward, on personal levels, the burdens of all people they are in caring relationships with, and resources should be available for debriefing and

recovery when necessary. I have no dispute that mindfulness and boundaries are important components of self-care; however, I want to suggest that isolation and systemic stasis are under-recognized as significant contributors to work-related frustration and fatigue.

Most of the midwives, social workers, physicians, nurse practitioners, nurses, and allied health workers and activists I have had contact with around Ontario, who are prioritizing the needs of persons at risk for and experiencing newborn custodial loss, are improvising care to some degree due to a lack of province wide policies and local resource deficits. Despite meaningful successes, there are frequent and persistent challenges and stressors. For example, it is difficult to go off call for births if you do not have colleagues who similarly advocate respectful and dignity-based care to all persons and actively incorporate harm reduction and strengths-based practices into their care. Some colleagues may not be as well versed in the navigation of local and distance resources needed to support people in socially complex situations. In worst-case scenarios, hand-over options may be limited to people who will provide diminishing and discriminatory care. In this way, the work becomes unnecessarily burdensome and reflects a systems failure.

People doing outreach pregnancy work can also feel isolated and lonely when they are not part of a well-integrated network of people doing similar work and providing support and relief to each other. Although working towards goals for improved care can be gratifying, problem solving and debriefing opportunities are diminished without the opportunity to share challenges with colleagues who hold similar commitments and do similar work. In these situations, conversations that may otherwise be healing become exhausting when the person wanting to share has to turn their energy towards education, destigmatization, justification, and advocacy.

Another challenge is the fragility of the continuity of new care initiatives without long-term base funding, widespread professional development opportunities, and collaborative and infrastructural support. For example, when the commitment to a marginalized population is held by an individual practitioner or by a small team but does not reflect an institution-wide commitment, let alone broader community commitment, initiatives to improve care remain vulnerable to changes in management and turnover in staff. If someone serves as

a linchpin for coordinated care, sustained awareness, and renewal, and then leaves their role, care too often reverts to pre-existing care norms.

It is also important to acknowledge there is a heaviness to the work at times, and exhaustion may stem not so much from working with people under various duress but from the oppressive cultural and systemic factors that contribute to people experiencing duress in the first place and that continue to obstruct possibilities for interrupting and mending cycles of duress. In this way, it is not the despair associated with singular stories, although these can be quite devastating; it is the despair that comes from there being so many devastating stories. Patterns of oppression and disenfranchisement will continue without responsive cultural and institutional accountability.

I have two other major concerns. My first is the harm potentially done when people without a particular experience imagine for others who do have it the how, what, and why of the experience. For example, I have heard lay and professional people, more than once, say that perhaps people who experience newborn custodial loss keep having babies "because they are trying to replace the babies they have lost" and because they are "hoping to finally keep one." I have yet to find any such accounting by people who have experienced custodial loss. Furthermore, people with the privilege of parenting their own children are rarely put in the position of having to defend decisions to have more than one baby or to defend their hopefulness to parent. At the same time, changes in opportunity to parent between one birth and another birth do occur for people in diverse situations, including people with and without prior experiences of custodial loss. Also, for people with custodial losses, their babies are still out there, so any new pregnancy and parenting of a new child, or loss of parenting, are always in the context of what is happening with existing children. It is my hope that care providers and others will critique speculations and assumptions for embedded and discriminatory norms, and instead invest in creating opportunities for people to share other experiential possibilities. When people are perceived in stereotypical and objectified ways, they are denied their full complexity and robust humanity, as well as the richness of their daily lives and aptitudes. Intervention strategies, then, are often untrustworthy and ineffectual; they possibly do harm and can discourage future community participation and engagement. People are less likely to seek care or to make disclosures about their

needs when they anticipate being stereotyped by their care provider or when they anticipate receiving check-box list care or discriminatory care (Zadunayski et al.; Novac et al.; Darlington et al.). Most importantly, there are lost opportunities to better understand ways in which people are already managing their lives with resilience, resourcefulness, and meaningfulness within their current contexts.

Women and persons experiencing newborn custodial loss may be challenging to locate and engage in steering research to meet their needs, due to challenges of many issues associated with newborn custodial loss—including unstable housing, homelessness or trading sex for housing, intimate partner violence, substance use, mental health illnesses, and their own childhood histories of trauma, which may be associated with lower rates of completing high school and, thus, lower income and poverty. The difficulty of designing inclusive, community-based research should not be considered an adequate deterrent to doing the work.

My second concern is that there remains so much unspoken background trauma. I am thinking especially of people I encountered prior to my work as a midwife, particularly ones facing challenges coping with memories and feelings related to previous pregnancy experiences, which are inextricable from childhood, adolescent, and adult physical, psychological, and sexual abuse, including incest. Some of these encounters were as long ago as twenty years, and I feel that I am still waiting for many of the realities of their lives to surface in the literature on pregnancy broadly and specifically related to substance use and other challenges, as well as voluntary and involuntary abortion, adoptions, and custodial losses. Although it is important to develop resources responding to current needs of pregnant people and new parents, such as housing and food security, it is also important to invest in childhood trauma prevention, detection, and treatment in ways that equalize opportunities for the whole person, reproductive autonomy, and wellness.

I often find myself wondering about my daily responsibilities in practice and in the teaching and mentoring of student midwives. I wonder about the impact of routinized intake questions—such as how many times have you been pregnant before, have you ever had a miscarriage or a termination, and is this current pregnancy a planned pregnancy. I wonder how many times people have withheld information about important experiences in their lives and how many times people

have not come to midwifery care or other prenatal care at all because of the pain of concealing or retelling or the feeling that they will not be adequately listened to and supported. I also wonder about what has worked well, what role midwives and others can play in changing social conditions so that fewer people experience newborn custodial loss and so that when losses do occur, immediate and longer-term trauma can be better attended to and mitigated.

Despite being daunted by the scale of work to be done, I feel some optimism. Colleen Reid et al. contend that for meaningful change to occur, attention needs to shift away from individual parenting deficiencies to contributing factors and conditions (231). This shifts accountability in significant ways. Midwives have a role to play, and examples of midwives doing outreach with people at risk of newborn custodial loss include the following: provision of culturally informed and appropriate care; coordination of meetings between multiple care providers to address issues related to pregnancy; provision of clinical visits off-site, including homes, shelters, mobile health clinics, community organizations, and coffee shops; and accompanying clients to other appointments, such as social work appointments related to housing and parenting, counselling appointments, ultrasounds, and physician appointments for substance use management or medical treatment of co-morbid conditions, such as diabetes or mental health. For midwives, and others, there needs to be adequate recognition that prenatal, intrapartum, and postnatal care requires resource development in consultation with people who are vulnerable to newborn custodial losses, and funding must account for the distinctiveness of care compared with routine care.

I believe we are often asking too much of people when their babies are taken from them at birth. How does one survive this? And why is there such a strong persistence of a context in which the depth of loss and suffering cannot be acknowledged? The need for newborn and child safety is real. At the same time, how we perceive problems and solutions can be revised. There is more than pain and suffering that we do not understand well enough; there is also survival, endurance, resourcefulness, and, sometimes, successful reunification, despite conditions of adversity, legacies of trauma, and the lack of adequate infrastructural supports. There is so much to learn, starting from listening.

Works Cited

Abrahams, Ronald, et al. "Rooming-in Compared with Standard Care for Newborns of Mothers Using Methadone or Heroin." *Canadian Family Physician*, vol. 53, no. 10, 2007, pp. 1723-1730.

Adam, Tony, and Stacy Holman Jones. Telling Stories: "Autoethnography, Reflexivity and Queer Theory." *Cultural Studies–Critical Methodologies*, vol. 11, no. 2, 2011, pp.108-116.

Barrow, Susan, and Nicole Laborde. "Invisible Mother: Parenting by Homeless Women Separated from Their Children." *Gender Issues*, vol. 25, no. 3, 2008, vol. 25, pp. 157-172.

Clumpus, Lynne. "The Feminism & Psychology Undergraduate Prize 1995: Prizewinning Entry No-Woman's Land: the Story of Non-Custodial Mothers." *Feminism & Psychology*, vol. 6, no. 2, 1996, pp. 237-244.

Commission to Promote Sustainable Child Welfare. *Aboriginal Child Welfare in Ontario: A Discussion Paper.* Minister of Children and Youth Services, 2011. Web. Accessed 20 Nov 2017.

Darlington, Yvonne, et al. "Challenges in Implementing Participatory Practice in Child Protection." *Children and Youth Services Review*, vol. 32, no. 7, 2010, pp. 1020-1027.

Healy, Karen, et al. "Parents Participation in Child Protection Practice: Toward Respect and Inclusion". *Families in Society: The Journal of Contemporary Social Services*, vol. 92, no. 3, 2011, pp. 282-288.

Krane , Julia, and Linda Davies. "Mothering and Child Protection Practice: Rethinking Risk Assessment." *Child and Family Social Work*, vol. 5, no. 1, 2000, pp. 35-45.

Mcleod, Carolyn, and Susan Sherwin. "Relational Autonomy, Self-Trust, and Health Care for Patients Who Are Oppressed." *Relational Autonomy: Feminist Perspectives on Autonomy, Agency, and the Social Self*, edited Catriona McKenzie and Natalie Stoljar, Oxford University Press, 2000, pp. 259-279.

McKegney, Sherrie. *Silenced Suffering: The Disenfranchised Grief of Birthmothers Compulsorily Separated from Their Children.* MA Thesis. McGill University, 2004.

Newman, Adam et al. "Rooming-in Care for Infants of Opioid-Dependent Mothers: Implementation and Evaluation at a Tertiary

Care Hospital. *Canadian Family Physician*, vol. 61, no. 12, 2015, pp. e555-561.

Novac, Sylvia et al. *A Visceral Grief: Young Homeless Mothers and Loss of Child Custody.* Center for Urban and Community Studies, University of Toronto 2006.

Novac Sylvia et al. "Supporting Young Homeless Mothers Who Have Lost Child Custody." *Finding Home: Policy Options for Addressing Homelessness in Canada*, edited by David Hulchanski et al. Canadian Observatory on Homelessness, 2009, pp. 415-427.

Reid, Shyenne, et al. "Living on the Streets of Canada: A Feminist Narrative Study of Girls and Young Women." *Issues in Comprehensive Pediatric Nursing*, vol. 28, no. 4, 2005, pp. 237-256.

Reid, Colleen, et al. "Good, Bad, Thwarted or Addicted? Discourses of Substance-Using Mothers." *Critical Social Policy Ltd.*, vol. 28, no. 2, 2008, pp. 211-234.

Robertson, Andrea, and Elizabeth Anne Kinsella. "Caring for Women with Custodial Losses: Literature Review." *Canadian Journal of Midwifery Research and Practice*, vol. 13, no. 3, 2014, pp. 18-31.

Wiley, Mary, and Amanda Baden. "Birth Parents in Adoption: Research, Practice, and Counseling psychology." *The Counseling Psychologist*, vol. 33, no. 1, 2005, pp. 13-50.

Zadunayski, Anna, et al. "Behind the Screen: Legal and Ethical Considerations in Neonatal Screening for Prenatal Exposure to Alcohol." *Health Law Journal*, vol. 14, 2006, pp. 105-127.

Notes on Contributors

Brittnie Aiello is an associate professor in the Department of Criminology and Criminal Justice at Merrimack College in North Andover, Massachusetts. She received her PhD in sociology from the University of Massachusetts, Amherst in 2011.

Lucy Baldwin is a senior lecturer and doctoral researcher at De Montfort University. Lucy has worked in criminal and social justice for over twenty-five years being a qualified social worker and probation officer. She is author and editor of *Mothering Justice: Working with Mothers in Criminal and Social Justice Settings* (Waterside Press 2015). Lucy has worked both in the community in courts and in prison. Lucy's research and publications focus predominantly on the impact of imprisonment on mothers in relation to maternal emotion and maternal identity. Lucy has presented nationally and internationally on the importance of working positively and compassionately with mothers.

Lizbett Benge is a native of Seattle, Washington, U.S. and is a certified labor and birth doula, playwright, and performer. She is a third-year doctoral student in gender studies at Arizona State University. As a scholar-artist, Lizbett works at the intersections of theatre, mother studies, and feminist praxis. Her research interests include ethno-theatre, the U.S. child welfare system, mothering, and intergenerational trauma. Her art combines the above material with movement, voice, and breath to create pieces that are political, vulnerable, and ephemeral. This work is guided by a desire for community, healing, resistance, and the presentation of counter-narratives.

Charlotte Beyer is Senior Lecturer in English Studies at University of Gloucestershire, UK. She has published widely on crime fiction and contemporary literature. Her edited monograph *Teaching Crime Fiction* was published by Palgrave in 2018. Charlotte is currently co-editing

Mothers Who Kill/Infanticide for Demeter Press with Josephine Savarese, and writing a monograph on the crime short story for McFarland. She is on the Editorial Boards for the journals *Feminist Encounters*, *The New Americanist*, and *American, British and Canadian Studies*.

Maya Bhave's PhD (Loyola University, Chicago) focused on Ethiopian immigrant women. After teaching sociology at North Park University for ten years, she now lives in Vermont researching life, work, and family balance, gender identity among female soccer players, and motherhood and child loss. She teaches as an adjunct professor at Saint Michael's College and lives with her husband and two sons near Burlington.

Rebecca Jaremko Bromwich is a mother to four, an assistant crown attorney, and teaches full time in the Faculty of Law and Legal Studies at Carleton University. She has a PhD from Carleton, an LL.M. and LL.B. from Queen's, a graduate certificate in women's, gender, and sexuality studies from the University of Cincinnati, a BA (Hon.) from the University of Calgary, and a certificate from the Master Class of the Program on Negotiation at Harvard Law School. Rebecca has authored and co-edited several books and collections published by Demeter Press as well as numerous law textbooks. After having lived in several cities in the US and Canada, she now resides in Ottawa.

Katherine Carroll (PhD) is a research fellow in the School of Sociology at the Australian National University. She researches how the donation and banking of female reproductive tissues such as oocytes and breastmilk intersect with the enactment of motherhood or anticipated motherhood, and the delivery of safe, quality healthcare. She also conducts collaborative research with health professionals in a variety of medical settings using the video reflexive ethnography methodology in order to enhance patient experience and healthcare delivery.

Emma Dalton is an honorary research associate in the Department of Creative Arts and English at La Trobe University in Melbourne, Australia. She has a Doctor of Philosophy and a Master of Arts from La Trobe University, and a Bachelor of Performing Arts (Hons.) from Monash University. She has four prior publications. Most recently she contributed a book review of Megan Rogers' *Finding the Plot: A Maternal*

Approach to Madness in Literature to JMI (Fall/Winter 2018). She writes about the representation of mothers in contemporary Australian plays.

Indrani Karmakar is a final year PhD student of the Department of English and Related Literature at the University of York. Her research project examines and analyzes the representation of motherhood in Indian women's writing, paying particular attention to the works of Ashapurna Debi, Mahasweta Devi, Anita Desai, Shashi Deshpande, Jhumpa Lahiri, and Chitra Banerjee Divakaruni. Her thesis investigates how their literary representations both reflect and reconceptualize the notion of motherhood in terms of gender roles, femininity, female embodiment, and the mother-daughter relationship.

Brydan Lenne (PhD) B.A./B.Sc. (Hons), works as a policy officer in the early childhood education directorate, New South Wales Department of Education and is a PhD candidate in the Department of Sociology and Social Policy at the University of Sydney. Her research focuses on the diagnosis of autism within a clinical trial using a video reflexive ethnographic approach.

Kristin Lucas is an associate professor in the Department of English Studies at Nipissing University. She has published on early modern and contemporary drama, and is currently working on affect in contemporary Indigenous literature.

Laura M. Mair is the Hope Trust Postdoctoral Fellow at the University of Edinburgh. Her current research explores ragged school sectarian divisions. Her doctoral research analysed the nature of the relationships formed between teachers and children in ragged schools in England and Scotland; her PhD was awarded from the University of Edinburgh in 2016. The monograph based on her doctoral research, *Religion and Relationships in Ragged Schools*, was published by Routledge in 2018. Between 2014 and 2016, Laura was a research consultant to the On Their Own: Britain's Child Migrants exhibition at the Victoria and Albert Museum's Museum of Childhood.

Sheri McClure, MA, California State University, Fresno, is a doctoral student in the Technical Communication and Rhetoric Program at Texas Tech University. Her research interests involve feminist issues

within medical rhetoric, including how computer mediated systems fragment the body and contribute to reduced empathy in patient care. She is currently an instructor at the University of San Francisco.

Shihoko Nakagawa is a second year master's student in social work at Wilfrid Laurier University. She received her doctorate in women's studies from York University in 2017. Her research areas are gender, poverty, public policy, and social movements, and her research focuses on single mothers' movements and social welfare policy in the U.S., Canada, and Japan. Her chapter "Single Mothers' Activism against Poverty Governance in the U.S. Child Welfare System" appears in *Motherhood and Single-Lone Parenting: A Twenty-First Century Perspective* from Demeter Press.

Rachel O'Donnell is a mother who experienced full-term baby loss and a lecturer in writing at the University of Rochester. Her research is on the feminist politics of botanical exploration and women's knowledge of contraceptive plant properties in Latin America and the Caribbean.

Sinead O'Malley MA (Social Work), Ph.D., recently completed her doctoral thesis with UNESCO Child and Family Research Centre (in the National University of Ireland, Galway) entitled *Motherhood, Mothering and the Irish Prison System*. Sinead currently practices full-time as a social worker with children in long term foster care but continues to publish and conference on the topic and has been researching and publishing on – and with – mothers in prison since 2012. Sinead has delivered various national and international accredited training and invited lectures focused on mothers engaged with the criminal and social justice systems for state agents, NGOs, students and health professionals. She contributes to this book as a survivor, as someone who is passionate about working positively with mothers facing adversity, as a wife, and as a mother of two amazing boys.

Marilyn Preston is an assistant professor in liberal studies at Grand Valley State University. She holds a doctorate in human development and family studies. Her work explores critical pedagogy, sexuality education, and affect. She has two brilliant daughters.

Andrea Lea Robertson, RM, MHSc. has been a registered midwife in Ontario, Canada since 2003 and member of faculty in the Midwifery Education Program at Ryerson University since 2010. Her path to midwifery includes frontline work in shelters and services for women experiencing past or current violence, housing instability, and mental health issues. Along with close colleagues, she is committed to improving access to midwifery for populations who typically experience marginalization. She is grateful for the unrelenting support of her partner and children, and to each person who has included her in their pregnancy and birth experiences.